TO WEAVE AND SING

TO WEAVE

Art, Symbol, and Narrative in

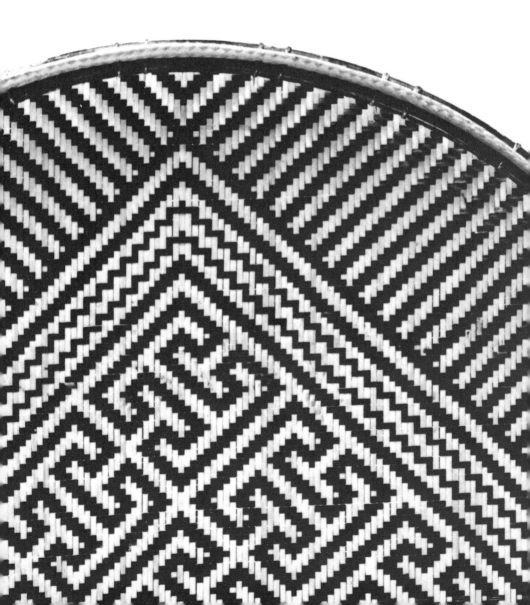

To Barbara,
who not only shared it
but made it her own

Contents

Illustrations

Acknowledgments

As with all long journeys, there have been many people along the way who have lent a helping hand. Marc de Civrieux, who first invited me to Venezuela to translate his version of *Watunna,* not only shared his many years of research with me but also encouraged and aided me in my initial visit to the Yekuana. This contact on the Paragua River was facilitated by Juan Carlos Schwartzenberg and Carlos Sembrano, the latter tragically killed in 1982. While in the village of Parupa, Julio Delgado opened his house and heart to me, as did his wives Lucia and María Pacheco and his sister Josephina. Although there are no members of that community who did not contribute in some way to this work, Luis Delgado, Manuel González, Juan Castro, Philippe Pacheco, and Antonio Contreras all aided in special ways. When I returned in 1983, they once again welcomed me back to continue my education. It was during this year as well that I was first invited to the village of Canaracuni on the upper Caura. As in Parupa, the members of this community also welcomed me into their world, sharing the wealth of their knowledge, humor, and insight with me. Above all, however, it was their chief, Manuel Garcia, a true *towanajoni,* along with Luisi and Joseito, who made this such an extraordinary stay.

To get to Canaracuni was particularly difficult and I am especially grateful to the people at Malariología in Ciudad Bolívar who made it possible; and also to Capitán Martín Henríquez de Paz, Sky King of the Amazon, who saved my life more than once. In Caracas, Luis Ignacio Ruiz of the Ministerio de Educación helped get me under way. And in Cumaná, Benito Yrady, Rafael Salvatore, and Steven Bloomstein kept me going.

xi

Financial support for this work came from various sources. During my first stay in Venezuela from 1976 to 1978, I was sponsored by grants from the Organization of American States, the Explorers Club, and the Marsden Foundation. Grants from the National Endowment for the Arts and the Tinker Foundation helped to support my second period of research from 1982 to 1984. Even more important, however, was the generous aid I received during this latter period from Joan Seaver. Without her timely and tactful support, this work would never have been completed, and I am deeply and forever grateful to her for it. I am also grateful to Lew Langness at UCLA who did so much to make these financial arrangements possible and then later nurtured the work as well. Ann Walters, too, did all she could to make my time away as worry-free as possible. The final completion of the manuscript was undertaken with a grant from the Charlotte W. Newcombe Foundation of Princeton, New Jersey. A grant-in-aid from Vassar College enabled me to prepare the index, as well as to complete other production details.

Grateful acknowledgment is also made to those who have granted permission to reproduce certain materials included in this work: to Walter Coppens and the Fundación La Salle de Ciencias Naturales for permission to reprint illustrations from *Antropológica* 16 and 44; to the Museum of Cultural History, UCLA, for plates 6, 21, 25, 32, 34, and 36; to Johannes Wilbert for permission to reprint line drawings by Helga Adibi originally published in *Survivors of Eldorado;* to Princeton University Press for permission to reprint John Gwynne's drawing of Wanadi tonoro originally published in *A Guide to the Birds of Venezuela,* by Rodolphe Meyer de Schauensee and William H. Phelps, Jr.; and to Jack Shoemaker and North Point Press for permission to reproduce the work of Barbara Brändli, along with a version of the map initially included in *Watunna: An Orinoco Creation Cycle.* I am equally grateful to Rose Craig for her original execution of this map and to Grace Mitchell for her careful revisions. Plates 6, 21, 25, 32, 34, and 36 were photographed by Richard Todd of the Museum of Cultural History, and plate 9 by Bobby Hansson. The photographs of the other baskets and artifacts were taken by Phillip Galgiani, who generously helped in many other ways as well.

The final preparation of the manuscript was aided by the indefatigable Marji Zintz and by the Watts family—Tony, Mary, and Sarah—and through their careful readings and comments by César Paternosto and Cecilia Vicuña. I also wish to note the enthusiasm and support of my

editor at the University of California Press, Scott Mahler, and the many fine suggestions made by John Sposato. To them and all of the above, I offer my most heartfelt thanks.

But there are two people for whom thanks is hardly enough. Johannes Wilbert, who encouraged this project from the start, has been a loyal friend and inspiration throughout. And finally, Barbara Einzig, my companion and collaborator of many years, joined me in both Canaracuni and Parupa and then kept on helping long after. Her love for not only the material but also the landscape and the people by whom she was held so dear helped enrich every judgment of my own. And so it is to her, whose hand has touched each page, that this book is dedicated.

1 · INTRODUCTION:
The Syntax of Culture

There are many gods, many spirits, and many people who live above the earth and below the earth. I know them all because I am a great singer. There is the one who created the baskets, and the baskets began to walk, and they entered the water after having eaten many Indians. They are the cayman alligators—you've only got to look at their skins to see that. An Indian doctor saw this spirit creating the first basket, and he managed to escape in time to avoid being eaten. It was a Yekuana. That's why our baskets are better made than anyone else's.

— Kalomera, quoted by Alain Gheerbrant,
Journey to the Far Amazon

I went to the Yekuana for the first time in 1976 as part of a grant from the Organization of American States to translate their creation epic known as the *Watunna.* While this translation was based on a Spanish version prepared over the course of nearly two decades by the French paleontologist Marc de Civrieux (1970*b*, 1980), I nevertheless wished to hear these tales told within their own context and language. So with a tape recorder perched on the top of my pack, I arranged to visit the village of Parupa, also known as Adujaña, on the upper Paragua River. But listening to stories among the Yekuana turned out to be an entirely different proposition than I had originally imagined. There were no neatly framed "storytelling events" into which the foreign observer could easily slip, no circles of attentive youths breathing in the words of an elder as he regaled them with the deeds of their ancestors. Rather, *Watunna* was everywhere, like an invisible sleeve holding the entire culture in place. Derived from the verb *adeu,* "to tell," it existed in every evocation of the mythic tradition, no matter how fragmentary or allu-

1

sive. "That's *Watunna,*" a Yekuana would say, and yet there would be no semblance of a narrative. To hear a story with anything remotely approaching completeness would take many years, and even then new details and episodes would continue to surface. But it was not only this open-ended quality of storytelling, the "stitching together" (*rhapsōi-dein*) of narrative into the fabric of daily life, that made recording myths so difficult. For even when tales were organized into self-contained units of expression, such as during the Garden and House Festivals, other problems still prevailed. First among them was the mode of composition, the specialized shamanic language unknown even to many of the participants themselves. Designed to communicate directly with the spirits of the invisible world, these songs had a purposefulness resistant to any electronic interference. And so, added to the difficulty of understanding these lengthy epics was a strict proscription against tape-recording them (Guss 1986*b*). In short, I soon began to realize that to understand even a single story among the Yekuana required a long and active apprenticeship.

It was this recognition, along with the initial limitations of my linguistic skills, that led me to seek another entrance into the mythic universe I had come to explore. For it soon became obvious that although I could not yet understand the myths as told, I could at least see them. It was with this in mind that I began to concentrate on basketry, particularly the round serving trays known as *waja*. Of course, it was hard to avoid focusing one's attention on these beautiful objects, not only because of their dramatic geometric designs but also because they were inevitably where the attention of the Yekuana one was speaking to was also focused. Conversation simply did not occur without someone making a basket. It was the principal activity of almost every male while in the village and, as such, orchestrated each dialogue, with pauses and transitions paralleling the critical moments of a basket's construction. To really communicate it often seemed one had to be making a basket. And so, it was not long before I too entered into the long process of becoming a basket maker.

My teacher was the eldest member of the village, a taciturn and brooding man named Juan Castro.[1] Although he had once been chief, his deposal had left him isolated and bitter. His days were now spent with his wife and daughters and small grandchildren, doing little else than weaving baskets. There were many times when we were the only adult males in the village, all the others being off hunting or fishing or

constructing canoes. I took advantage of these moments to pursue my interest in *Watunna,* to ask about details of stories, hunting lore, magic, rituals. But Juan Castro would have none of it. He would simply give me a blank stare and then, turning back to his basket, shrug, "*Yawanacädä,* I don't know." About basketry, however, he was always happy to speak. The names of designs, the form of a weave, the preparation of a cane, the location of a dye—these were subjects about which he concealed nothing. So it was that our long afternoons behind his house, surrounded by women preparing yuca, were occupied more and more with talk of baskets. Until finally I asked if he would not teach me how to make one.

No sooner had I done so than Juan Castro excitedly began preparing for our trip to find cane. Suddenly this quiet, even sullen man was ebullient, transformed by his new role as a teacher. In the weeks and months that followed, he closely supervised every aspect in the preparation of my basket: the cutting of the cane, the scraping of the sides, the application of the dyes, the peeling of the strips, the plaiting of the designs, the formation of the frame, the weaving of the finishing band and then finally its attachment to the body of the basket itself. There were many nights when, too tired to continue, Juan Castro took over the completion of a task, anxious that I should go on to the next. But it was not only Juan Castro who was my teacher. For I now entered the circle of elders gathered daily at the center of the roundhouse as a basket maker. And while it was with some humor that they accepted me, they nevertheless continued my education. Details were now exchanged concerning the intricacies of designs, the meaning of motifs, the proper usage of different baskets. Then, in 1977, on a cold and rainy afternoon, I was told the origin myth of the *waja.* Slowly, it became obvious that I was being introduced to a world as complex and extensive as that of the *Watunna.* In fact, it was a replica of the *Watunna,* a parallel symbolic system that would take just as many years to penetrate as the one I had originally come to study.

Juan Castro died of Kanaima magic just before my return to the Yekuana in 1982.[2] As I resumed my education as a basket maker, I wondered if he had known that he had answered all the questions I had pestered him with during my first months living in Parupa, if he had realized that the only way to explain the inner workings of *Watunna* was to enable me to participate in its creation. For while he had been uncomfortable, like most Yekuana, in speaking directly about *Watunna,*

by teaching me how to make baskets he had just as clearly initiated me into its secrets. Although this was not evident to me for some time, my ongoing work with baskets taught me that it made little difference at what point one entered the culture. Each activity, whether ritual or material, was determined by the same underlying configuration of symbols. Thus whatever an action's external form or particular function, it was involved in the same dialogue as the rest of the culture, communicating the same essential messages and meanings. It was truly a mutually reflective universe in which every moment was filled with the same possibilities of illumination as any other. To tell a story, therefore, was to weave a basket, just as it was to make a canoe, to prepare barbasco, to build a house, to clear a garden, to give birth, to die.

In a society such as the Yekuana's, it was possible to see the entire culture refracted through a single object or deed. Every part was a recapitulation of the whole, a synthesis of the intelligible organization of reality that informed every other. As such, the baskets provided a prism through which the Yekuana universe was reflected. One could see the basic symbolic organization that helped to determine the structure of every other aspect of the society. One could also comprehend the ethos and philosophy that inspired these symbols, the underlying meanings that the culture, in all of its parts, was organized to communicate. No less important than this was the ability to perceive the conflicts that each of these aspects attempted to resolve. Cast in a metaphor of endless dualities, the symbols in the baskets, like those elsewhere, confronted the most elemental oppositions between chaos and order, visible and invisible, being and non-being. The concept of culture which they presented was not simply one of communication, or what Geertz calls "a mode of thought" (1976:1499), but also of transformation, of the constant metamorphosis of reality into a comprehensible and coherent order.

As both an observer and basket maker, I was able to participate in this process of transformation, to experience culture not as the distillation of a set of abstract ideals but as an ongoing act of creation. To understand the *Watunna* I had originally come to learn demanded much more than just verbal skills. It required the use of all my senses or, more precisely, a reorientation to the nature of meaning and the manner of its transmission. The story that follows, like all good ethnography, is, therefore, also one of personal growth and initiation. Yet the details of that tale must await another book. The one told here is that of the Yekuana and the world they weave and sing into being every day of their lives.

2 · THE PEOPLE

Our first contact with the Spanish was a long time after their arrival in Venezuela. We met them when they came to find the famous City of Gold, El Dorado. They thought this was in our land.

A little while later, the Spanish tried to conquer us by force. Then we Yekuana, together with our neighbors, the Maco, Yabarana, and others, defended ourselves, and we overthrew the Spanish. That's why, for a long time, we called ourselves "The Unconquered" and "the ones who beat the conquerors."

— Raphael Fernández
Ye'kuana: Nos cuentan Los "Makiritares"

"THE ONES OF THIS EARTH"

If it is true that a name reflects an inner essence, then the many used to refer to the Yekuana offer a profile of the varied character of this highland jungle people. The earliest mention of the Yekuana occurs in the report of the Jesuit priest Manuel Román, who in 1744 journeyed to the upper Orinoco to investigate rumors of Portuguese slave traders in the area. Somewhere in the vicinity of present-day La Esmeralda, he was surprised by a group of these Portuguese insisting they were not in Spanish territory but on a tributary of the Amazon. To prove their assertion, they invited Román to accompany them back along the route they had traveled, thus revealing for the first time that phenomenon known as the Casiquiare—a natural canal connecting the two great watersheds of South America via the Río Negro. To aid in this journey, Román enlisted the services of a Carib-speaking group of Indians living near the mouth of the Kunukunuma, a large river entering the Orinoco several miles below the Casiquiare. Román refers to these

5

excellent navigators in his reports and maps as the "Makiritare," a name which was to dominate most written reference to them for the next two centuries. Like many ethnographic tribal denominations, Makiritare is not autogenous, but is borrowed from the neighboring group responsible for guiding the first whites to them. Names of places and tribes on Román's map confirm his use of Arawak-speaking guides (de Barandiarán 1979:739); hence the term *Makiritare,* derived from the Arawak roots *Makidi* and *ari,* meaning "people of the rivers" or "water people."

The terms used by ethnographers and explorers to identify the Yekuana usually indicate the direction of their approach. In 1838 the German naturalist Robert Schomburgk arrived among the Yekuana with the aid of Carib-speaking Pemon and Makushi guides. It is therefore no surprise that in his *Reisen in Britisch Guiana* (1847) he uses the Pemon name, Maiongkong.[1] It has been suggested that this name, translatable as "Round Heads," derives from the Yekuana's distinctive *totuma* cut that gives their hair the appearance of an inverted gourd. But another interpretation of this commonly heard name is that suggested by Armellada, who claims Maiongkong means "those who live inside their *conucos*" (Salazar 1970:12). Although the Yekuana do not actually live in their gardens, the coincidence of these two definitions is notable, as there is a close symbolic relation between body care and gardening, which will be further discussed at length.

Another name mentioned by Cesáreo de Armellada and others working with the neighboring Pemon tribes to the east is "Pawaná" or "Pabanoton." Meaning "those who sell," it is almost a generic term among Carib speakers for traders from a distant tribe (Butt 1973:16). The fact that Pawaná and Maiongkong are nearly synonymous among their Cariban neighbors is a clear indication of the importance that trade plays among this highly mobile tribe that one writer referred to as "the Phoenicians of the Amazon" (González Niño n.d.:7).

The first person to actually use the autochthonous term "Yekuana" was also the first ethnographer to spend a concentrated period of time among them. Approaching the Yekuana in a way that no other explorer ever has, Theodor Koch-Grünberg, on a three-year expedition sponsored by the Baessler Institute of Berlin, in 1912 climbed out of the Uraricoera basin of northern Brazil and, with the aid of Wapishana and Makushi guides, crossed the Pacaraima Mountains into the headwaters of the Orinoco. Once in Venezuela, his expedition quickly made contact

with Yekuana villages along the Merevari and Canaracuni. Over the next several months he gathered the material that was to form the Yekuana section of his monumental three-volume work, *Vom Roraima Zum Orinoco*.

Although throughout this seminal work Koch-Grünberg consistently uses the term *Yekuana,* he does so with some hesitation, believing that further investigation would reveal a more accurate division into four separate groups representing sub-tribes or clans: the Yekuana, Dekuana, Ihuruana, and Kunuana (Koch-Grünberg [1924] 1982:24).[2] Unfortunately, Koch-Grünberg was mistaken. These four indigenous terms, all of which have been used on occasion by various travelers to identify the entire tribe, indicate neither bloodlines nor sub-tribes but simply geographical areas of such distance from one another as to permit substantial linguistic variation. Yet for the Yekuana, these names have a mytho-historic significance that transcends mere regional identity.

"Yekuana," the first of these divisions, was believed by Koch-Grünberg to properly refer only to those Indians living along the Merevari or Caura rivers. Yet for the Yekuana this name refers to the whole tribe. Like its Arawak counterpart, the name reflects the Yekuana's prodigious skills in navigating the rapids of the Upper Orinoco and its tributaries. Derived from "tree" (*ye*), "water" (*ku*), and "people" (*ana*), it can be translated as "Water-Log" or "Canoe People."

A phonetic variation of this term, "Dekuana" is said by Koch-Grünberg to represent those groups living on the middle and lower Ventuari. And indeed, several myths tell of a numerous band of cannibalistic Indians known as Dekuana who formerly inhabited this area. However, as a result of their unrelenting belligerence, they were all but destroyed (Gheerbrant 1954:159–61). But the term *Dekuana* has greater significance: it is the name of the sacred mountain in the headwaters of the Arahame and Kuntinamo from which the culture hero Wanadi created the first Yekuana:

> In order to populate the villages he made the new people. He took earth. He formed it into men. Then he sat down. He dreamed: "It's alive." He smoked. He shook his maraca. That's the way the new people were born; the ones of this earth, of today, now. First a man was born in Mount Dekuana, in the headwaters of the Arahame River. He was made with the dirt from that mountain. That's why he was called Dekuana, like us, his

grandchildren. That man was the first Yekuana. Mount Dekuana was the beginning for us. (de Civrieux 1970*b*:56)

Located in the Guiana highlands, out of which flow the major tributaries of the Orinoco River, Mount Dekuana is in the very center of what the Yekuana call Ihuruña, the "Headwater Place." This is the name of their homeland, a vast region of mountains, rain forests, savannas, rushing rivers, and waterfalls stretching all the way from the right bank of the upper Orinoco to the lower reaches of the Caura and Ventuari. To those who still occupy the most sacred and remote zones nearest the source of these rivers is reserved the term *Ihuruana,* the "Headwater People." Spoken of with the special reverence due to elders, the Ihuruana are considered the most knowledgeable and authentic Yekuana—untainted by the criollo influence that has undermined those groups who have migrated further downriver. Ihuruana is not a term exclusively applied to those of the upper Ventuari as Koch-Grünberg asserted, but is more of an honorary epithet for any Yekuana who maintains the traditional life-style of the tribe in the original area of its settlement.

Koch-Grünberg's fourth and final tribal division, the Kunuana, whom he claims "form the nucleus of the entire tribe," may therefore be closer to the actual Ihuruana. The Kunuana, he maintains, are the Yekuana of the Kunukunuma, Padamo, and Orinoco rivers—the Indians of Kamasowoiche, the original savanna in Ihuruña from which the first Yekuana migrated. But of all the divisions, Kunuana is in reality the most restricted geographically, referring only to those Yekuana of the Kunukunuma River, a group whose geographic isolation, early contact, and intensive evangelization have resulted in a certain degree of cultural variation from the rest of the tribe.

One term that Koch-Grünberg did not cite but which has been suggested by several ethnographers (Fuchs 1962, de Civrieux 1980) as an appropriate successor to the unfortunate but popular "Makiritare" is "So'to." For regardless of where a Yekuana may live, "So'to" is the accepted term for a "human" or "person." It is also the word for "twenty," the number of digits for each individual. But more importantly, "So'to" is an expression of the common culture and language shared by every Yekuana as distinguished from that of any other species, human or nonhuman. It is their unique heritage as bequeathed by the culture hero Wanadi and recalled daily in the body of oral lore and tradition known as the *Watunna.*

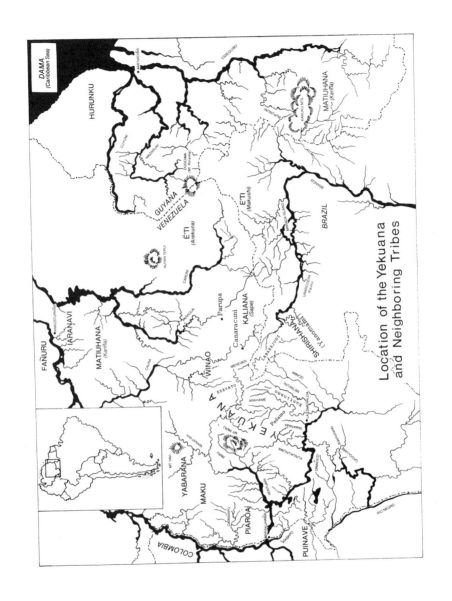

Location of the Yekuana
and Neighboring Tribes

IHURUÑA, "THE HEADWATER PLACE"

With a total population of less than 3,100 people, the Yekuana are but one of the many Carib-speaking tribes that migrated north along the Amazonian waterways of Brazil, entering southern Venezuela several hundred years ago to begin the displacement of the Arawak bands who had preceded them.[3] Although it is impossible to say precisely when the Yekuana arrived, they were certainly well established in the Kunukunuma and Padamo area by the time the first Border Commission visited them in 1758.[4] In fact, there were so many Yekuana settled along the Padamo and its upper tributaries, the Kuntinamo and Arahame, that this river soon came to be known as the "Maquiritare." As for the other areas the Yekuana now occupy—the Ventuari, Erevato, Caura, and Paragua in Venezuela, and the Labarejudi in Brazil—it would appear that settlement occurred only after the arrival of the Spanish.

Much of this territory had been too hostile for the Yekuana to occupy any earlier. The fierce Kariña cannibals trafficking along the Caura and Ventuari rivers to the north were the Yekuana's habitual enemies, and it was only with their reduction by the Spanish that these large and attractive rivers became available for settlement.[5] It therefore comes as no surprise that de Barandiarán (1979:781) and Arvelo-Jimenez (1971:15) should estimate the beginning of this Yekuana expansion at around 1750. But there were other factors in this diffusion. Warlike bands of Yanomami, arriving from Brazil and the territory south of the Orinoco, began to attack the Yekuana, pushing them north. Known also as Waika, Guaharibo, and Shirishana, these newcomers proposed to dislodge the Yekuana in the same way the latter had the Arawak. The hostility between these two groups, which has been noted by travelers and ethnographers, raged for well over a hundred years, and according to tribal tradition only subsided around 1940, when a large group of armed Yekuana slaughtered a band of Yanomami in reprisal for past raids (Gheerbrant 1954:157, de Civrieux 1980:150–51,168). Today these two groups, though still suspicious of one another, coexist peacefully in a truce maintained by trade and labor exchange.

Far more destructive than the raids of the Yanomami was the incursion of the rubber gatherers that began early in this century. By 1913, this had degenerated into full-scale genocide. In May of that year, Tomás Funes, a rubber merchant, marched into the provincial capital of San Fernando de Atabapo and murdered the governor and 140 other peo-

ple. For the next eight years, Funes ruled the Territorio Amazonas as an independent fiefdom with no ties whatsoever to the central government in Caracas. Not satisfied with the enslavement of the Yekuana male population for the gathering of rubber, Funes sent out expeditions to destroy villages and to murder and torture the inhabitants. De Barandiarán calculates that no fewer than one thousand Yekuana along with their twenty villages were destroyed before Funes's reign of terror came to an end in 1921 (1979:791). The migration northward that the Yanomami had encouraged was now accelerated, with a large group of Yekuana moving away from the Territorio Amazonas entirely and settling along the Paragua River in the southern part of Estado Bolívar.

But the diffusion of the Yekuana from their original homeland in the upper Padamo and Kunukunuma was not just northward. Their furthest migration, recounted in a series of legends called the "Waitie," was eastward toward Brazil, at one point penetrating to the island of Maraca on the Uraricoera River. Unlike their resettlement on the Ventuari and Caura, this move was less the result of hostile pressures than an attempt to exploit new trade possibilities created by the arrival of the Europeans.

After Manuel Román's brief visit in 1744, contact was firmly established with the appearance of an official Border Commission sent out to both verify the Jesuit explorer's claims of an Orinoco-Amazon link and to adjust the southern limits with Brazil. Led by two lieutenants, Francisco Fernández de Bobadilla and Apolinar Díez de la Fuente, the expedition also hoped to investigate the availability of cacao and any minerals that might lead to that ever-illusive kingdom known as El Dorado. Arriving in 1758, they soon made contact with Yekuana living around the mouth of the Kunukunuma, as well as along the Padamo. Goods were exchanged and an alliance quickly forged that promised to give the Yekuana protection from the Kariña slave traders who regularly attacked them in search of slaves for themselves and their Dutch allies. Initial contact was so cordial that the Yekuana concluded these new visitors must be the creation of their culture hero Wanadi. Their white skin was simply the result of the color of earth used in their formation, and their miraculous gifts of iron and cloth, presents bestowed upon them in Heaven. The Yekuana called this new being Iaranavi and in 1760 eagerly assisted in the creation of a joint community to be known as La Esmeralda, located on the Orinoco midway between the mouths of the Kunukunuma and Padamo. They also traveled hundreds of miles to

the new Iaranavi capital of Ankosturaña (Angostura, present-day Ciudad Bolívar) where they traded canoes, baskets, and cassava for machetes, knives, hooks, and cloth.[6]

> [Iaranavi] was the rich man, Wanadi's shopkeeper, friend to the poor. He was always traveling around, trading goods. Our grand-fathers traveled to Ankosturaña to get goods from Iaranavi. They learned how to trade there, how to exchange their stuff for the things they didn't have. (de Civrieux 1980:148)

But this relation was soon to sour. By 1767, a new governor had been installed in Angostura and the Spanish embarked upon a more aggressive policy of colonization on the upper Orinoco. In an attempt to secure the entire region, a new expeditionary force was sent out to build a road and nineteen small forts connecting Angostura with La Esmeralda. This ambitious plan, which to this day has never been accomplished, was to cut directly through the homeland of the Yekuana. Refusing to cooperate, the Yekuana were forcibly relocated and set to work on chain gangs. They were also exposed for the first time to the ideas of Capuchin and Franciscan missionaries sent out to administer their conversion. Amazed by this sudden change in behavior, the Yekuana decided that this was no longer Iaranavi, but a different species altogether. Fañuru, as they called him, was not a creation of Wanadi, but of his demonic arch-rival Odosha.[7] Along with their allies, the Fadre (Padres, "Priests"), they had come from Caracas to overrun their friend Iaranavi in Angostura (de Civrieux 1980:11, 154). Left with no alternative, the Yekuana organized several neighboring tribes and, in a single evening in 1776, rose up and destroyed all nineteen forts, driving the Spanish out of the upper Orinoco for what turned out to be the next 150 years.

The sudden severance of all contact with the Spanish created a crisis for the Yekuana, who had developed a trade dependency upon them. In a period of less than two decades their economy had been dramatically transformed by the availability of iron and other European trade goods. In an attempt to escape Spanish reprisals and to locate new sources for these goods, a group of Yekuana crossed the Pacaraima Mountains and entered Brazil. Led by the legendary dynasty of Waitie chiefs, they descended the Uraricoera River, creating settlements all the way to the mouth of the Traenida beside Maraca Island. It was here that

they established trade contacts with the Makushi. But they soon tired of dealing with intermediaries and decided to trace these new goods to their source, embarking on a long and dangerous journey to the principal Dutch fort of Kijkoveral in the mouth of the Essequibo. This journey by dugout canoe along the Uraricoera, Río Branco, São Joaquín, Tacutu, Mahu, Rupununi, and finally the Essequibo, took well over a year and was the greatest odyssey ever undertaken by any member of the tribe. When at last they had come to the Caribbean, they were so amazed by its size that they pronounced it the shore of Lake Akuena, that mythical lake located in Heaven. They also claimed that the Dutchman must be the new favored child of Wanadi. They called him Hurunku and his village Amenadiña:[8]

> Now they saw a village there called Amenadiña. It wasn't a So'to village, but a spirit village. The chief of Amenadiña was Hurunku. He was Wanadi's friend. He went to Heaven with all his people to visit Wanadi. That's why such big boats would come to Amenadiña. They'd travel across Dama, the Sea, and go to Wanadi's village, to Motadewa. Hurunku's boats would leave empty. Then they'd come back across Dama full and unload all the goods from Heaven in Amenadiña. They'd just go and come back, go and come back. (de Civrieux 1980:170)[9]

A combination of factors that included trade agreements with the Makushi, Yanomami hostility, and isolation from the main branch of the tribe, led to the Yekuana's eventual withdrawal from Brazil. By the time of Koch-Grünberg's arrival in 1912 only one community remained on the east side of the Pacaraima Range. (Today the situation is much the same, with the village of Fuduwaruña, located in the headwaters of the Uraricoera on the upper Labarejudi, the only Yekuana village left in Brazil.) However, the Yekuana continued their special trade relation with the Dutch (and subsequently the British) and, as historical records corroborate, continued to make the remarkable journey from the headwaters of the Orinoco to the mouth of the Essequibo on the Caribbean. In 1840, the German explorer and naturalist Robert Schomburgk reported his astonishment at meeting a group of these navigators on the Rupununi headed for Georgetown (Coppens 1971:35). A missionary named W. H. Brett also reported encountering them in British Guyana during one of their long voyages in 1864 (Butt 1973:10). And even into

this century, with goods accessible to them at much closer locations, they have been known to make such journeys (ibid.).

Not only Europeans have recalled these epic voyages. The collective body of oral tradition referred to by the Yekuana as *Watunna* is filled with detailed accounts of not only their migration into Brazil and subsequent voyage to Amenadiña, but of the entire history of Yekuana contact with Western culture. Through a process of "historical incorporation" (Guss 1981c, 1986b) these verifiable events are recontextualized within an already established mythic universe; hence the recasting of such occurrences as the Spanish-Yekuana conflict after 1767 into the familiar dualistic motif of Wanadi's battle against Odosha and his forces of darkness (such as the Fañuru and the Fadre).[10] History becomes its own exegesis as calendrical time is replaced by that of the atemporal mythic, and historical personalities by the culture heroes and demons who inhabit it. But this mythopoesis is far more than a mnemonic device with moral overtones. It is one of the many ways in which the Yekuana transform the foreign into the currency of their own culture, making it safe and familiar. Through such adaptability to new historical situations the Yekuana are able to reaffirm a cosmology that forever locates them at its center.

ETHNOGRAPHIC HISTORY

The ability to "metaphorize" (Wagner 1981:31) new historical realities into the symbols of one's own universe is an important mechanism through which any culture maintains its vitality and psychic health. The success of the Yekuana in confronting a hostile European ideology for more than two hundred years is a testimony to their creativity and resourcefulness in responding to the potentially catastrophic influx of both spiritual and material contradictions. Instead of permitting these challenges to undermine the stability of their society, the Yekuana have consistently defused them by incorporating them into the traditional structures that order their world. By continually reaffirming these structures along with the values they represent, the Yekuana have achieved a level of organization and self-esteem unique among the tribes of Venezuela today. This self-assurance has been noted by travelers and ethnographers who often, as in the following statement of Koch-Grünberg, react with surprise to what they perceive as an attitude of superiority:

The Yekuana are arrogant beyond belief. They consider them-
selves a chosen people and without any reason look down on all
the other tribes. As Robert Schomburgk has already said of them:
"They are a proud and conceited tribe. The Maiongkong are al-
ways strutting about with great self-confidence, as if the entire
world were their domain." ([1924] 1982:302)

What Koch-Grünberg perceived as arrogance was the Yekuana's
unabashed confidence in the absolute propriety of their way of life as
opposed to any the Europeans might wish to substitute for it. Combin-
ing this attitude with an already existing institutionalized xenophobia
(fed by two hundred years of intermittent abuse) and a highly disci-
plined social organization, it is no surprise that the Yekuana have sur-
vived so successfully. For of all the Carib-speaking tribes that once
dominated Venezuela, none have succeeded in maintaining their cul-
tural identity as have the Yekuana.

An additional factor in this ability to resist the devastating effects of
acculturation (and worse) that have befallen so many neighboring
groups has been the Yekuana's ability to isolate themselves behind an
almost impregnable landscape. The rivers along which their thirty vil-
lages are located—the Padamo, Kunukunuma, Erevato, Ventuari, Caura,
and Paragua—are all tributaries of the Orinoco, with their sources in
the high *tepui* and mountains of southern Venezuela's Guiana massif. It
is a rugged landscape of dramatic contrasts, with huge tabletop moun-
tains rising directly out of the jungle floor to heights of over eight
thousand feet. Understandably, few outsiders have been able to pene-
trate this dense rain forest homeland with its natural barriers of rapids
and waterfalls. Aside from the twenty years of contact during the eigh-
teenth century and the influx of rubber gatherers in this one, the only
Europeans to enter Ihuruña have been the isolated explorer and
ethnographer.

By the time of Alexander von Humboldt's brief visit to La Esmer-
alda in 1800, the only European settlement to ever exist in the region
was already nearly defunct (1852,2:434).[11] And by 1818 the few Catholic
missionaries remaining in the upper Orinoco were forcibly removed by
order of the new Republic. In 1838, while making his memorable jour-
ney from British Guyana to the upper Orinoco by way of the Merevari
(upper Caura) and Padamo, Robert Schomburgk observed that the
Yekuana in this area were already embattled with bands of Yanomami
pushing north. His account of his ascent of the Orinoco reports only

one family remaining in La Esmeralda. A French explorer named Jean Chaffanjon passed through this same region fifty years later in a renewed attempt to discover the headwaters of the Orinoco. His contact with the Yekuana of the Caura and Kunukunuma is detailed in his memoir, *L'Orénoque et le Caura* (1889).

It was not until Theodor Koch-Grünberg's expedition of 1911 to 1913 that any serious study of the Yekuana was undertaken. Visiting several communities along the Caura, Ventuari, and upper Padamo, Koch-Grünberg documented Yekuana material culture, depositing his collection of photographs, recordings ("phonograms"), and artifacts in the Berlin Museum of Ethnography. Hindered by inadequate translators and his own inability to speak Yekuana, he confessed his frustration at being unable to penetrate the mysteries of their religion and mythology ([1924] 1982:317). It was while returning to the Yekuana in 1924 as ethnologist for the Hamilton Rice Scientific Expedition that this important pioneer of South American ethnography died of malaria in Brazil.

Twenty-five years later a young Frenchman named Alain Gheerbrant along with three companions left Bogotá, Colombia, in an attempt to reverse Koch-Grünberg's journey and retrace his path all the way back to Boa Vista. After descending the eastern slopes of the Andes, they crossed the *llanos* to Venezuela and canoed up the Orinoco to the Ventuari in search of Yekuana to guide them. The record of this remarkable journey, published in 1952 as *L'expédition Orénoque-Amazone,* is particularly valuable in that it is our only written description of the three greatest Yekuana leaders of this century—Kalomera, Cejoyuma, and Frenario. Laden down with hundreds of pounds of recording and photographic equipment, Gheerbrant and his companions visited all three of these chiefs' villages in the hope of taping and filming their rituals. Unfortunately, a canoe accident during the last days of the journey resulted in the loss of these invaluable documents. Nevertheless, Gheerbrant's written record of what was no more than seven or eight months with the Yekuana is filled with accurate and perceptive detail, presenting us with the most readable and enjoyable account we have of Yekuna life.

Sustained and systematic investigation of the Yekuana did not begin until the early 1950s, when not only ethnographers but also missionaries and government officials began to enter the region with greater frequency. This period of renewed interest was inaugurated by a well-publicized 1952 French-Venezuelan expedition to discover the

headwaters of the Orinoco. One member of this expedition who became interested in learning more about the Yekuana guides and porters accompanying it was Marc de Civrieux, a young paleontologist who had migrated to Venezuela from France in 1939. Using this opportunity to make contact with various Yekuana living along the Kunukunuma, de Civrieux began a relationship that was to last for twenty years. Returning again and again, he dedicated himself to the collection of the myths and legends that were to compose his *Watunna: Mitología Makiritare,* an invaluable contribution to not only Yekuana ethnology but to that of all of South America (1970*b,* translated as *Watunna: An Orinoco Creation Cycle,* 1980).

Other investigators to work in this region during this period were Meinhard Schuster along the Padamo and Kunukunuma from 1954 to 1955 as part of the Frobenius Expedition, and Johannes Wilbert and Helmuth Fuchs along the Ventuari, albeit on separate expeditions, in 1958. It was also in the Ventuari area that Nelly Arvelo-Jimenez, from 1968 to 1969, did the fieldwork for the only dissertation ever done on the Yekuana. Entitled *Political Relations in a Tribal Society: A Study of the Ye'cuana Indians of Venezuela* (1971), it is an analysis of how social control is exerted in the absence of institutionalized political authority. A particular focus of Arvelo-Jimenez, both in this and subsequent works (1973, 1977) is the process by which Yekuana villages are formed and dissolved.

During the same period in which Arvelo-Jimenez was conducting her fieldwork, Walter Coppens was working with various Yekuana groups along the Caura, Erevato, and Paragua. Based on sporadic visits of no longer than one month, his studies deal with issues of acculturation (1972, 1981) and intertribal trade (1971). More recent work among the Yekuana has been carried out by Raymond and Ilene Hames, who conducted a preliminary survey of Yekuana basketry on the Padamo from 1975 to 1976, and by Alcida Rita Ramos, who concentrated on relations with the Yanomami while working in the only remaining Yekuana community in Brazil in 1974.

Of particular interest is the work of Daniel de Barandiarán, a former missionary with the Fraternidad de Foucauld, who helped to found the community of Santa María de Erevato in 1959. Despite a highly polemical style and the lack of anthropological training, de Barandiarán's work is nevertheless informed by years of daily contact with the Yekuana. He has produced several important studies, including

those on Yekuana shamanism (1962*b*) and the roundhouse (1966), and is the author of the only two articles on the Yekuana language, published under the pseudonym of Damian de Escoriaza (1959, 1960).

Ironically, it is de Barandiarán, in his most recent work, who counsels against the dangers of increased centralization among the Yekuana (1979:795). For the village of Santa María, which he was so instrumental in organizing, was not only the first Catholic mission located in Yekuana territory but also the principal model for the demographic upheaval that threatens to revolutionize Yekuana settlement patterns. Unlike communities of the past which never exceeded one hundred people, Santa María was not formed by a handful of extended families intending to remain in the area only as long as the gardens and surrounding supply of game lasted. This was meant to be a permanent community, with a constantly expanding population. The economy was not to be based on the traditional mix of subsistence horticulture and hunting and gathering, but on a cash crop, which in the case of Santa María was coffee. The Yekuana were to form their own metropolis, replete with school, infirmary, airstrip, radio, and generator, and in this way, it was theorized, would best defend themselves against the encroaching criollo world.

Today, with a population of over four hundred people, Santa María is the largest Yekuana community to ever exist.[12] But it is not the only one of its kind. In the late 1960s, a former Yekuana national guardsman named Isaías Rodriguez appeared on the Ventuari announcing his intention to organize a large settlement on a plain called Aseniña. Meeting with initial resistance from several upriver villages, Rodriguez eventually attracted enough supporters to form the successful community of Cacuri. With substantial backing from Jesuit missionaries, cattle were shipped in to form an economic base and enough facilities provided to continue to attract additional Yekuana from even further away. Incorporated as the Unión Makiritare del Alto Ventuari (UMAV), Cacuri now has a population of over three hundred people and an office and representatives in Caracas.[13]

An equivalent experiment also exists on the Kunukunuma River. But unlike the Catholics who helped organize Santa María and Cacuri, the Protestant founders of Acanaña—the New Tribes Missions—have no pretentions of discovering ways of adapting Yekuana values to new social realities. For them, all of Yekuana culture is a form of diabolic possession that must be exorcised. As one shaman from the Kuntinamo explained it:

They forbid all our customs, our drinks, our *Watunna,* our music and our way of life. For me this is serious. The missionary Jaime Bou [the head of New Tribes] arrived here with a law they had passed accusing my fathers and my grandfathers of being liars, saying that our *Watunna* and our way of life is negative. He lacked respect when he said that about our culture. They're destroying our way of speaking to our fathers. They're creating a huge gap. (Mosonyi et al. 1981:238)

A nondenominational Protestant organization based in the United States, the New Tribes Missions arrived in Venezuela soon after World War II. After an unsuccessful attempt to establish themselves in the Ventuari area, they began to penetrate the Kunukunuma. By the end of 1958, they had attracted enough Yekuana converts to found the village of Acanaña near the mouth of the Kunukunuma. Like Santa María and Cacuri, Acanaña has also drained smaller upriver communities of their members. Yet in other ways this new community has been far different from its neighbors to the north. Whereas the Catholic missionaries of Santa María and Cacuri have not demanded conversion and play only limited roles in the organization of these communities, proselytism is at the very heart of Acanaña's existence. An evangelical community where the practice of Yekuana traditions is strictly forbidden, Acanaña has been set up with the express purpose of training Yekuana to be sent out as missionaries among both their own and neighboring tribes. This strategy has not only failed to win converts outside of the Kunukunuma area, however, but has resulted in the increased isolation of the Kunuana. As Arvelo-Jimenez observed:

Baptist evangelization has provoked a wide schism between evangelized and traditional Yekuana such as was never known before. Those who have not given up the traditional way feel very much threatened by the religious zeal of the evangelists. They despise the converts and at the same time fear their tactics for gaining more and more Yekuana to their side. (1971:22–23)

This conflict, paralleled in other groups where the New Tribes Missions have located, such as the Panare and Piaroa, has recently gone beyond the level of intratribal strife to one of national debate. A barrage of publicity that has included symposia, congressional investigations,

books, and such award-winning films as Carlos Azpurua's "Yo hablo a Caracas" (1978) has galvanized the Venezuelan public against the activities of these American-based missionaries and has forced a reassessment of official indigenist policy.[14] For the first time, a national coalition of artists, politicians, academics, and indigenist leaders has banded together to demand not just the expulsion of these missionaries but also legislation to guarantee the rights of the approximately seventy-five thousand Indians remaining in Venezuela (Arvelo-Jimenez 1972:41).

Yet while such developments can only be positive for the Yekuana, the real decisions affecting their future remain their own. For although Acanaña and other New Tribes missions in the Kunukunuma area clearly threaten their cultural and territorial integrity, the greatest challenges to their traditional way of life may be those taken on their own initiative. The decision to relocate in larger, permanent settlements such as Santa María and Cacuri is one which the Yekuana have negotiated among themselves (albeit with material incentives provided by Catholic missionaries). The debate is not simply between "Creyentes" and nonbelievers but also between Yekuana of smaller upriver communities and those of the newer centralized ones.[15] Exactly how these new settlements, with their committment to cash crops and nonindigenous technology, will affect the fabric of Yekuana life may not be determined for some time to come. Ihuruña, defended by natural barriers, strong leadership, and disciplined organization, is still the unconquered homeland of the Yekuana. Yet today it is a culture at a crossroads, challenged by an ideology that knows no borders.

3 · CULTURE AND ETHOS:
A Play of Forces

THE HOUSE

The traditional Yekuana settlement, of which there are approximately thirty dotted throughout the upper Orinoco, is a fiercely independent community, resistant to any pan-tribal authority. Each village is a completely self-contained, autonomous unit, with its own chief and shaman. What unites these communities is their shared linguistic and cultural heritage. For although kinship ties do cross village boundaries, "marrying-in" is regularly enforced and any attempt to break the primacy of village relations discouraged. Village autonomy is reinforced in a host of other ways as well, including ideological belief, socialization, and simple ecological necessity. In fact, virtually all systems of Yekuana thought and activity recognize some distinction between one's immediate community and the world beyond it.[1] The most important of these systems is the physical and symbolic composition of the Yekuana village itself.

Each village is refered to as a "house" or *atta* and is not only conceived of as a self-contained universe but is actually constructed as a replica of the cosmos. It is said that Wanadi himself came down to Earth to reveal the structure of this sacred house to the Yekuana by building the first one in Kushamakari. Today this house can be seen in the form of a mountain located in the center of the Yekuana homeland. The *atta* that Wanadi built and on which all Yekuana houses have subsequently been modeled was based on his own house—the entire world of Kahuña or Heaven. Each of the *atta*'s architectural components therefore represents and takes the name of a part of the landscape of this invisible world.

21

The conical roof is said to be the Firmament of Heaven and like its namesake is divided into two concentric circles. The upper section, made of precious and durable *wahu* palm, corresponds to Akuena, the Lake of Immortality, which sits at the very center of Heaven, while the more ephemeral, outer *maahiyadi* thatch may be said to represent the six houses of Kahuña, where the various spirit beings and animal masters live. The two main crossbeams are called the *ademnie dotadi,* "the spirit of the *ademnie* tree," and represent the Milky Way of the same name. Emphasizing the four corners of the world, these crossbeams are arranged on an exact North-South axis, with two doors positioned directly below them and two more precisely along the East-West axis. The ten additional beams that form the roof's infrastructure are called *biononoi* or "sky trees," paralleling similar structures said to hold up Heaven itself. All twelve of these roof beams stand just like Kahuña on the "star supports," which in the case of the *atta* are the twelve *sidityadi* posts encircling the entire structure.

Passing through the middle of the roof to the outside is a long post, made from one of several species of hardwoods, which extends to the very center of the house floor. This post represents the centerpost of the universe, the *axis mundi* by which the two worlds, the visible and invisible, are connected and through which they maintain contact. Known as the *ñunudu,* this post is the clearest expression of each village's distinctive place at the center of the world. Derived from the same root as the Yekuana words for "tongue" (*nudu*), "navel" (*yenadu*), "*waja* drawing" (*ñenudu*), and "tiger spot" (*ichahe hato ñenudu*), the term is most closely related to the nearly indistinguishable word for "eye," *yenudu.* This synonymity is more than linguistic; the eye is where the most important of each person's six "doubles" or *akato* is located. Identical to the centerpost of the village, it is the location of the celestial spirit dispatched by Wanadi from Kahuña to animate each individual.

Surrounding the centerpost at its base are two concentric circles, mirroring the same division found in the roof above. The inner one, known as the *annaka,* "in the center," corresponds to the dimensions of the *wahu* palm and, like this sacred cap, represents Heaven's inner circle. It is the *annaka,* therefore, which is reserved for all ceremonial and ritual occasions. Like Lake Akuena with its restorative waters imbued with *kaahi,*[2] it is the site of initiation and rebirth. Here the men gather daily to confer, share food, and do craftwork. It is also where shamans perform their cures and elders discuss their dreams. Forbidden to the women except while serving the men or participating in

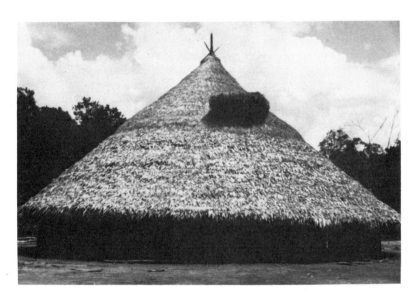

Newly constructed *atta*, Canaracuni. Visible are the single window (*mentána*) and the *tingkuiyedi* or *hiyanacachi,* rising above the roofline (photo David M. Guss)

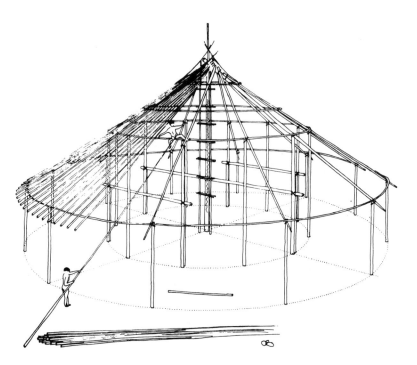

Detail of *atta,* showing centerpost and infrastructure of roof and walls
(courtesy *Antropológica,* 1966)

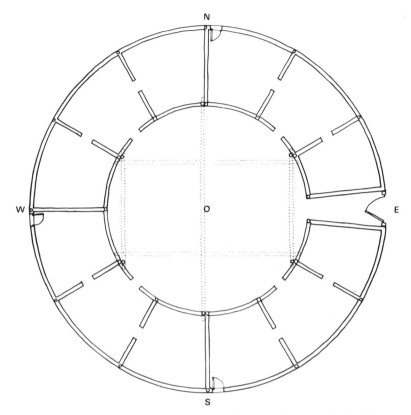

Floor plan of *atta,* showing the *annaka* and surrounding *asa,* divided into living compartments (courtesy *Antropológica,* 1966)

festivals, the *annaka* is also where all single males from the time of puberty to marriage sleep.

Encircling the *annaka* are the various living compartments for each extended family within the community. Known as the *asa* or "outside," this second circle clearly corresponds to the six divisions of Heaven surrounding Lake Akuena. Like its celestial counterpart, the space of the *asa* is divided into different living areas, in this case by bark hangings. This pattern of two concentric circles, with the profane and ephemeral enclosing the sacred and eternal, is reproduced not only in the invisible landscape of Heaven but also in the Yekuana image of the Earth.[3] For it is claimed that the visible world of man also consists of two circles: a large inner one composed of water and referred to as Dama or "Sea," and an inhabited outer one called Nono. Although the floor plan of the roundhouse certainly reflects this concentric image of the Earth, it also transcends it, with the entire *atta* becoming a sacred inner circle surrounded by a demonically possessed and hostile outer one. In this sense, the *atta* may be said to correspond to the sacred inner space of Dama or Akuena, and the unknown world of the outlying forest to that of a contaminated Nono. The final phase of the roundhouse construction calls attention to this schema, when the *Aschano caadi* ceremony that accompanies the application of the last mud to the outer wall lists the name of every foreign spirit and tribe, commanding that they stay away or face destruction.[4] The circle of the house is thereby sealed both physically and symbolically, reinforcing the autonomy and self-reliance that is the ideal of every Yekuana community.

The *atta* may accommodate anywhere from forty to a hundred people, depending upon the size of the village. If a community should grow much beyond this number, a group of younger members will band together to form a splinter group, setting off to establish a new and separate house. This secession is based not merely on shortage of living space within the *atta* but also on the fragility of the highland jungle, which can only support low-density populations. It is this ecological imperative that requires the Yekuana to locate their villages at safe distances from one another. This is why, regardless of whether more living space is needed, an *atta* will be abandoned every several years to give the surrounding environment time to replenish itself.[5]

The demands the Yekuana place on their environment are twofold, for they are both a hunting-and-gathering and a horticultural society. Each of these subsistence activities alone would be enough to deplete any given area of the rain forest within a short period of years. Hunting,

which often concentrates on mammals that are both nocturnal and solitary, demands enormous spaces in which to range. This need, combined with the constant quest for new garden territories due to rapid soil depletion, necessitates the maintenance of village independence in autonomous and inviolable areas.

Economic Activities

All economic activities are strictly divided along sexual lines, and even when both sexes participate in a single activity some form of gender differentiation will be employed. Thus when men and women fish together with barbasco, the men do so with bows and arrows and the women with nets called *fahi*. But most activities demand no such collaboration, and the daily working lives of tribal members are spent almost exclusively in the company of their own sex. Men are responsible for all hunting, which is carried out either in small parties or singly, depending on the game pursued. Techniques also vary, with bows and arrows, spears, blowguns, curare poison, dogs, machetes, and today even shotguns being used as availability and need dictate. Prey too may range in scale from tapir of several hundred pounds to the diminutive but highly prized agouti, with wild boar (peccary), deer, capybara, paca, armadillo, caiman, and tortoise falling somewhere in between. Equally valued are such birds as the curassow, tinamou, and quail, while smaller species are predominantly sought by young boys using blowguns.

Although fishing may be a mixed activity, the larger species are usually caught by the men alone. If women accompany their husbands, it is usually around dusk when the small-sized catch may serve as a pretext for other activities, sexual or social. Drifting along in a dug-out canoe in the silence of the late afternoon, couples may enjoy a welcome opportunity alone, away from the commotion of the village. A more serious form of cooperative fishing is that done with barbasco. Known as *ayadi* in Yekuana, barbasco refers to any of a variety of vines that are beaten and then released into the rivers, temporarily depriving them of oxygen and thus stunning the fish and forcing them to float to the surface.[6] Because of the great number of fish affected, the whole community usually participates in an *ayadi t'denke*. The larger fish, much more resistant to the effects of barbasco, are pursued by the men with bows and arrows while the smaller ones, quicker to rise to the surface, are scooped up by women using nets. Undertaken with the air of an enormous picnic, those fish not immediately eaten are smoked and

preserved for later use. As may be imagined, barbasco fishing is destructive to a river if done too often. This danger is avoided, however, by strong taboos restricting the use of barbasco to not more than once a year in any given area. Nevertheless, barbasco's unusual effectiveness and the requirements for its inclusion in various rituals encourage the Yekuana to travel greater and greater distances in order to use it.

Hunting and fishing are regularly alternated with the various construction projects occupying the rest of the men's time. Although the need for food naturally demands that the Yekuana frequently interrupt these more collective tasks, the men welcome this opportunity to balance village-oriented work with the more solitary and peripatetic pursuits afforded by hunting. In harmony with Marshall Sahlins's claim that in tribal economies "domestic contentment" and "livelihood" are valued more highly than the maximization of production (1972:74 passim), the Yekuana joyously mix their activities, varying solitude with cooperation, travel with domesticity, and excitement with tedium. Periods of intensive collective work are always followed by relaxation and dispersion. The best example of this is the construction of the roundhouse, the most demanding and time-consuming of all male activities. If it were not for the regular interruptions that are ultimately just as much a part of the construction as the building itself, the *atta* might be completed in a much shorter period of time. For each of the many phases is succeeded by a long antidote of hunting and fishing or some other individual pursuit. Most construction activities, however, take nowhere near the three to five months required to build a new roundhouse. These other exclusively male tasks include the construction of canoes, paddles, arms, baskets, yuca presses, grating troughs, and work-huts for the women. The men are also responsible for the clearing of the new gardens or *conucos,* an annual responsibility that marks their only direct contact with the otherwise female world of yuca production.

Less varied than the men's is the daily routine of the Yekuana women who, faced with the constant challenge of growing food in the acidic and sandy soils of the Guiana rain forest, are more concentrated in both movement and activity. Although sweet yuca, bananas, pineapple, sugar cane, chili peppers, squash, sweet potatoes, and tobacco are also grown in the gardens, the main crop is bitter yuca (*Manihot utilissima*), from which cassava bread and manioc meal are derived. It is cassava bread (*u*) which is the only storable food and the staple of the Yekuana diet. In fact, no food or liquid is ever ingested without some form of yuca derivative. For cassava is not only used as a type of silver-

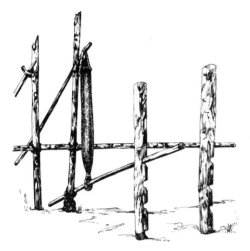

Yuca press or *tingkuiyedi* (courtesy Helga Adibi, Wilbert 1972)

ware with which to scoop up each morsel of food but is also the basis of all drinks, such as the fermented *iarake* and nonalcoholic *sukutuka.* Because yuca in its raw state contains deadly prussic acid, its preparation is extremely time-consuming and taxing. It is no exaggeration to say that a Yekuana woman, working in necessary collaboration with all other adult females in her extended family, spends a full ninety percent of her working time involved in some aspect of yuca production.

Women rise early and after preparing food for their families and the men's circle leave for their gardens before the sun is too hot. Here they dig up and peel a quantity of the enormous tubers sufficient to fill their *wuwa* baskets. Secured by tumplines, these baskets, which may weigh well over a hundred pounds when full, are carried back to the village and placed in the work-huts that the women of each extended family share. The large yuca graters, which the younger women have so laboriously made, are now brought out and the tubers grated into large wooden troughs called *kanawa.* The damp pulp is stuffed into long mesh sleeves that serve as yuca presses. When full, these great tubes, called *tingkui* or *sebucans* (*lingua geral*), are capped with special leaves and hung from hooks on elaborately constructed post devices known as *tingkuiyedi,* "the *sebucan* teeth." At its base the *sebucan* has a loop into which a long pole is inserted. The pole is then forced down into one of several notches

cut in the post of the *tingkuiyedi,* and in this way the prussic acid is eventually forced out of the pulp. With periodic readjustments for pressure, the *sebucans* are left standing for the afternoon, while the women continue with other phases of cassava production.

They retrieve the dried yuca pulp, which has been pressed and stored during one of the preceding days, and force the white, chalky yuca through round *manade* baskets which act as sieves. The resulting flour is now ready to be spread on hot grills, where it is transformed into cassava bread. The grills, formerly made of stone but now commercially purchased and made of iron, are several feet in diameter, enabling the women to make enormous, flat, circular loaves. After one side has cooked, the loaf is quickly flipped with the aid of a woven fiber fan. The cassava is now either dried and stored for later use or brought into the house for immediate consumption.

In addition to this lengthy preparation process, the women are also responsible for all domestic maintenance: the drawing of water, the gathering of firewood, the serving of food, and the collection of game left out on the trails by the men who have shot it. When there is no game to collect, the women may supplement the village diet by gathering grubs, ants, or sacred worms called *motto.* Even when uninvolved in the physically demanding daily regimen of food preparation, women relax by making the two principal artifacts used in it—yuca graters and carrying baskets. Because of the hundreds of pieces of jasper or tin that must be individually hammered into each slab of cedar, these graters, known as *tarade,* are extremely time-consuming to produce. Often made by the younger women while looking after their siblings, *tarade* have an additional value as a trade item highly coveted by the Yekuana's neighbors, particularly the Pemon. In fact, commerce in yuca graters has become so institutionalized that the Yekuana have given up the manufacture of certain items such as hammocks and pots, preferring to trade for them with other tribes. The other indispensable item made by the women is the carrying basket. The only basket manufactured by them, the *wuwa* is a durable, all-purpose container which serves to transport not only yuca between garden and village but also firewood, game, fish, and, when traveling, an entire household's possessions.

All of these economic activities, both male and female, require the fulfillment of certain ritual actions that are as essential to providing food and housing as the practical resolution of where to locate game and how to process yuca. The material demands of survival are but an integument for the far greater spiritual challenge underlying each en-

counter between the village and the world that lies beyond. In a universe where every object—animal, mineral, and vegetable—is animated with an independent and potentially destructive life-force (*akato*), the problem of appropriation becomes less a practical than a spiritual one. The conversion of a poisonous tuber into a life-sustaining food is not only the result of an ingenious technology of graters and presses, but of ritual skills that enable the Yekuana to detoxify these plants of even greater malevolent forces. Ritual activity is therefore not only relegated to specially demarcated sacred events but permeates every cultural function, no matter how mundane or material it might appear on the surface. The division between sacred and profane is not defined as that between religious and nonceremonial time. Rather it is the recognition of a cultured, ritually safe state and an uncontrolled, toxic one. The challenge of Yekuana subsistence is in the transcendence of this division and the ability to transform the contaminated and impure into the culturally-infused and human. To do so, more than mere practical expertise is needed. It also requires the mastery of ritual skills, along with a knowledge of the hidden world they are keyed to unlock.

THE DUAL NATURE OF REALITY

Among the Yekuana every object, animate or inanimate, is said to possess an invisible double or *akato* that is both independent and eternal. Organized into different species with their own culture heroes (*arache*) and traditions, these spirit-beings are described as living much like the humans, in their own world obscured by this one. They have their own roundhouses, gardens, and body decorations. Yet when humans see them, they appear as either fish or game, concealing their true identity behind their nonhuman disguise. Although equanimity is achieved by a complex of ritual procedures that penetrate their world and accompany every human-nonhuman interchange, these spirit-beings can be potent enemies when one of their members is treated in unkind fashion. As stated by Arvelo-Jimenez:

> All known systems of life, plant and animal, as well as the technical and social aspects of Yekuana society, have a double manifestation: an objective, tangible form and an accompanying invisible mirror image form.
> These invisible forms are endowed with a share of the gen-

eralized supernatural power which, manifested in these invisible forms, is potentially uncontrollable and disruptive. This means that these invisible forms can turn against an individual and inflict misfortune and death. However, the art of manipulating the supernatural power and its concomitant manifestations can and must be learned. (1971:184)

While ritual knowledge is the most effective conduit to the invisible world of this supernatural power, the entire Yekuana culture may be used as a map. Every detail of their society reiterates the dual nature of reality, providing a clear indication of where real power is located. The fact that the observable, material manifestation of an object may be an illusion masking yet another more powerful reality is not esoteric information reserved for shamans and singers alone. It is the most centrally encoded message of the culture, repeated in every symbolic system of which it is composed.

As previously alluded to and as noted in many other societies (Reichel-Dolmatoff 1971, Dumont 1972, Bourdieu 1977, Crocker 1985), the house is the model par excellence for a culture's conceptualization of the world. In addition to presenting a faithful visualization of the structure of the universe, the Yekuana *atta* also provides a template upon which all other symbolic systems may be measured. The duality so central to Yekuana thought is reproduced in the spacio-temporal relations that determine their lives. As with all other forms, the *atta* is the result of two interlocking realities—an illusionary and material outer one encasing a more powerful and invisible inner one. It is in this latter or "inner one," the *annaka,* that all ritual events take place, as communication with the unseen spirit-world is facilitated by the direct link provided through the centerpost. But the *annaka* and its surrounding *asa* also reflect the interdependence of these two realities and as such are as indivisible (and interpenetrating) as any daily economic activity is from its spiritual counterpart.

The image of two concentric circles is not limited to the *atta's* floor plan but as already detailed reflects that of the roof which in turn mirrors that of Heaven. In addition, the Earth or Nono is also described as consisting of two circles, with the sea that occupies its center paralleling the sacred inner spaces of both Heaven and the house. The house itself may simultaneously be seen as a single inner circle surrounded by the *asa* of a hostile and profane Earth. This elusive landscape is further complicated by the fact that every *atta* also has its invisible double, just

as Wanadi built an invisible roundhouse to parallel the first one constructed at Kushamakari, which in its turn was mirrored by that other unseen roundhouse of Heaven itself (de Civrieux 1980:35). Forbidding a single fixed overview, this continual unfolding of forms upon one another proposes a world of constant movement and transformation, wherein no sooner is one's vision focused than it is forced to shift. The perception of reality as a series of illusions belying another more powerful world concealed behind it is not presented as a static opposition but as an endless interplay of these dual structures. Their continual rejuxtaposition not only redefines their symbolic meanings but also questions their place in the world, challenging every participant to decide what is "real."

As oppositions shift, what was once on the outside may be transposed to the inside and vice versa. Hence, the external and finite, depending on its positioning and context, may suddenly be perceived as internal and infinite. One example of this is that of the Yekuana women. Within the confines of the house, the women are associated with the outer circle of hearths and living spaces that rings the central, more ceremonially related space of the men. As such, the women are both temporally secondary to the men (in terms of eating and other activities) and spatially external to them. They represent the finite and material that encloses and shields the infinite and invisible. Their world within the *atta* is that of the profane and toxic, dependent on the central (and centering) position of the men to render them ritually safe. But this symbolic placement (routinely considered fixed in nearly all symbolic and structuralist studies) is completely transformed in yet another context beyond the house, that of the garden.

The Garden

Often regarded as just a further extension of the women's already peripheral status in relation to the men, the garden is actually a systematic inversion of the symbolic world of the *atta*. Referred to by a variety of names including *adaha, guiedeca* ("in the yuca"), and *conuco* (*lingua geral*), the garden recreates the sacred space of the roundhouse, with the significant difference that the ritually pure center is reserved for the women and not the men. Consisting of two concentric circles identical to the *atta,* the garden's outer one is dedicated to the material production of food, while the inner is the special preserve of women's ritual knowledge and herbal magic. These enormous, seemingly chaotic

spaces where the women spend the greatest amount of their time are not only the source of their material power but also the locus of their ritual and sacred power. They are the women's *atta,* based on the same divine architecture as the men's, yet with the duality that underlies them reversed.

Although an exclusively female space, the garden is initially cleared of its larger trees by the men, with the women and children moving their hammocks and hearths into the forest to support and accompany them. Coinciding with the end of the rainy season in December or January, this felling, *adaba yakadi,* may take anywhere from three to five weeks, depending on the number of new *conucos* to be cleared, for not only does each extended family possess several gardens but the village at large also maintains several of its own.[7] Regardless of whom the garden is being cleared for, however, the work is undertaken collectively by all the men. When this task is completed and the downed trees are left to dry in preparation for their burning two or three months later, the *Adaba ademi bidi* is held. This festival, the name of which simply means "To Sing Garden" (or "Garden Song"), effectively marks the transference of the gardens from the world of the men to that of the women. It also transfers the power of the *annaka* with it, converting the center of each garden into a centerpost linking it to Heaven and the supernatural powers required to make yuca grow. To do so, the women must use the occasion of the Garden Festival to usurp the center of the roundhouse and carry off the power associated with it.

The festival begins during the morning, as the final section of the last garden, left specifically for this purpose, is cut down. Once this is done, the men gather in the forest to make *siwo* horns from long lengths of bark stripped from *momi* trees.[8] These horns, made by rolling the inside part of the bark into tight, spiral funnels, are decorated with flowers and fresh shoots, emblems of the new life soon to come. When all the men have finished and tested their horns, they organize themselves into a long row of dancers, one hand on the shoulder of the person in front, the other on the *siwo* horn to be played. The sound of these horns is deafening, giving the women ample warning of the men's approach and thus an opportunity to finish their own preparations before the dancers reenter the village. For in the men's absence, the women have taken over the *atta's* inner circle, converting it into a reproduction of the *annaka* of each garden.

In addition to bundling long stalks of yuca around the centerpost and leaning others up against it, each woman has hung a smoke-stained

gourd filled with *kawai'hiyo,* the leaf necessary to prepare the fermented alcohol known as *iarake.* But most important is the large selection of "women's herbs," the *wodi maadadi* laid out in a large flat basket that sits at the centerpost's base. These plants, collectively referred to as *awanso catajo,* "the one stuck in the center," represent the essence of women's secret power and healing lore. Without them, yuca will not grow, as it is claimed that the *awanso catajo* are the "parents" of the yuca and that in their absence the yuca (which in Yekuana is *guiede* or "child," from the word *ñiede*) "grows sad and dies."[9] But the *awanso catajo* does more than protect yuca. Among its various members are plants to heal children, initiate women, ease menstruation, aid or prevent birth, cure or produce fever, frighten snakes, stop rains, secure lovers, induce sleep, dispel ill humor, deter evil spirits (Odoshankomo), protect travelers, and cause death. While men have their own herbs or *maada,* some of which duplicate the work of the women's, they are separate species, kept as secret from the women as the women's are from the men.[10] The *awanso catajo* therefore are the paramount expression of women's sacred knowledge and ritual independence. Their position at the center of each *conuco* underlines the parallel (but inverted) structure of house and garden, the centers of which are both designed to facilitate communication with the supernatural. For as the Yekuana women themselves say, pointing to the *awanso catajo,* "Each one of these is a *ñunudu,* a centerpost."

The garden's recreation within the roundhouse is completed when the men finally arrive in the village. Playing the *siwo* horns and dancing, they circle the *atta* several times before entering. As they continue their dance around the centerpost and the elderly women who are huddled there chanting over the *awanso catajo* and yuca, their own wives approach them. They confiscate the axes and machetes that have been used to clear the new gardens. These tools now belong to the women and as such are placed with the other garden paraphernalia set up around the centerpost. Soon the men toss their *siwo* horns there as well. At this signal the women break in among them, joining a dance that will last for the next seventy-two hours, or "as long as the *iarake* lasts."

During this entire time, an *aichuriaha* or "song master" leads them in singing the *Adaha ademi hidi.* Sung in a syncopated responsive style, the main body of this epic is the fourteen-part *Toqui* which takes its name from the burden repeated after each phrase. These narratives, composed in a secret, shamanic language, as is the entire "Garden Song," recount the episodes most central to the *Watunna.* In addition to describing the

origin of yuca and the planting of the first garden, the *Toqui* also explain the genesis of the stars, lightning, Venus, honey, and various animal species and culture heroes. But the *Adaha ademi hidi* is more than a summary of the mythological events contained in the *Watunna*. Running throughout is a series of chants designed to infuse the objects gathered at the centerpost with the power they will need to protect the new gardens. Often composed simply of lists of the various spirits' names, these chants also cleanse the men, who have been working in the spirit-infested environment of the forest, while at the same time protecting the women who are about to. As one Yekuana explained it:

> To make *conucos* we have to cut down, to kill many trees, and the invisible masters of these can turn against us and cause illness, bad luck and even death. Through the Garden Ceremony we admit our guilt to the invisible masters of these trees and ask them for their favor. The song cleanses us of that guilt.
> (Giménez 1981:40)

Although the composition of dancers is continually shifting as individuals drift off to rest or eat, the cumulative effect of three sleepless days of dancing, singing, and drinking leaves no one untouched. By the afternoon of the third day the circle of dancers moves as if in a dream, indifferent to the huge gourds of *iarake* they are still forced to swallow and throw up. This trancelike state does not slow the dancers down, however, nor does it interfere with the precision of their movements and singing. Pushed to the limits of endurance, a new spirit seizes them, their steps becoming even more lively and coordinated. It is then that the women subtly disengage from the main body of dancers to reorganize themselves at the centerpost once again. The two circles that began the dance are now reconstituted with the counterpoint between them even more accentuated, for as the men continue to sing and dance, the women, now huddled at the centerpost, begin a completely separate chant of their own.

The *ademi*, delivered in the soft, high-pitched falsetto characteristic of all women's singing, is called the *Guiede hiyacadi* or "Taking Out the Yuca." Similar to the *Sichu hiyacadi* ("Taking Out the Child") sung over newborns when they are brought out of the roundhouse for the first time after their umbilical cords have fallen off, this chant is a final invocation to protect the "newborn" yuca and other garden plants from the spirits they will confront in the new gardens. As the women con-

tinue to sing this chant, the eldest among them carry out a careful inspection of the *awanso catajo* and yuca stacked up around the centerpost. Before beginning the distribution to the other women, they must search for any defects or imperfections. Once satisfied, they begin to hand out portions of these now sacred plants to each of the women, who will soon resurrect them as the centerposts of their own gardens.

While this distribution is taking place, the men suddenly reach in among the women and pull out the *siwo* horns deposited there three days before. Resisting this intrusion, the women mockingly accuse them of stealing pieces of their special herbs while retrieving their horns. Although facetious, this confrontation underlines the reality of the new order that has been established with the women at its center. This new order is even more concretized when several minutes later the men leave the roundhouse completely. As they continue singing and dancing around the outside of the house, the women move into the space just abandoned by them. Holding the yuca shoots like batons between their hands, they lock arms to begin a frenetically demanding new dance. Unlike any other dance performed by the Yekuana, this ecstatic rocking and swaying, executed with such perfect timing, clearly celebrates the new status of the women. Sole possessors of the inner circle, their chant, formerly obscured by the men's, now booms like a paean to women's solidarity and power. When the men dance back into the roundhouse a half hour later, the redeclaration of space has already occurred. They dance around the women, forming an outer circle as each group continues to move and sing independently of one another. Then, very slowly, the women begin to penetrate the men's circle. Subtly, almost imperceptibly, they maneuver to outflank them. The two rows of dancers spiral about, each vying for the position of the other. And then finally, as suddenly as it was turned inside out, the world is again righted: the male dancers are once more encircled by the women. But the power of the center has been shared with the women and will be taken with them when they recreate the space of the *atta* in their gardens. Perhaps in acknowledgment of this, it is the men who leave the roundhouse first, exiting toward the river and the west. Dancing and singing as they go, a halt is called just before they reach the water. Here the leader solemnly addresses the spirit of the yuca:

> Kawadetto, father of the yuca, now you are here. This is your home, where you belong and will stay. Don't go off for any other part. Stay here always!

Then, signaling the end of the men's part in the festival, they all lift their *siwo* horns, and with a single great shout of *Suwei,* throw them back to the forest from whence they came.

The women meanwhile continue their ecstatic dance, luxuriating in their regained control of the *annaka.* Chanting the same *Guiede hi-yacadi* that has not stopped for over two hours, they exit through the western door and proceed, as the men did earlier, to dance around the outside of the house. After circling it several times, they reenter once more to resume the dance around the centerpost. When they leave again a half hour later, it is in the opposite direction of the men. Dancing through the eastern door, toward sun and life, they arrive at the edge of the new *conucos,* out of which the men have marched three days before. The image of an inverted reality continues as the women, at the opposite end of the world, mark the end of the festival with the same gesture as the men. Raising their arms as one, they wave and, with a single breath and cry of *Suwei,* dispel whatever evil spirits still remain.[11]

Over the course of the next several days, when they have suffi-ciently recovered from the strain of the festival, the women of each extended family take the yuca and *awanso catajo* received at the cen-terpost to their new gardens. Accompanied by elders capable of singing the chants necessary to plant them, they clear a large circle in the middle. Referred to as the *anawana,* "the very center," or *adaba yewana,* "the garden's heart," this inner circle parallels that of the *annaka* in the roundhouse. This space must be cleared with special care, for not only is it to receive the plants made sacred by the *Adaba ademi hidi,* but it must also withstand the burning of the rest of the *conuco* at the end of the dry season in two or three months time. When the yuca is finally planted in this outer circle, that of the *anawana* will stand far above it, emphasizing its role as both parent of the yuca and centerpost of the garden.

The ceremony that accompanies the initial planting is also called the *awanso catajo,* identical to the women's magic herbs planted in the *anawana.* Unintelligible to the men, this exclusively female rite lasts a full day and must be performed for each new garden. With rigorous detail, every element in the new space is given its final purification. As the name *awanso catajo* indicates, this ceremony is the last stage in the appropriation of the garden from the wilderness. "The one stuck in the center" is the human, and to center the nature of human activity. The Garden Festival, culminating in this final day of ritual, represents the successful colonization of nature. The human imprint of two concentric

circles with a large post as the center has been transferred to the world of the forest, making it equally safe and inhabitable. But this mirror image is just that, identical yet inverted. In the world of nature the sacred is turned on its head. Here women occupy the center, while the surrounding wilderness is the domain of men.

THE GEOGRAPHY OF THE BODY

The symbolic expression incorporated into the structures of both the garden and house are anything but unique examples of the manner in which Yekuana material culture communicates more fundamental spiritual truths. The competing dualities that inform these paradigmatic collective manifestations are equally recognizable in the other physical elements of which the culture is comprised. Forms may differ but the essential message remains the same. The garden and house are not organized into the human configuration of symbols just to render them inhabitable and safe, but also to enable them to communicate. Or conversely, "comprehensible" is human, thus explaining perhaps the Yekuana's definition of a So'to or "person" in linguistic rather than racial terms. Yet there is more than one language with which to speak Yekuana, for the human body is not exempt from the symbolization impressed upon every other physical (and nonphysical) object. Each person communicates to himself and others through the same organization of symbols revealed in both the house and garden.

In many ways the most difficult to appreciate, the values internalized by the body through both external dress and movement and interior conceptualization are also the most profound and affecting. Pierre Bourdieu, particularly concerned with the way in which body language incorporates larger structural schemes among the Kabyle of North Africa, makes this point well in his *Outline of a Theory of Practice:*

> The principles em-bodied in this way are placed beyond the grasp of consciousness, and hence cannot be touched by voluntary, deliberate transformation, cannot even be made explicit; nothing seems more ineffable, more incommunicable, more inimitable, and therefore, more precious, than the values given body, made body by the transubstantiation achieved by the implicit persuasion of a hidden pedagogy, capable of instilling a whole cosmology, an ethic, a metaphysic, a political philosophy,

through injunctions as insignificant as "stand up straight" or
"don't hold your knife in your left hand." (1977:94)

While primarily focusing on the way in which personal attitudes (such
as sitting and holding one's head) conform to collective symbolic struc-
tures, Bourdieu is keenly aware that it is through the entire body that
"the world is read and enacted" (ibid.:90). Certainly this is true among
the Yekuana, where each individual in the form of his or her own
person recapitulates the symbolic world of the tribe at large.[12]

The first human created by Wanadi—the chief of the birds brought
to cut down the original *conuco* at Farahuaka—was called Wanato.
Falling into that amorphous category of the "Old People," Wanato lived
at a time when the distinctions between species had not yet been con-
cretized, and it was still possible to be simultaneously human and ani-
mal. It was when Wanato and his comrades left the Earth that each
species adopted a fixed form based on "examples left behind by the first
ones." Today Wanato is remembered not only as the chief of all the
birds but also as the purple-breasted cotinga (*Cotinga cotinga*), the
most beautiful creature in the entire Amazonian rain forest. But Wanato
was not always so beautiful. In fact, before the first *Adaha ademi hidi,*
Wanato was considered to be the ugliest. Known as Fwesanadi at that
time, Wanato had two wives, the eldest of whom preferred to sleep with
an anaconda (Wiyu)[13] rather than a husband as ugly as he. Then, after
the last tree had been felled in the new garden, Wanato led the others in
preparing for the Garden Festival. He showed them how to make the
siwo bark horns and led them in putting on the first arm and leg bands,
a headdress, necklaces, ear plugs, a loincloth. In short, he became the
first ever to dress as a human. By the time Wanato led the others back
into the village, he had been so transfigured by his new attire that he
was unrecognizable:

> Then they went to the village, playing horns, *siwo.* They came to
> the port. And Fwichité, Wanato's youngest wife, said, "Let's go
> down there."
>
> But Kaschanadu, the eldest, said, "No." She didn't want to.
> "He's too ugly." She didn't want him.
>
> "No," said Fwichité. "He's beautiful. Let's go. *Marché.*" But
> Kaschanadu didn't want to.
>
> Then they were dancing with their hands on the men's

shoulders. You know the way they do. And they asked
Kaschanadu which one was Wanato. She looked at them. She
said, "Fenefene." She didn't know.
 "No."
 "Madima."
And then another and another and another. She didn't
know. She couldn't tell. Finally there was just Wanato. "Him!" He
was the most beautiful.[14]

The message here is clear: culture not only beautifies, it also trans-
forms. Like the Fathers of the Old Testament whose direct contact with
God resulted in the adoption of new identities, Fwesanadi, dressed as a
human, now takes on the new name of Wanato. Yet the catalyst for this
conversion is not personified as a single, exterior deity. Rather it is the
diffuse symbols of culture successfully organized into a human configu-
ration. The foundation of the first garden and the arrival of the first
human become synonymous events, with Wanato serving as the vehicle
for both. His transformation is the assumption of the garden (that is,
culture) into the body, or as Pierre Bourdieu states, "the em-bodying of
the structures of the world" (1977:89). The body, like the initially wild
area of the garden, must also be "cultivated" with symbols. Only in this
way does one recognize it as human (So'to) with the sacred space at its
center reserved for the invisible *akato.*

The decorations that Wanato wore for the first Garden Festival
become the paradigm for all Yekuana dress thereafter. Although some-
what more elaborate than everyday dress, the spatial relations they
emphasize are parallel to it. Thus instead of the elaborately feathered
arm bands (wings recalling the first birds) that dangle from the men's
biceps during the *Adaha ademi hidi* and other festivals, one simply
finds straps woven from *kurawa* sisal. Worn by both sexes, these bicep
bands, known as *ahatmi* (from "arm") or *komata,* are tied so tightly that
their impressions remain even after the wearer in old age removes
them. In similar fashion, the carefully braided hair wrapped around the
ankles in festival wear is replaced in daily life by long strings of beads
called *wa'hiyu.* Separate strands of these beads are also wrapped tightly
around the calves just below the knees, leaving indelible marks similar
to those of the arm bands. Complementing this double-banded pattern
of the legs, the wrists are also evenly wrapped with several inches of
white beads, commonly referred to as *saiyu* or "salt." To complete this

encirclement of the torso, various necklaces made from combinations of beads, seeds, and animal teeth are hung around the neck, while a loincloth passes just below the stomach.

As one may easily observe, Yekuana dress is a deliberate charting of the human space, with the trunk of the body fastidiously circumscribed from the outer limbs and head. The bands, so tightly applied, along with the necklaces and loincloth, create an inner circle of each torso not unlike that found in both the house and garden. Identical to these collective structures, each Yekuana body is intersected by two imaginary concentric circles, the outer running through the wrist and ankle bands and the inner through those of the biceps and calves. Thus like the outer ring of the house, which is sectioned off for individual families, the outer ring of the body—between knee and ankle, bicep and wrist— is also a world of differentiation and division. The inner circle, on the other hand, like the *annaka* and *adaha yewana,* is a world of whole- ness and union, devoted to communication with the supernatural forces of Heaven. Here is where the divine breath resides. For it is at the solar plexus, the very center of this inner human circle, that the Yekuana locate the heart, claiming it to be the home of the *akato* Wanadi dis- patched to animate each body. It is this "akato inside the heart" (*ayewana akano akato*) that serves as the centerpost of each individ- ual, granting him or her the same access to the invisible world provided the group through the *ñunudu* of the house and the *awanso catajo* of the garden.

The *akato* located in the heart is not the only "double" occupying the human body. An equally important and powerful one is also said to reside in the eye. Referred to as the *ayenudu akano akato* or "akato inside the eye," this double is a parallel to that of the heart, underlining the analogous relation that exists between head and body. For if the torso and limbs may be said to replicate the floor plan of the house, then the head is clearly conceived of as its roof (and firmament). Draw- ing attention to this close relation, the Yekuana refer to both the form of the roof and the cut of their hair by the same name. *Sekude* or *sekudato,* which means "clean-cut" or "sharp-edged," describes especially well the perfectly finished round edges of both roof and hair. It also describes the relentless effort required by the women to keep the gardens free of the ever-encroaching jungle. Weeding is pursued with a passion that leaves the floor of the garden as clean as that of the roundhouse. It is this same passion—again referred to as *sekudato*—that is demanded for the depilation of all facial and neck hair. Meticulously removing not

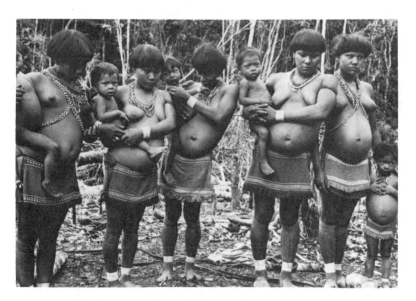

Women and children in traditional Yekuana dress, Parupa, c. 1960 (photo Sup. Dr. Agostini)

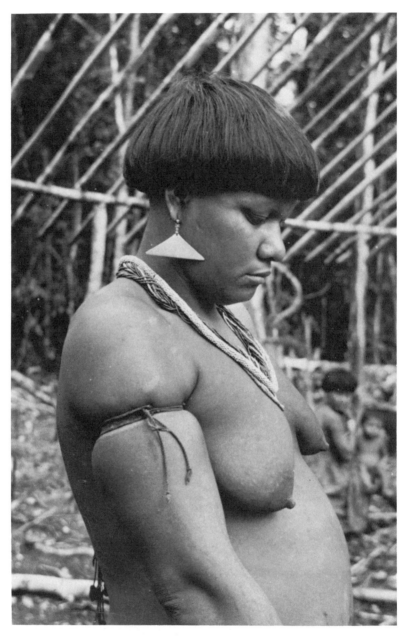

Yekuana woman with *totuma* or *sekudato* cut and arm bands (*ahatmi*) (photo Sup. Dr. Agostini)

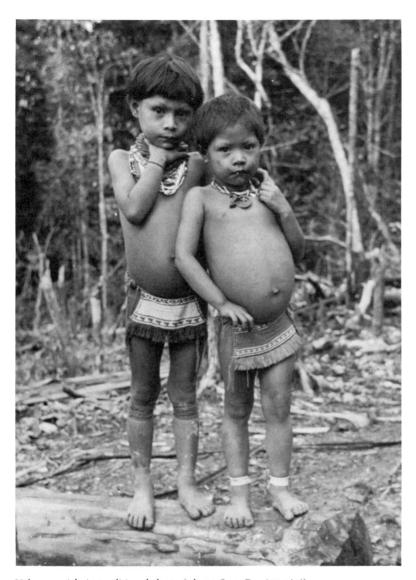

Yekuana girls in traditional dress (photo Sup. Dr. Agostini)

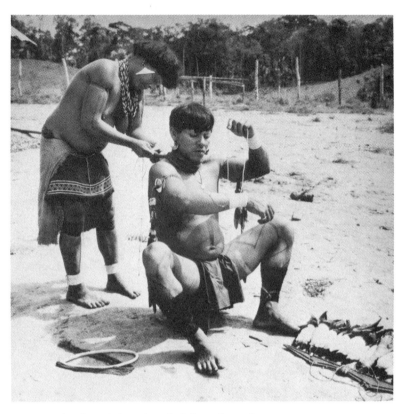

Preparing for the *Adaha ademi hidi* festival, a Yekuana man puts on wrist
bands (*saiyu*) while his wife adjusts his *womo ansai* necklace (photo Barbara
Brändli, courtesy North Point Press)

only the hairs on the upper cheeks, neck, chin, and lip, the Yekuana also pluck those of the eyelids and brows, setting off the circle that remains on top as dramatically as the torso below.

Ahachito Hato, "The New Person"

While Yekuana dress and body care assure the internalization by each individual of the structure of the universe as reflected in both house and garden, a certain amount of daily variation may occur from person to person. In addition to personal style and the availability of beads and other items, the status of the individual helps to determine how closely he or she adheres to the ideal. Elders with years of ritual experience and a reduced threat from the supernatural may forgo the wearing of arm bands and other adornments. On the other hand, those most vulnerable, such as children and young mothers, are rarely seen without all items of dress in place. No one, however, exemplifies the proper manner of dress better than the *ahachito hato,* "the new person" who has just been initiated following her first menstruation. Existing in what is considered the most toxic and therefore wild state in the entire culture, the *ahachito hato* must be "rehumanized" before she can reenter the community once again. In a lengthy ceremony paralleling the Garden Festival, the young woman to be initiated is brought from the seclusion of the house to the inner circle of the garden. As she is led there holding onto an "umbilical cord" (*hiommudu*) fashioned from magic *awanso catajo* herbs, the women chant a *hiyacadi* similar to that used to "bring out" the new baby and new yuca. Following a morning of instruction and chants, the women start back to the village. Along the way, the men attack them using whips braided with *kurawa* fiber. This chaotic scene is soon reenacted in the village center where each woman, preceded by the one being initiated, is given an individual flogging referred to as *wawatuhana* or "advice," for the Yekuana say that the purpose of whipping is to instruct the young on the mode of proper behavior. The *ahachito hato,* who stands out from all the rest by her strange costume of old rags, now returns to her family's quarters to begin a three-month period of isolation and fasting. But first the hair from her head is completely shaved off.[15]

As is easily observed, the pattern for the creation of a "new person" follows closely that of a new garden: the movement from centerpost to *conuco,* the use of similar chants and herbs, the solidarity of the women, the "clearing" symbolized by both the whipping and the shav-

ing of the *ahachito hato*'s head, and finally, the three months of isolation in which neither the garden nor initiate are touched. The parallel continues when at the end of this period of confinement the young girl is led to the roundhouse for the conclusion of her initiation. Known as the *Wenakwajodi* or "Purge," this final phase of the ceremony begins with the first cutting of the *ahachito hato*'s new head of hair in the traditional *sekudato* sytle. Brought into the *annaka* in nothing but a simple loincloth, the girl is seated among the other women beside a large flat basket. Upon this basket are stacked all the clothes and adornments necessary to a mature Yekuana woman. As the song master begins leading the others in the special *Wenakwajodi* chants, those attending the *ahachito hato* slowly start to dress her. Many of the songs are specific to the garments and ornaments being put on, imbuing them with the power necessary to protect her. Others deal with such female subjects as the origin of yuca, Wanadi's first family, and the history of his various wives while on Earth.

During this entire time the girl sits on her legs, back upright, eyes straight ahead, seemingly paying no attention to the transformation she is undergoing. But little by little a different person starts to emerge. Thick rows of beads are placed around her neck, hanging all the way down to her breasts. Bands are wrapped around her ankles, her calves, her wrists, and her biceps. Silver earrings called *fwanasede,* in the form of triangles, are attached. Her *muaho* beadskirt, the most intricate item of every woman's wardrobe, is put on. And finally small cottonballs are attached to the paints that have been applied in various designs all over her body.

Transfigured in the same way Wanato once was, the girl now takes her place by the centerpost, a "new person" ready for her final "purge" to be administered. But first her father, as he did several months earlier when she was flogged, comes up and berates her in a harsh voice, telling her to be obedient and hardworking, to carry out all her duties as a Yekuana woman in every way. Then an enormous vat of *iarake* is brought up. A man who has been honored with the request to assist in the ceremony approaches and offers her a gourd of the fermented yuca. This continues for many gourdfuls until the girl is wretching so violently that the man must hold her up and pour the liquor down her throat. During this entire time the chanting and drinking among the other villagers does not stop. When the girl can barely stand, her parents begin reproaching her with loud screams of "*Inko! Inko!* Drink! Drink!" Finally the girl, by now semiconscious, can take no more and collapses.

Her mother appears with a blanket in which she carries the girl away. When she awakes in her hammock the next morning, the initiation will be over and she will be a member of the community once again, yet with the new identity of a mature Yekuana woman.

Until the *ahachito hato* marries and has a child, she will wear the clothes from her initiation with an impeccability unrivaled by any other member of the community.[16] This is not the vanity, however, of a young woman searching for a husband. The fragile status of a human just born demands the unequivocal definition that Yekuana dress is intended to provide. In the transition from child to adult the young woman is temporarily lost in a wilderness (symbolized by menstruation) from which she must be rescued. In tracing a map of the Yekuana universe, the clothing and ornaments so carefully arranged during the *Wenakwajodi* attempt to lead her back to its center. With the "inductive" property of symbols identified by Lévi-Strauss,[17] those of Yekuana dress restore the contaminated *ahachito hato* to the community by realigning personal structures with collective ones. Hence, just as the organization of space in the garden and house wrests these areas from the hostile world of the forest, rendering them safe and inhabitable, so too does the corresponding organization of bodily space. But the symbols that transformed Wanato into the first human (and Farahuaka into the first garden) are not reserved for the extreme case of the *ahachito hato*. They are the same ones that continue to humanize every Yekuana daily.

The Six Souls

Through the parallel arrangement of personal and collective symbols, every individual becomes a microcosm of the Yekuana universe, incorporating the dominant configurations repeated throughout. The symbols that organize the collective into a meaningful whole are also those that successfully integrate the individual. The patterns of concentric circles impressed upon the body provide yet another source of subliminal instruction on the nature of a reality they also help to define. By skillfully applying clothing and other body ornaments, the Yekuana acknowledge the same principle of duality recognized in every other form of existence, animate or inanimate, man-made or natural. They point, as do all Yekuana dualities, to the true source of power located in an invisible realm concealed behind the physical one. Yet this scheme is anything but static, and as one duality gives way to another, concentric circles dissolve into spirals. The interior conceptualization of the body,

for example, does not merely repeat the division of space mapped out on its surface. It also amplifies it, exploding into a multiplicity of forms that reach even further into the infinite.

Although it is called the "double" or *akato,* from the word for "two" (*aka*), each person is actually said to possess six souls. As already noted, two of these are located inside the body, the *ayenudu akano akato* and the *ayewana akano akato,* those of the eye and heart. Sent down by Wanadi to animate an otherwise inert being, these eternal *akato* not only return to Heaven at the death of the forms they occupy but also travel about nightly while the body is asleep. Recounted in the form of dreams (*adekato*), these regular journeys into the invisible become important auguries of the future. They are collectively analyzed every morning by the men, with the events that occur in them determining the course of action to be followed during the day.[18] These journeys are not without their danger, however, as a wandering *akato* may be captured by any number of hostile spirits and, if not returned promptly, the person may die. When this happens, it is up to the shaman, who alone has the power to see the *akato,* to go off and rescue it.

Emphasizing the irreversible goodness of these *akato,* the Yekuana are somewhat nonplussed by Christian threats of eternal damnation. For even the *akato* of those committing the most heinous crimes of incest and murder will eventually, after some wandering, return to Heaven. Yet missionaries continue to insist that the souls of these sinners will be condemned forever to the "boiling pots" (*Fiyoto Anadiña*) of Hell. What has been so difficult for them to understand is not that the Yekuana have a concept of immoral behaviour but rather that they have more than one soul with which to redeem it. For radiating out from each individual are four more *akato,* shadows of doubles responsible for absorbing the sins of those they accompany. Rather than a blank screen upon which the deeds of the body are projected, each Yekuana *akato* is an already predetermined entity for either good or evil. Of the four surrounding the body, none is a greater receptacle for this evil than the *Nuna awono akato,* the "*akato* in the Moon." Referred to as a person's "night shadow," this *akato* resides beside each human, absorbing all their bad thoughts and wicked actions. Related to the feared cannibal spirit of the Moon, it is this "double" that is said to burn and suffer forever upon the death of the body. Opposing this *akato* is the *Shi awono akato,* the "*akato* in the Sun." Said to be "*ascha seca*" or "somewhat good," this double is responsible to the benevolent force credited

with giving birth to Wanadi himself. As many stories relate, the Moon and Sun are mortal enemies (de Civrieux 1980:119), prototypes of the negative-positive duality of the *akato*. Upon the death of an individual, this *Shi awono akato* returns to its home in the Sun once again. Also returning to its original source is the *tuna awono akato,* the "*akato* in the water." Visible as the reflection one sees when gazing into a river, this "double" is nearly as evil as that of the Moon. Prefiguring the negative role of this *akato* is its close association with Wiyu, the mistress of all that dwells in the water. Once the sister of the Moon, Wiyu was forced to flee under water when her brother tried to rape her. It was then that she was converted into the feathered serpent, a demonic parallel to the forces of evil (Odoshankomo) that reside on the Earth. As an extension of Wiyu the *tuna awono akato* serve each individual as yet another double for their malevolent thoughts and deeds.

The final *akato* is that of the Earth itself, the *akatomba*. This is the "double" one actually sees in the form of a shadow accompanying the body along the ground wherever it goes. Regarded with some ambivalence, the *akatomba* is claimed to be "bad," though not quite as bad as the *akato* of the Moon or water. It neither goes to Heaven nor Hell, but remains on Earth, wandering (and suffering) for all eternity. Visiting all the places it did when its body was alive, the *akatomba* is said to be visible as a small dwarf covered with white *fade* clay. Even more noteworthy, however, is its audibility—small bleating sounds announce its presence whenever it appears. Reflecting a general uncertainty as to where the *akatomba* eventually reside, one Yekuana speculated: "In the grave, the canoe the person is buried in. Yes, I'm not sure. We don't know. The tomb. But if you go there, you won't see it."

The extension of the *akato* into all four elements of the universe—earth, air, water, and fire—reinforces the metaphor of human as cosmos. With the two inner *akato* serving as roof and centerpost, the four that surround it act as doors opening into the four corners of existence and beyond. The fact that doubles are possessed by not only physical forms but also by thoughts and actions, assures that each individual is connected to various invisible worlds. The doubles of the eye and heart may provide a direct link to Wanadi and Heaven, yet those that surround the body lead elsewhere. As one traces these *akato* of both good and evil back to their source in the supernatural, each body becomes a true center of the universe and every human a vessel for the infinite.

The First People

While animals are said to possess the same six souls as humans, it is repeatedly emphasized that the creatures one sees walking the earth are only replicas of the first ones that existed. These "First People," who had the power to change forms at will, left them here as "examples to show those of today how it had been in the beginning." The Earth's present animals are not nearly as powerful as the originals, differing as much from them as ordinary humans are said to differ from shamans. Like shamans, the First People did not have "doubles" called *akato* but rather *damodede*. In contrast to the passive, uncontrollable *akato* of an ordinary human, the *damodede* is an independent soul that can be directed at will.[19] Whenever its owner desires, it can be removed from the body and dispatched into the supernatural. For those possessing *damodede,* the form the body takes is irrelevant, as the barriers between realities are only transparencies to be easily transcended. The First People lived just as shamans do today, in a polymorphous state in which no boundaries yet existed. It was the time of origins (*illud tempus*) when Heaven and Earth were still connected and the distinctions between species not yet recognized. Only when these divisions solidified did the First People finally remove themselves from Earth, leaving their forms behind as reminders of what this Dream Time had been like.

After their withdrawal from the Earth, each of the First People became the "Master" or *arache* of the species they engendered. In addition to bequeathing its form, each *arache* is also credited with developing every aspect of a species' culture. As such, all the *arache* are perceived as culture heroes of their own species, with the deeds they performed in the Old Time serving as invisible prototypes for them to follow. The tradition of the humans (*Watunna*) is therefore not seen as unique but as one of many, recast in as many versions as there are species. What is unique is the form taken, a form determined by the *So'to Arache*. This "Master of the Humans" is, of course, Wanadi, the son of the Sun sent to Earth "to make people" (de Civrieux 1980:21) and to give them the skills with which to survive. The record of his stay, however, is much more than a simple genesis of the Yekuana and the cultural forms that define them. For as Wanadi gives birth to form itself, his adventures turn into the quintessential models of a duality that eventually drives him from the Earth.

Wanadi appeared on the Earth three times, each one as a separate incarnation of the *damodede* of that other invisible Wanadi who lives in Kahuña:

> He sent his messenger, a *damodede*. He was born here to make houses and good people, like in the Sky Place. That *damodede* was Wanadi's spirit. He was the Earth's first Wanadi, made by the other Wanadi who lives in Kahuña. That other Wanadi never came down to the Earth. The one that came was the other's spirit.
>
> Later on, two more *damodede* came here. They were other forms of Wanadi's spirit. (de Civrieux 1980:21)

In each of these manifestations Wanadi's work is deemed by him a failure, leading to his return to Heaven and the end of the cycle. Instead of recreating Kahuña on Earth as he sets out to, Wanadi's efforts result in an ever-increasing rift between the previously united worlds of the visible and supernatural. Where no dualities originally exist, Wanadi's creations inadvertently beget them. Time after time his efforts backfire, producing the opposite effect for which they were intended. Finally, bereft and threatened by the monster he has made—Odosha—Wanadi admits defeat and returns to Heaven forever. In what is the great tragedy (and irony) of the *Watunna*, Wanadi must ultimately reject his own creation. He now becomes a *deus otiosus,* indifferent to the problems of the world he has made and playing no further part in it. Yet the imperfection of Yekuana creation is not without the hope of redemption. Upon his departure, Wanadi promises the eventual arrival of another cycle, an apocalyptic fourth one in which a new *damodede* will come to reunite Heaven and Earth:

> "I'm going," he said. "I'm going back to Heaven. I can't live here anymore. Odosha has made himself Master of the Earth. There's fighting, war, sickness, death, evil of every kind.
>
> "I'm going. I'll return soon. Odosha will die. When Odosha dies, the Earth will end. Then there will be another one, a good one. The sun, the moon, the stars are all going to fall on the Earth. This sky is going to fall. It's a bad sky, a fake one. Then you'll see the good Sky (Heaven) again, the real one, like in the beginning. When the sun falls, Wanadi's light will come back and

shine. I'll return. I'll send you my new *damodede,* the new Wanadi. It will be me with another body, the Wanadi of the new Earth." (de Civrieux 1980:161)

As indicated, the fourth cycle will once again return the Earth to the original state of perfection in which Wanadi first discovered it. At that time it was simply an extension of Heaven, a single infinite space filled with eternal light. There were no material forms, and if Wanadi wished to create something he merely dreamed it; hence the name of his first incarnation, Seruhe Ianadi, "The Thinker." Whenever he made something, he just took his maraca and tobacco and thought it. This is exactly the way Wanadi gave birth to himself. Unfortunately, his *damodede* did not know what to do with his own umbilical cord and placenta. By disposing of them improperly, they rotted and gave birth to another creature, "ugly and evil and all covered with hair like an animal" (ibid.:22). This was Odosha, also known as Kahu and Kahushawa.[20] The incarnation of all evil in the universe, Odosha is the direct opposite of Wanadi in every way. Whereas one represents light, goodness, truth, and life, the other embodies darkness, evil, deception, and death. In fact, if Wanadi is the "Master of the Humans" (*So'to Arache*), then Odosha may be said to be the master of all that threatens them, the *arache* of the Earth's demons known collectively as the Odoshankomo or "Odosha People." From the instant Odosha enters the world, he challenges Wanadi's hegemony over it, declaring him to be his enemy: " 'This Earth is mine,' " he said. " 'Now there's going to be war. I'm going to chase Wanadi out of here' " (ibid.).

In giving birth to himself, Wanadi also creates his opposite, defining the basic condition of human existence: the separation of the perishable individual from the infinite whole. As the principal manifestation of earthly evil, Odosha becomes the consummate expression of all that blocks man from reuniting with Wanadi. Yet he himself is also the creation of Wanadi, born out of the same womb. Connected by an umbilical cord, their "fraternal" relation underlines the inextricable link between the polarities they represent. Translated into the ongoing conflict between Wanadi and Odosha, it is these endlessly generated oppositions that form the centerpiece of the *Watunna.* Nevertheless, Wanadi must eventually decide (as all Creators must) whether or not to embrace a creation that is filled with vice and evil. Regardless of his own responsibility, Wanadi confesses the failure of his work and abandons it to the "play of forces" (Turner 1969:84) he has unleashed. Before doing so com-

pletely, however, he returns two more times in an attempt to revive his original vision and to wrest control from the now-entrenched Odosha.

Wanadi's second *damodede,* Nadeiumadi,[21] arrives on Earth determined to expose Odosha as a fraud. Toward this end, he attempts to prove that Odosha's most powerful weapon, namely death, is but an illusion. With his maraca and tobacco, Nadeiumadi dreams his own mother into existence, only to kill her several moments later:

> He dreamt that a woman was born. It was his mother. She was called Kumariawa. That's the way it happened. That man was thinking and smoking. He was quietly blowing tobacco, dreaming of his mother, Kumariawa. That's the way she was born. He made his own mother. He gave birth to her dreaming, with tobacco smoke, with the sound of his maraca, singing and nothing else.
>
> Now Kumariawa stood up and Wanadi thought: "You're going to die." So Wanadi dreamt that he killed his mother. She was born full-grown, big like a woman. She wasn't born like a baby. And right away she died, when he dreamt her death, playing the maraca and singing. It wasn't Odosha who killed her but him himself. He had a lot of power when he thought. When he thought: "Life." Then Kumariawa was born. When he thought: "Death." Then she died. Wanadi made her as a sign of his power, of his wisdom. He knew that that wasn't real. Death was a trick. (de Civrieux 1980:23)

After burying her corpse in the ground, Wanadi goes off to await her promised reappearance. His plans are foiled, however, when Odosha destroys her with urine just as she begins to reemerge from the earth. In addition, Odosha prevails upon Iarakuru, the weeping capuchin guarding Wanadi's personal effects, to disobey his orders and open his *chakara* or "shaman's pouch." This allows the night hidden inside to escape, casting the world into total darkness. Until this moment, there had been only light on the Earth, with no division between day and night. "Whenever Wanadi got tired, he just opened his *chakara,* stuck his head inside, and slept" (ibid.:24). Now another duality is created, a temporal one to be added to the spatial one that already exists. Realizing instantly what has happened, Wanadi gathers up his mother's remains and, conceding another defeat, returns to Heaven.

The third and final Wanadi to be sent down to the Earth is "the one of the people today, of the world we live in now." As his name Attawanadi or

"House Wanadi" suggests, he is the one responsible for instituting the cultural forms that define the Yekuana. In addition to creating the first So'to (along with the people of various other tribes, including whites), he also built the initial *atta,* designed the first garden, and taught the use of the most important sacred herbs, including *woi, ayawa,* and *kaahi.* All of these forms were developed as effective responses to the unremitting threat of Odosha against Wanadi's new creation. Through the organization they provided, the newly-born humans were able to repel Odosha while remaining in contact with an invisible Wanadi. Yet Odosha was not without his successes. He continued to plague Wanadi in an attempt to force him to renounce the Earth. The most important narrative element of this cycle therefore remains the enmity between these two figures, with the newly added twist being that of sexuality. For if the first cycle of creation signals the division between Earth and Heaven (i.e., form and formlessness) and the second that between night and day, the third is dominated by the establishment of gender.

The conflict between Wanadi and Odosha resumes when House Wanadi, soon after arriving on Earth, decides to take a wife. Suggested as a cause for the diminishment of his power, Wanadi discovers Kaweshawa, the daughter of the master of fish, in the Kunukunuma River. Yet before they can marry he must clear her vagina of the deadly piranha that protect it. No sooner is this accomplished, with the aid of the first barbasco ever prepared, than Odosha abducts her.[22] After a lengthy search, replete with countless transformations and disguises, Wanadi finally succeeds in rescuing Kaweshawa. She has been so abused, however, that Wanadi has no alternative than to destroy her body (as he did his mother's) and revive it in Heaven. Once this is done, Kaweshawa and Wanadi return to Kushamakari and construct the first house. But their peace is soon disrupted once again.

As has already been noted, up to this time all reproduction was through thought alone. Sex as we know it had still not occurred and if Wanadi wanted to create anything, he simply dreamed it into being. It is in this way that he gives birth to his two children, Wanasichawa and Wanachadewa. Then one day, while Wanadi is out hunting, Odosha appears and, disguised as their father, convinces the children to have sex with one another.

> Wanadi's daughter. Her name was Wanasichawa. She was very small, very young. She was there at home, with her brother. He was very small too. They were alone there. Wanadi was off

hunting, way off there. And then Odosha came. He came up to the house and went in. He said to her, "Close the door. Why don't you close the door?" So she closed it.

Then he said, in a low, sweet voice, "Look, go sleep with your sister. Go ahead now, sleep with her." He said this just like Wanadi. They didn't know it was Odosha. He tricked them. He looked just like Wanadi. *Igualito.*

So Wanachadewa, this was the name of Wanadi's son, took her and slept with her. Then later, in the afternoon, Wanadi came back.

"Why is the door closed?" he asked. Then he saw Wanasichawa there trying to hide. She had her hands over her vagina, like this (indicating both palms crossed over it). So Wanadi knew. He was mad. It was Wanadi who said that incest (*kaña*) was bad.

Then his son died. The next day he died. He was very young. So Wanadi left. He went away from there.

With a single stroke, Odosha not only converts the mode of creation from a mental to a material one but also causes the first act of incest, resulting in the death of Wanadi's son and the departure of the culture hero himself. Before he can begin his long voyage back to Heaven, however, he must tend to his daughter Wanasichawa. As a result of having sex with her brother, the young girl begins to menstruate and nearly dies. As the Yekuana state, the early instances of menstruation, of which this was the very first, were far more serious and dangerous than they are today. Women bled much more profusely and not infrequently came close to death. Remedies were more extreme as well; in order to cure Wanasichawa, her father "must make her just like a shaman." He first places pots filled with boiling *woi* all around her. (These large-leafed caladiums, of which both men and women have their own varieties, are the most potent of all Yekuana magic herbs [*maada*]. Introduced here by Wanadi, they have become an essential means of protection against Odosha, as well as a weapon for both committing and avenging murder.) After securing a safe space within the circle of boiling *woi,* Wanadi introduces the body paints—*ayawa, wishu,* and *tununu.* Derived from the sacred trees of the same names which Wanadi brought to Earth specifically for this purpose, the paints are as indispensable as the arrangement of clothing for the "humanizing" of an individual. As will be further discussed at length, the shield of

invisibility that these pigments provide is not restricted to humans. Every Yekuana artifact, from the house to a baby's rattle, is covered with enough paint to insure its protection. The final ingredient in Wanadi's cure is the hallucinogen *kaahi* (*Banisteriopsis spp.*). Prepared from long vines and ingested in liquid form, this plant was created as a medicine to endow its taker with the power of "divination" (*kiniwachai*). Only in this way can the ill and their healers penetrate the supernatural, where the source of their maladies is located. Wanasichawa in taking *kaahi* becomes just like the shamans of today to whom this drug is now restricted. She goes into a trance and, with the guidance of her father, navigates the invisible road to her cure.

Once Wanasichawa is safe, Wanadi begins to flee from Odosha. At first, he intends to not so much leave the Earth as simply escape Odosha's presence. At each stage of his journey, Wanadi invents impediments to Odosha's pursuit of him. He creates the rapids in rivers and stocks them with game. When Odosha is not deterred, he creates even larger diversions, entire cities filled with riches to deceive Odosha into believing he has found Wanadi and entered Heaven. But Odosha continues to pursue him to the very end of the Earth, to Kahu Awadiña, "the foot of Heaven." Here, convinced there is no place left in the world where Odosha cannot penetrate, Wanadi leaves his greatest creation, a city made entirely of glass and mirrors. After populating it with people (Odoshankomo), he takes *aiuku* and, with his wife and family, reenters Heaven, from which "he never returns."[23] When Odosha arrives in Kahu Awadiña soon after, he believes he has finally overtaken Wanadi and achieved Heaven. But he is only in "the Foot of Heaven," at the extreme edge of the universe and the furthest end of materialism. Surrounded by his own image wherever he looks, Odosha comes to reside in the ultimate world of surface, cut off entirely from any access to Wanadi. For although he believes he has entered into a world of pure light, the "glitter" he sees reflected everywhere is only an illusion. As every Yekuana knows, Kahu Awadiña is a land of darkness and decay.

The record of Wanadi's flight from the center of the universe in Kushamakari to its outermost edge at Kahu Awadiña constitutes the most reliable map of the occupied world the Yekuana possess. With each encounter between these two antagonists another landmark is created. The geography they traverse enters into the collective memory of the tribe, distilling the conflict between Odosha and Wanadi into a series of place names. As new additions to the landscape emerge and the Yekuana horizon is expanded, these too must be charted on the same mythic map.

The outposts and towns founded by the Dutch and Spanish over the last several hundred years are incorporated as participants in the epic struggle between these mythic figures. Puerto Ayacucho, the farthest outpost of the Spanish in the Territorio Amazonas and the first stop on any Yekuana expedition to visit them, becomes the scene of Wanadi's first clash with Odosha. Here, while casting barbasco at Atures Falls, Wanadi gets revenge against Odosha by trapping his children beneath the water. Then, further upriver, in another attempt to end his pursuit, Wanadi creates the village of Angostura, populating it with a new race of whites called Iaranavi. Eventually becoming Ciudad Bolívar, the largest Spanish trading post on the lower Orinoco, it is stocked with a wide variety of goods, from shotguns and cloth to Bibles (Wanadi's "written papers") and fruit trees. When this does not stop Odosha, Wanadi creates the even greater city of Caracas. Here he places another race of whites, the evil Fañuru who will overrun the Iaranavi and become Odosha's close allies. Wanadi leaves them with even more spectacular goods—domestic animals, radios, tape recorders, cameras—all given with the intention of convincing Odosha that this material paradise is Heaven and thus encouraging him to abandon his pursuit. But Odosha continues to follow Wanadi, forcing him to establish even larger cities, each to be filled with a more sophisticated technology and a more powerful people. On the shore of the Caribbean, he makes the city of Amenadiña where he places Hurunku (the Dutch), along with a wealth of new material objects. And on the other side of Dama, in the unexplored half of the world (America? Europe?), he leaves a city endowed with the most stunning creations yet—cars, airplanes, even jukeboxes! Finally, when all of this fails, Wanadi erects his ultimate creation, the crystal city at the edge of the universe, Kahu Awadiña:

> There he made more than he already had: houses completely of glass, everything sparkling, all more beautiful than he had made before. And he put people there to keep Odosha away from him. Then he gave them a paper.
> He thought a lot about this, about how to stop Odosha.
> "I am Wanadi. Because from this point on there is no more Wanadi. Because look at these houses—pure *wiriki,* shiny, brilliant. No tin![24]
> And he took *aiuku* to get away from there. He took his children and his woman Kaweshawa. And he never came back again.

And Odosha arrived there and he stayed there in that village, the last one that Wanadi made.

And so you have many forms, but Wanadi made them all, to console Odosha. That's the reason you say you have so much there—motors, boats, radios . . . You say, "Look at those poor Indians who have nothing." But all those things you have there, Wanadi made them. He made them so Odosha would stay here with them.

And so Odosha stayed there in that last village that Wanadi made at the end. And from there, Wanadi left. He opened the door to Heaven and he never returned.

Incorporated into the existing mythic landscape of the Yekuana is not only the new geography but the new technology encountered within it as well. Rather than devastating the Yekuana world view as it might easily have done, this sophisticated technology is used as another example to reaffirm it. By turning the tables around completely, Wanadi uses this new material wealth to deceive both Odosha and the Spanish (the Iaranavi and Fañuru) who mistakenly believe they have invented it. The incorporation of these new events is smooth and natural. Inserted into easily recognizable motifs, the entrance of the Spanish into the Yekuana world is simply translated into the same symbols of duality that dominate every other aspect of their life. Joining the oppositions constellated around Wanadi and Odosha, the Spanish and their wealth of goods become synonymous with the world of form and illusion that blocks man from the true sources of power that dwell behind it. Instead of providing Odosha and the Spanish with access to the determinant world of Wanadi and the supernatural (invisible), their possessions prevent it.

Through their incorporation in a narrative structure based upon the same "received categories" (Sahlins 1981:7) as the rest of the culture, the historical events surrounding the arrival of the Spanish, along with the new technology they introduced, are reinterpreted into the meaningful language of Yekuana symbols. Once brought into comprehensible focus, the threat these newcomers present can be controlled. The location of the Yekuana at the center of the universe is preserved, while those who threatened it are exiled to Kahu Awadiña and beyond. Preserved also is the creative capacity of the culture to go on synthesizing new historical realities. For the ideology that maintains the Yekuana at the center of their world is above all a generative one. While its

vocabulary may be limited to the symbols manifest mainly in its artifacts, rituals, and myths, the ability to endlessly manipulate these insures that the culture continues as a dynamic mode of thought capable of processing new information and ideas. Regardless of the nature of the new realities it confronts, the Yekuana world view is capable of accommodating them within the existing series of oppositions that plot the structure of their universe and lead to another wherein all may be transcended.

THE MANIPULATION OF THE INVISIBLE

The conciliation of oppositions achieved in domestic, horticultural, and individual physical arrangements is restated in each encounter with the world beyond one's immediate village. Recognizing the existence of an invisible, independent force behind every object, the Yekuana accompany each material activity with a series of ritual ones designed to disarm it. It is not enough, for example, to simply cut down a tree and carve a canoe. One must also communicate with the supernatural power that controls the tree, negotiating its transfer of ownership. If this is not done, not only will the artifact be flawed but the spirit accompanying it will be hostile and vengeful, leading to disease and possible death. Ritual tools are therefore as essential as physical ones for the accomplishment of any task. Without their capacity to influence the invisible, there can be no transformation of the objects of nature into those of culture. By acting out the dualities encoded elsewhere, rituals provide the mechanism for the daily, minute-by-minute conversion of the foreign into the safe and controlled. This synthesis, however, does not eliminate the essential duality of every object, it simply reformulates it in human terms. As Pierre Bourdieu observed in another context: "The union of contraries does not destroy the opposition (which it presupposes), the reunited contraries are just as much opposed, but now in quite a different way" (1977:125).

While the Yekuana recognize differing levels of ritual skills, their indispensability in all material activities requires that every individual master a certain number of them. Without the ability to locate and neutralize "the arbitrary forces of the supernatural world" (Arvelo-Jimenez 1971:184) that are provoked in every encounter with this one, a hunter or gardener is completely vulnerable. The most valued member of every community is therefore the person who most thoroughly dominates the full range of techniques for manipulating the invisible (Guss

1980*b*). Among the most important of these elaborate systems of control are the uses of herbs, paints, and chants.[25]

Magic Herbs

As already noted, herbal knowledge is strictly divided along sexual lines, with men and women each possessing their own body of sacred plants. Yet gender does not necessarily entitle one to ownership, as these powerful herbs, known generally as *maada,* are closely guarded by the members of each family. Because of this secrecy, many people deny any familiarity with the plants whatsoever, making research extremely difficult.[26] One man described the difficulty of obtaining these herbs as follows:

> It's like getting a job. You know. You go to Ciudad Bolívar and you ask. And they say, "No." And you have to go back again and again and again. That's the way it is to get *maada.* At first they say no and you have to go back again and again and again. It's just like *aichudi* (sacred chants). I don't know why they're so stingy. That's why, remember how I told you? They don't want to give it. They start very slowly, never directly, talking like that. You have to stay awake . . . two days. The first day they talk. Then the next day, when you don't come back, they say, "OK, see, he doesn't want it." For two days you have to go without sleep. That's the way it is with *maada* too. I don't know why they're that way, the old ones.

Yet despite such secrecy, people do become associated with the ownership of certain plants, as their possession enhances their communication with different species. This is particularly true for men, whose *maada* tends to be dominated by plants used for hunting. A man especially adept at capturing deer, for example, will be spoken of as possessing strong *kawadi maadadi,* the "deer herb" that communicates directly with the master of this animal, "making it come to him tame and completely unafraid." Each *maada* is applied differently, with some being rubbed into small incisions made along the wrists, while others are passed over the arms and legs. Many forms of *maada* are applied not to the hunter but to his weapons or as extracts poured into the eyes and nostrils of his dogs. Formerly, it is said, men also took *maada* in this way, but the practice made them too savage and had to be abandoned.

Just as men's *maada* underscores their role as hunters, so too does women's their place as mothers and horticulturalists. A great many of their sacred herbs are directed either to the problems of menstruation, childbirth, and child-care, or to the maintenance of yuca and the protection of the women in the garden. While many of these herbs are applied directly to the body, a good many of them are combined in various mixtures that are then sealed in gourds called *tiritoho*. Hung from the end of one's hammock or the tassels of a baby sling, these small gourds are always within reach, to be shaken against an unwelcome spirit as need demands.

Body Paints

Often the strength of a *maada* is enhanced by combining it with one of several paints which is then applied to the body. A plant called *awana,* for example, is commonly mixed with *ayawa* and painted in long lines down the legs in order to provide hunters and gardeners with protection against snakebite. Other admixtures cure children of colic, induce sleep, prevent fevers, avoid accidents, and dispel spirits. Yet body paints do not depend on herbal ingredients for their power. As one woman pointed out, "*Maada* is plant magic. *Ayawa* is tree (*iye*)." Brought to Earth to cure Wanadi's daughter of the nearly fatal menstruation caused by Odosha, body paints continue to be one of the Yekuana's main items of defense in their ongoing struggle against this demon and his forces. Not only are people given daily protection by these paints, but so is every manufactured object. Canoes, paddles, baby swings, baskets, gourds, bows, arrows, benches, drums—all are coated with enough paint to safely incorporate them into the sacred circle of Yekuana culture. Without the symbolic coverage these pigments provide, an object, animate or inanimate, is simply not considered human. Analogous to the Western distinction between "clothed" and "naked," it is body paint, more than any other single object, which for the Yekuana distinguishes the civilized from the wild. A similar distinction was noted by Lévi-Strauss among the Caduveo of Brazil:

> The missionaries condemned Indian men who, forgetful of hunting, fishing, and their families, wasted whole days in having themselves painted. But they would ask the missionaries, "Why are you so stupid?" "In what way are we stupid?" the latter would reply. "Because you do not paint yourselves like the

Caduveo." To be a man it was necessary to be painted; to remain in the natural state was to be no different from the beasts. (1977:201)

Introduced as a cure for menstruation, it is no surprise that body paints should continue to serve as an antidote to the chaos that this process represents. For it will be recalled that the first menstruation was the direct result of incest, Odosha's challenge to the new human order that Wanadi had just created. In direct opposition to Odosha and his world of darkness, body paints are called *ayawa* or "light." In addition to this nominal symbolism, however, it is important to note that one of the three species of body paints brought to Earth by Wanadi also provides the Yekuana with their source of light. By wrapping the clear, fragrant extract of the *ayawa* tree (*Icica heptaphylla*) in dried leaves, the Yekuana form torches that burn for hours. Yet both of these aspects of *ayawa* are functions of the same process: Wanadi's attempt to dispel the darkness that Odosha has imposed upon a once luminous Earth. To light *ayawa* may be seen as having the same symbolic significance as wearing it. Hence the statement uttered whenever the first torch of evening is lit: "Odosha *emetaka kenadu*. Right in Odosha's eye."

Of the three species of paints the most important is *ayawa*. Taken from the colorless resin of a tall tree of the same name, which is found only in the headwaters of the Orinoco, it is *ayawa* that was specifically used by Wanadi's daughter as both a cure and a source of light and whose name was subsequently adopted to designate all body paints in general. Nevertheless, the other two paints are also powerful entities, capable of providing the same protection against malevolent spirits. Brought from Heaven at the same time as *ayawa*, *wishu*, and *tununu* complete the trinity of sacred trees so essential to the demarcation of human space.[27] It is therefore not uncommon in the most critical rituals to find all three of these substances combined. One instance of such combining occurs on the occasion of the roundhouse groundbreaking, when the entire length of the new centerpost is painted with all three pigments in an interlocking zigzag design. The paints are also mixed in other ways: the seeds of *wishu*, a much smaller and fuller tree (*Bixa orellana*) than *ayawa*, are packed with the dye used to convert the other two paints into deep reds. Like *ayawa*, *tununu* (unidentified) is derived from an extremely tall tree with a neutral resin. When not combined with *wishu* or the rust-colored dye extracted from the leaves of a tree called *kodaiyu*, *tununu* is turned into a black paint. This is

accomplished by mixing it with the soot that collects beneath the cassava grills, known as *fwatadi inhadoniya* or "the ash below."

Although Wanadi's daughter was the first to use *ayawa,* it is Wanato and his bird people who are credited with teaching the Yekuana how to properly apply it. This occurred when they prepared for the first Garden Festival, after cutting down the original *conuco* at Farahuaka. Wanato, as the first human, was so transformed by the combination of ornaments and body designs that even his own wife did not recognize him. Later, when he and the other First People left the Earth to turn into birds, it was their body paint that became the colorful markings distinguishing each species. Today *ayawa* remains a critical ingredient in the creation of each "new person" (*ahachito hato*). While other cures might be used for menstruation, it is still the application of body paint that, after three months of isolation and fasting, marks the young girl's transition into her new status of womanhood. It is also the application of *ayawa* that begins the ceremony of the newborn, the *Sichu hiyacadi* that "takes the child out" of the safety of the roundhouse to introduce it to the world beyond. As in the instance of the new centerpost, *ayawa* not only provides a protective seal but by invoking its strength directly from Heaven creates a parallel human space on Earth.[28]

Singing

As powerful as Yekuana healing herbs and body paints are, neither can be used without first being purified by the appropriate chant or *yechumadi.* Even more generalized and multipurpose than *ayawa,* these chants are required for every object and being incorporated into a Yekuana village. Beginning with the paint that covers a newborn, a specific *yechumadi* will be sung for each new item that enters into an individual's life, from foods and artifacts to magic herbs and natural forces. These chants are not reserved for the use of individuals alone, however. Objects of collective use and construction must be similarly treated with the powerful conjurations that these chants invoke. Still, the Yekuana do distinguish between collective and individual *yechumadi.* Those sung by the entire group are called *ademi.* Lengthy epics sung in a syncopated responsive style, the *ademi* are performed in the large collective festivals which inaugurate a new roundhouse (the *Atta ademi hidi*), celebrate the annual new gardens (the *Adaha ademi hidi*), or welcome back a large group of travelers who have been away for an extended period of time (the *Wasai yadi ademi hidi*). All of these chants

require from two to three days to sing and are the occasions for the most complete and faithful renditions of the *Watunna*. Yekuana emphasize that the length of these rituals is the result of the need to individually purify every one of the parts being integrated within the new structure. The *Atta ademi hidi* sung over a new house, for example, must carefully focus on every detail, from the largest crossbeam to the smallest piece of thatch.

Much shorter than the *ademi* are the numerous private rituals performed daily for each individual. Referred to as *aichudi,* these personal *yechumadi* are not so much narratives as long lists of names of the many spirits said to adhere to every object. The majority of *aichudi* are connected to the Yekuana's rigorous dietary restrictions, which demand that each new food ingested after a fast be "cleansed." Other *aichudi* are used to transform each new personal or household possession into an object of culture. Before a hammock can be slept in, an instrument played, a gourd drunk from, an arrow shot, an axe swung, it must first be sung over with the appropriate *aichudi.*

Regardless of whether the chant being sung is for a lengthy collective ritual or a shorter private one, the principles guiding its performance remain the same. For the Yekuana every object in the universe, controlled as it is by a foreign spirit, is *amoihe* or "taboo." To be rendered safe for human cohabitation, each must be systematically "detoxified" through the application of the proper *yechumadi.* It is through these chants, with the help of paints and herbs when appropriate, that the invisible dangers inherent in each object are neutralized. Once this is accomplished, the Yekuana refer to the object as *amoichadi,* "de-tabooed," or *chokwadi,* "cleansed." While the Yekuana do recognize certain things as permanently restricted from human use, such as snakes, jaguars, and vultures, these are not classified any differently from any other *amoihe* object. There are simply no chants available to make such things *amoichadi.* The spirits that control them are more powerful than any force a human chant could bring to bear. Perhaps this explains why almost all animals classified as permanently taboo either prey upon humans or upon those who do.[29] But in most instances the chants employed are capable of successfully communicating with the spirits attached to each object. This power derives in part from the special secret language in which all *ademi* and *aichudi* are composed, a language of the invisible, like those to whom it is directed. Of equal importance to the magical character of this language is the manner by which it is communicated. Powered by the breath that ani-

mates them, the words of the chants are blown or "taled" to the forces they are meant to influence. Words are not simply uttered or sung but are infused with the actual spirit of the chanter who, breaking at certain points in the performance, disseminates them with short, rapid blowing. As Audrey Butt observed among the neighboring Akawaio: "When a person blows, it is that person's own spirit or vitality which is projected in the breath and which is sent to perform certain work" (1956:49). The "work" to be performed, of course, is the communication with the supernatural forces animating each object, without whose submission it cannot be safely incorporated into the life of the community.

By acknowledging the dual reality of all existence through the simultaneous performance of ritual and physical activity, the Yekuana are able to successfully transform the objects of nature into those of culture. Each encounter with the natural world (*chutta*) beyond one's village produces another triumph of cultural synthesis, wherein the objects confronted are made to conform to the existing organization of the Yekuana world. It is not enough to simply take precautions. One must completely "humanize" the foreign, bringing it into harmony with the symbolic structures—domestic, economic, and spiritual—that serve as the primary systems of integration and control. Hence, Roy Wagner's observation that "what we would call 'production' in these societies belongs to the symbolization of even the most intimate personal relationship"(1981:24). For it may be that ritual does not simply facilitate physical activity, but that physical activity actually serves to allow for the performance of ritual. The preoccupation of culture is not so much with the production of goods as it is with the re-production of itself.

Even if the continuous reorganization of raw materials into recognizable symbolic relationships is not defined as "work," it must be acknowledged as its principal by-product. Every activity, as demonstrated by the use of herbs, paints, and chants, participates in this ongoing construction of reality known as culture. The ritual performance demanded by each encounter with the unknown converts every material task into an act of cultural creation. Synthesizing, integrating, and transforming, culture is, as Wagner observes, "a style of creativity" (ibid.:26), a dynamic mode of thought and action regenerating itself daily in every one of the countless activities undertaken by its members. Like an unfinished symphony, culture is a work of art never meant to be completed. Its expressiveness demands that it be endlessly recreated and that its appreciation derive from this process of creation. Every event, through the manipulation of symbols it requires, becomes an-

other exercise in Yekuana cosmology, another form of revelation. Unfolding as does a story, with no one version ever being entirely complete yet each one reflecting the structure of completion, culture is the accumulation of every telling woven together like a basket to form the whole.

4 · "ALL THINGS MADE"

TIDI'UMA

While the Yekuana, like many tribal peoples, have no fixed category corresponding to the Western concept of "art," they do distinguish between objects manufactured within the guidelines of traditional design and those that simply arrive without any cultural transformation or intent. *Tidi'uma,* from the verb *tidi,* "to make," are the collective artifacts of the culture, the sum total of everything one must learn to make in order to be considered a Yekuana. These are the essential items, from canoes and graters to houses and baskets, the things that not only distinguish the Yekuana as a society but incorporate the symbols that allow them to survive. *Mesoma,* on the other hand, is simply "stuff," the undifferentiated mass of goods that the Yekuana have acquired through either trade or chance. Often referred to by the Spanish term *coroto,* these objects, such as tin cans and plastic buckets, have none of the magical power or symbolic meaning associated with *tidi'uma.* And though a person may occasionally try to disguise a commercially manufactured object with a layer of skillfully applied *ayawa, mesoma* remains a synonym for any insipid or alien object.

For the Yekuana, the distinction between *tidi'uma* and *mesoma* is an important one, as it recognizes culture as something to be made. Unlike the prefabricated *mesoma* that arrives from the outside lacking either significance or resonance, the objects classified under the term *tidi'uma* are all handmade. They represent not only the collective resources of the culture but also a conviction that culture is something to be created daily by every member. Through the complex arrangement of symbolic elements incorporated into the manufacture, design, and

use of each one of these objects, *tidi'uma* are able to take on a meta-phoric significance that far outweighs their functional value. The se-miotic content of every artifact demands that the maker participate in a metaphysical dialogue, often articulated with no more than his hands. Implicit in the growth of every individual as a useful member of society, therefore, is the development of his intellectual capacity. For in learning how to make the various objects required for survival, one is simulta-neously initiated into the arrangements underlying the organization of the society as a whole. Just as ritual actions may be said to necessarily accompany all material ones, the symbols incorporated into the manu-facture of all *tidi'uma* require that every functional design participate in a greater cosmic one. Hence, to become a mature Yekuana is not only to develop the physical skills demanded of one's gender, but also the spiritual awareness that the preparation of these goods imparts. In a society that has no special category for a work of "art," there can be no object that is not one. Or, put another way, to become a true Yekuana is to become an artist.

As if to acknowledge the close relation between technical and esoteric skills, the Yekuana often speak of the development of manual expertise as analogically indicative of other more intangible qualities. The fact that those who create the most skillfully crafted objects are also the most ritually knowledgeable members of the community is a truism every Yekuana recognizes.[1] In order to manufacture even the simplest objects of everyday use, the maker will need to be familiar with the symbolic arrangements necessary to their completion. As these objects become more complicated, so too must the esoteric knowledge incor-porated into their design. Of all the artifacts the Yekuana manufacture, no other demonstrates this simultaneously incremental development of technical and ritual competence as does basketry. The most pervasive of all Yekuana art forms, basketry may not only be used to chart the growth of an individual but of an entire community as well. A shibboleth of tribal identity, the Yekuana state that "a person who does not make baskets is just like a criollo," and emphasize that the authenticity or "Yekuananess" of other villages may be judged by the quality of their weavings.

Of all the material activities required of a Yekuana, there is almost none that, in one way or another, does not demand the use of a basket. Whether it be simply to fan a fire or to carry a piece of game, all actions carried out by both men and women in some way incorporate an object woven from a cane, palm, vine, or twig. The largest number of these

baskets are those utilized in the complex transformation of poisonous yuca into edible cassava. Although this group of baskets is used exclusively by the women, all but one of them, the *wuwa,* is manufactured by the men. Referred to in sacred chants as *amunkayedono,* "that which hangs from the back," *wuwa* are proportionately designed so as to evenly distribute their enormous loads between the bark tumpline hanging from the head and the contoured basket resting against the back. Used primarily in gardening to transport tubers and remove weeds, the sturdy *wuwa* is the woman's all-purpose carrying basket, an extension of her body without which she is rarely seen leaving the village. *Wuwa* are used to gather firewood, carry fish and game, and to transport household goods on expeditions. Taking longer to make than any basket manufactured by the men, *wuwa* are characterized by a form of construction restricted to the women alone. This is the twining technique, wherein the flexible weft elements of the basket are wrapped horizontally around those of a stationary, vertical warp. To reinforce this structure, both elements are secured to a heavy vine called *amaamada* (*Hubebuia pentaphylla*), which is coiled along the inside of the entire basket.[2]

Differing from the twining technique used to make *wuwa* is that of twilled plaiting, the method employed for the manufacture of the four additional baskets that men must weave for women in order for them to process yuca. Of the four, the most simple is the *wariwari* or firefan. Made of thin strips prepared from the outer part of a tall itirite cane called *ka'na* (*Ischnosiphon* sp.), the *wariwari,* like all twilled plaiting, is created by passing these equally-sized strips over and under one another at ninety-degree angles. Although monochromatic, patterns can be derived by alternating the regularity with which warp and weft elements pass above or below one another. Unlike twining, there is no inner frame or sewn element, tension being maintained solely by the tightness of a weave that never permits a weft element to cross over more than three warps.[3] While referred to as firefans,

Firefan or *wariwari* of the *yamatoho* variety (courtesy Helga Adibi, Wilbert 1972)

wariwari also serve as spatulas with which to control the cooking of cassava. For this purpose, the large square variety, called an *u yanakato* or "cassava turner," is preferred, as its long straight edge is capable of easily gliding under the enormous loaves to both turn them over and remove them from the grill. The *watto yamatoho* or "fire beater," a triangular firefan to which a short handle is attached, is less versatile and may be limited in use to the family hearth. Because of the simplicity of both of these firefans, *wariwari* are usually the first objects a Yekuana boy learns to weave as he approaches the age of ten and begins to contemplate life in the inner male circle.

Much more demanding to make are the large round trays that are used to carry pressed yuca from the house to the grill and to catch it as it is sifted through another basket immediately prior to cooking. Referred to as *waja tingkuihato,* a name emphasizing their close relation with the *tingkui* or yuca press, these highly durable baskets may be up to three or more feet in diameter. While woven of the same unpainted *ka'na* as the firefans, the *waja tingkuihato* are plaited in a variety of simple patterns, the most common of which is the concentric square design known as *fahadifedi* or "armadillo face." Once the body of this basket has been completed, it is set inside two interlocking hoops prepared from the branches of a tree called *fumadi.* The edges of the basket are pulled through and the ends, in groups of three to five, are tightly twisted and then sewn onto the *fumadi* as a thick piece of *kurawa* fiber is passed through the perimeter and with a circular stitch used to bind the two pieces of the "frame" (*chähudu*) together. (See page 78.) A smaller, but otherwise identical version of this monochromatic basket serves as a plate for those undergoing fasts. Commonly known as *Kutto shidiyu* or "frog's bottom," this ritually indispensable basket will be discussed at length at a later point.

Serving as a companion to the *waja tingkuihato* is the slightly smaller *manade* basket. Woven and finished with the same materials and patterns, the plaiting in this basket is not closed but rather is left with small openings between the strips. It is through these gaps that the pressed yuca is forced, resulting in a fine flour which is then sprinkled over the grills to be cooked as cassava. Fitting perfectly into the *waja tingkuihato* it is used with, the *manade* may also be employed elsewhere as the need for fine sieves demands.

The fourth and final in this group of baskets is the *tingkui* or yuca press itself. Often referred to by its Spanish name, *sebucan,* this basket,

because of its awkward materials and complicated, reinforced ends, is among the most difficult for any Yekuana to master. Although made of *ka'na* the individual strips are much longer and wider, resulting in a finished basket strong enough to be suspended with up to 125 pounds of freshly grated yuca in it. Averaging six feet in length, the *tingkui* is constructed in the form of a long sleeve with the top open and loops at either end. When filled with grated yuca, it is hung from the top one and a pole is inserted into the bottom. As pressure is periodically applied to this pole, the prussic acid in the pulp is extracted through the tightly plaited sides and a poison-free, dry white mass created. It is this mass which is now ready to be forced through the *manade* in anticipation of the final stage of cassava preparation.

Although the *wariwari, waja tingkuihato, manade,* and *tingkui* comprise a special category of baskets set apart from all others, they represent but a few of the many that every Yekuana male must learn how to make. There are also baskets made for carrying, storing, caging, hunting, fishing, eating, dancing, fighting, playing, and trading. Among these others, the most commonly used is the *tudi,* the men's carrying basket, an open-backed rectangular basket carried by a bark strap around the shoulders. Manufactured with either a tightly plaited or open lattice-work weave, the *tudi* is used to transport everything from game and fish to personal effects and provisions. Should a man be caught away from home without a *tudi* and have need to transport something, a quickly improvised basket called a *duma* is woven in minutes from whatever palms are at hand. Using a bent branch as a frame, the temporary *duma* backpack is discarded as soon as the load reaches the village. Also used to transport goods, though not as a backpack, are the *mahidi* and *dakisa* baskets. Differing from one another mainly in size, these valise-like baskets are

Men's carrying basket or *tudi* (courtesy Helga Adibi, Wilbert 1972)

Mahidi (courtesy *Antropológica,* 1976)

woven in the same hexagonal weave as the open-style *tudi.* Yet instead of being attached to a frame, a wide-mouthed rim is simply fashioned from the loose ends of the body. When the *mahidi* is used to transport game and produce, or the smaller *dakisa* captive birds, this rim is closed to serve as a convenient handle.

Another basket used to cage small animals, as well as to store peppers, cotton, and other items, is the diminutive *cetu.* This elegant basket, approximately the same size as the *dakisa,* is made from strips of the *muñatta* vine (*Anthurium flexuosum*). The same material used to make *wuwa, muñatta* is sturdier, if less flexible than itiriti (*ka'na*). As such, it provides the wicker sides and coiled handle of the *cetu* with a strength and durability that far exceeds its functional importance. This cannot be said for another wicker-style basket constructed of *muñatta.* This is the *mudoi* or fish creel, which must be strong enough to withstand nights on end wedged between rocks in the shallows of rivers. Constructed of differing sizes of *muñatta* or sometimes of the even stronger *amaamada,* the *mudoi* consists of a large bottle-shaped frame as well as a flexible inner one through which unsuspecting fish enter and are trapped.

Cetu (courtesy *Antropológica,* 1976)

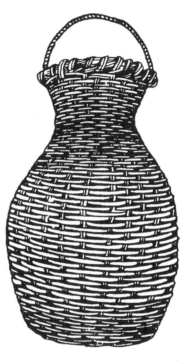

There are several baskets made not for daily use but for ceremonial occasions alone. Amongst these is the *fwemi,* a feathered crown worn by the men during the three-day Garden Festival. One of the most beautiful Yekuana artifacts, the structure of the *fwemi* succinctly restates the symbolism acted out in this annual dance. The transformation of Wanato and the bird people responsible for planting the first garden into an organized group of horticulturists—the So'to or Yekuana—is woven into the crown worn at the festival commemorating this event. For, like the garden and house, the *fwemi* consists of two concentric circles: an outer natural one of macaw, parrot, harpy eagle, and currasow feathers and an inner, humanly manufactured one of rigid, carefully coiled *ka'na.*

A much more simply fashioned basket, used in both the *Wasai yadi ademi hidi* and *Atta ademi hidi* as well as in the ceremonies for a newborn child and a newly harvested *conuco,* is the *maahi.* This small, packet-like basket is woven directly around the game or fish which returning villagers must ceremonially carry. Tightly plaited from the fresh San Pablo leaves (*maahiyadi*) that give it its name, the *maahi* is constructed with a loop so as to attach it firmly to one's wrist. This is an important feature, as those returning to the village in a *waseha* ceremony must have *maahi* dangling from their arms in order to show the success of their journey. Pride, however, soon turns to mayhem as those arriving are attacked and, after a struggle, relieved of their prizes.

A similar, though more substantial basket is the *ahadaño.* Translated as "from the arm" (from *yahadi,* "arm"), this basket, made from *muñatta* and lined with leaves, is also tightly woven around a prize of

fish or game. It is used only during one particular dance, which occurs during the first morning of the *Wasai yadi* festival to welcome home returning travelers. At a given signal, these travelers, all dancing with large *ahadaño* dangling from their biceps, are attacked by the women, who steal the baskets away from them. As with the *maahi,* the *ahadaño* are discarded as soon as the food inside them has been consumed.

One last basket closely associated with ceremonial use is the *amoahocho,* a five to seven-inch long replica of the *tingkui* yuca press. This miniature, though not required for any precise ritual purpose, is a favorite game of young people with which to capture the opposite sex during festivals. Functioning exactly like a Chinese finger game, anyone who inserts a finger finds it harder to escape the more he or she tries. Thus, it recalls the manner in which Wanadi captured his own wife, Kaweshawa, and as such explains why *amoahocho* are also referred to as *Wanadi hinyamo otohüdi* or "to catch Wanadi's wife."

The final group of baskets manufactured by the Yekuana are the bichromatic plaited ones that have received far more critical attention than any other Yekuana artifact. Referred to by the Hameses as "the pinnacle of Yekuana artistic achievement" (1976:17), it is also this tradition that Koch-Grünberg singled out for praise during his 1911–1913 expedition. Never particularly sympathetic to the Yekuana, he concedes that these baskets are "true works of art which far surpass through the fineness of the plaited strips and in all other aspects of their workmanship the similar products of their eastern neighbors and the tribes of the Río Negro" ([1924] 1982:289).[4] While the Yekuana also place this group in a special category apart from all other basketry, it is for reasons other than the aesthetic ones that have attracted the notice of Western visitors.

All bichromatic twilled plaiting is made from one of two types of cane, the thick, bamboolike *wana* (*Guasdua latifolia*) or the taller, slender *eduduwa* (unidentified). While *wana* yields strips noted for their whiteness and strength, *eduduwa* has almost twice as much space between nodes, permitting longer strips and hence larger baskets. After the materials have been chosen and cut, the green skin is scraped off with the back of a knife and the cane set out to dry. The basket maker now goes off to gather the bark of one of several trees. Scraping the pulp inside of this bark together, a moist raglike mass is formed, which is then passed along the underside of a cassava grill to collect the *fwatadi inhadoniya,* "the ash below." The resultant black dye is used to paint the outside of one half of the cane. After the cane is allowed to dry, the basket maker begins to prepare the strips, each a sixteenth- to an eighth-of-an-inch wide, from

both the painted and unpainted material. By carefully notching around the top of the cane, over two dozen fine strips can be removed from each piece, every one to be redivided and scraped before final use.[5]

The prepared strips, known as *setadi,* can be used to make one of three types of baskets: a round, slightly concave serving tray, a box-shaped telescoping basket, or the cover basketry used to sheathe weapons. Regardless of which is made, the plaiting technique follows the same formula. A small number of white and black strips are lapped together at right angles to create a corner. Then, after laying down additional white ones to enlarge the size of the warp, the blacks are individually inserted, with the number of white elements covered or revealed by each determining the final design. In no instance should a black ever cover more than five of the whites, as to do so would undermine the overall strength of the basket. This rule, along with the need to place all weft elements at a ninety-degree angle to the warps, is a technical determinant that every basket maker must incorporate into his design.

Of the three forms of bichromatic basketry, the simplest by far is the cover basketry used to sheathe the handles of all traditional Yekuana weapons. Referred to as *wayutahüdi,* this covering is plaited in simple designs directly onto the carved wooden weapons, producing a seamless effect. The only finishing is the wrapping of fine strips of *kurawa* fiber around the loose ends of both top and bottom to prevent unraveling.

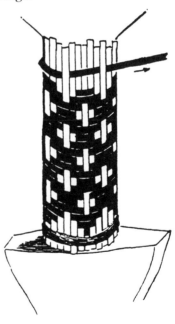

Much more complicated is the manufacture of the telescoping basket, referred to as such because of the two parts that slide into one another. Found throughout the Guianas, this basket is also commonly described as a *pegall,* a name claimed by Roth to be "the Creole corruption of the Carib

Cover basketry (Roth 1924)

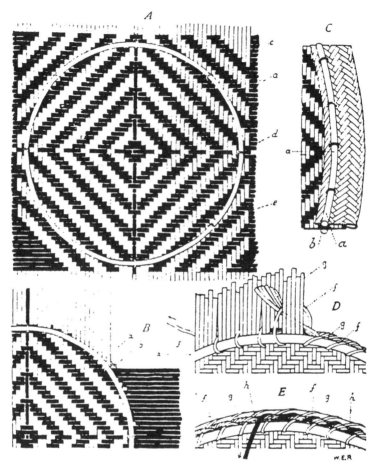

Waja finishing techniques (Roth 1924): A. The finished body of a *waja tomennato,* the "painted" *waja,* before trimming. Note the plaiting technique—weaving is diagonal from the bottom of the image to the *A* at the top. B. The *chähudu* frame bands temporarily fixed to the body as the loose ends of the strips are cut away. C. A close-up of the attached finishing band sewn tightly between the *chähudu.* Made from the same materials as the body, this separately woven monochromatic band is called a *chahiyü* or "lips," a name describing the manner in which it grabs the edge of the basket. D. Self-selvage technique of the *waja tingkuihato,* wherein a finished edge is made from the coiled ends of the basket itself. E. *Kurawa* being sewn around the *chähudu* bands to keep the edges and frame in place.

term *pagara* or *pagala*" (1924:345). To the Yekuana these baskets are known as either *kungwa* or *amato.* Made only by the most skilled craftsmen, this basket is completely double-plaited, with the outer parts bearing any of a variety of designs and the inner monochromatic. Woven into the shape of a box with reinforced edges, the bottom is slightly smaller than the top in order to fit inside it. When finished, the *kungwa* is hung from a rafter by a long piece of *kurawa* looped tightly around it and, unless made for trade, used to store such personal ritual objects as healing gourds, *maada,* quartz cyrstals, magic stones, and tobacco.

The final group of bichromatic plaited baskets is also the most frequently manufactured. These are the *waja,* the circular serving trays used as plateware for the cassava eaten at every meal. Better known than any other Yekuana basket due to their popularity as trade items, the different *waja* may incorporate up to thirty designs recombined in an infinite variety of ways. Because of this pronounced graphic element and the need to distinguish it from the other *waja*—the monochromatic *waja tingkuihato*—this basket is also referred to as a *waja tomennato* or "painted" *waja.* But a dramatic graphic element is not the only thing that distinguishes these baskets from one another. Though similarly shaped, the "painted" *waja* is just a third the size of the other, measuring in most instances only ten to fourteen inches in diameter. The two baskets are also made of completely different materials, one of *ka'na* and the other of either *wana* or *eduduwa.* And finally, each basket is finished with a different technique. The *waja tingkuihato,* made to carry heavy loads during the processing of yuca, is finished with a self-selvage, incorporating the twisted ends into the final design of the rim. The more delicate *waja tomennato,* on the other hand, has a separately woven finishing band which, once attached, gives this basket a grace and refinement not to be found in any other.

A CYCLE OF BASKETS

Marriage

The importance of basketry in every aspect of Yekuana life makes it a natural yardstick with which to measure the maturity and character of a developing male. As one masters the different skills required of every adult member of the society, he will also have to learn how to make the baskets necessary to accomplish these tasks. Basketry therefore be-

comes a significant indicator in the general growth and competence of an individual, used to chart not only practical knowledge but also status and identity. That this is the case is revealed in a variety of beliefs, many of which concern marriage. For to properly support a wife, one must be able to make the baskets that enable her to work. Hence, Yekuana regularly state that a boy is not ready for marriage until he is capable of making every basket, and will refuse to accept one for a son-in-law who is not. This view is articulated in a commonly repeated motif found throughout Yekuana mythology. In it, a young man has just married into a strange family. While his bride is attractive and loving, the father-in-law is an evil cannibal looking for a pretext to kill the boy. He commands his new son-in-law to weave a stack of *tingkui* baskets in a single day, an impossible task whose failure will be used as an excuse to kill him. But the young man is a shaman with supernatural powers, and with the help of other beings, usually birds, he weaves the baskets and, after carrying out several other miraculous deeds, kills not only the father-in-law, but the bride as well (de Civrieux 1980:88). While this story is, of course, a fearful exaggeration of marriage and the anxiety-provoking household realignment it represents for males, it nevertheless reaffirms the inevitable initiatory role of basketry in becoming a husband.

For the Yekuana the consecration of a marriage is a subtle and private affair. Lacking the public ceremonialism associated with festivals, it is an event that goes all but unnoticed, except by those immediately associated with it. Yet, despite this apparent lack of public recognition, the Yekuana attach tremendous importance to the marriage event, particularly as it affects the male. Unlike the bride who has recently undergone an *Ahachito hato* initiation, the man has no other ritual marking his transition from adolescence to manhood. True, he has gone into the circle of unmarried males at the age of ten or eleven, but now he is ready to move out of it to become part of an entirely new family. For matrilocal marriage means that it is the man who will have to shift his allegiance from biological parents to spousal ones. While his bride remains in the same secure environment she has known since birth, the groom faces the most radical transition he will ever undergo. The symbols surrounding marriage acknowledge this "rebirth" into a new family just as they test the young man's willingness to accept its authority.

While marriages may be contracted for either personal or political reasons, the ideal one is always between cross-cousins, a union which permits both partners to remain in their native village. Once proposed, the marriage is discussed by the parents, with particular importance

given to the views of the girl's. Unless they are convinced that their future son-in-law will be hardworking, faithful, and obedient, they will not agree. After both parties have given their consent, they approach the chief, who calls the entire community together for an open meeting. Only after every person in the village has had a chance to speak is the couple allowed to marry. The girl is now permitted to enter the *annaka,* where she removes the young man's hammock and rehangs it next to her own. When he enters the private quarters of his new family that evening, his bride offers him a gourdful of *sukutuka,* a beverage made from cassava and water. That night they eat nothing else, simulating the fast that begins every major life-cycle transition.

Although the couple now lives as husband and wife, the ceremony is not necessarily over. The man must first weave his bride a series of baskets in a strictly prescribed order. The first one he weaves for her shortly after moving is the *Kutto shidiyu,* the "frog's bottom" variation of the *waja tingkuihato.* Much smaller and more finely made than the otherwise identical *waja tingkuihato,* this "wedding basket" will be the only one the couple uses to eat from over the coming year. As such, it symbolizes their status of newness and rebirth, just as the simple meal of *sukutuka* did on the first night of their marriage. For although the couple does not undergo an actual fast, the *Kutto shidiyu* basket is the one used in fasting, especially by those involved in the three major fasts of life-cycle transition. These fasts—for the *abachito hato,* the birth of a child, or the death of a close relative—are ordered according to the foods that a baby first ingests, working up from the simplest meal of *sukutuka* to the most "toxic" one of peccary. During the entire year that one is on this restricted diet of a "newborn," he or she may only take food from a *Kutto shidiyu* basket and never from a "painted" *waja.* Because of this, the *Kutto shidiyu* is not only a powerful symbol of rebirth but also of purity and health.

The next basket every new husband makes is the *tingkui,* the complicated yuca press that is among a woman's most important daily tools. In weaving this basket, the young man quickly affirms his competence to an ever-wary household, which will be testing him in its own way with other improvised commands. Then reversing the order in which he learned to weave them, the man makes a *waja tingkuihato,* a *manade* sieve, and a *wariwari* firefan. Only when all of these have been completed does he begin to construct the enormous wooden apparatus from which the *tingkui* baskets are hung. This *tingkuiyedi,* which will require the aid of some of his in-laws to build, will be used not only by

the man's wife, but by the other women of the household as well. Now, after a full year, the husband is ready to make his final basket, a "painted" *waja* to replace the *Kutto shidiyu* the couple has used since the beginning of their marriage. But first he goes to consult his father over the design he should choose, for whichever one he gives her will be the basket the man must make for his wife throughout the course of their marriage. This does not mean that he will never weave other baskets to either trade or give as gifts to friends. Yet for his wife he may only make the design woven into the *waja tomennato* given to her at the end of the first year of their marriage. If he should ever do otherwise and his wife eats from the basket, she will die. As a result, a man contemplates seriously before deciding which basket to weave. Often he chooses one that his father or grandfather has made for one of their wives. In this sense, a *waja* design may assume the importance of a family crest passed on from generation to generation. But this is not how the Yekuana characterize it. For them it is the realization of a couple's identity, defining what until then has been an amorphous and transitional relation, as symbolized by the blank image of the *Kutto shidiyu* fast basket. With the gift of the *waja tomennato,* however, this period comes to an end. The couple is now accepted as a separate entity, ready to begin a family of its own. As long as they remain together, the special images woven into this "painted" *waja* will be a clear statement of the strength and uniqueness of their bond.[6]

While the completion of this cycle of baskets may represent the conclusion of a year-long marriage ritual, it is by no means the end of the husband's education as a basket maker. From this point on, his basketry will graduate into a new level of meaning and expertise. As a married man, he will begin to disassociate himself from the *modeshi* who hang their hammocks at the center of the roundhouse. He will be expected to take on more responsibilities now, carrying out tasks for his father-in-law and even leading work parties of his own. Soon he will start to speak at meetings, sitting with the elders as they discuss the affairs of the village late into the evening. And like them, he will spend more and more of his time making baskets, not just the ones needed by the women of his household or by himself, but baskets made as a means of meditation and expression. This is not to say that these baskets are any less functional than others he has made. Certainly every basket will at least find a place as an item of trade. Yet, as a man matures, his interests begin to turn more toward the metaphysical and hence toward basketry, particularly the *waja tomennato.* For beyond serving the

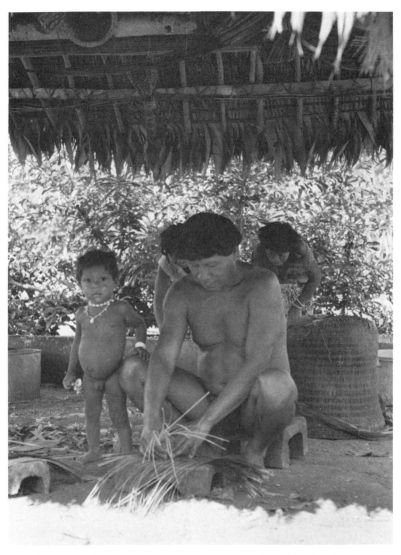

Juan Castro weaving a basket, Parupa, 1977 (photo David M. Guss)

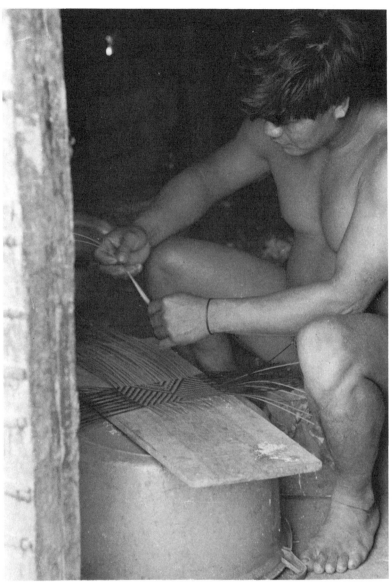

Juan Castro's son Pedrito starting a "painted" *waja* (photo David M. Guss)

Yekuana as plateware, these baskets incorporate a complex system of symbols that acts as an index and key to the rest of the culture. Yekuana men appreciate this, using these baskets as a discipline to penetrate the mysteries of their society and world. It is no surprise, therefore, that as a man enters into the serious study of *Watunna* and other esoteric lore, it is basketry that accompanies him, a fact which also explains why the most accomplished ritual singers and most skillful basket makers are inevitably one.

THE TRADITION

Although this tradition of twill-plaited basketry finds one of its most perfect expressions in the work of the Yekuana, it is in no way unique to them. As O'Neale (1963), Roth (1924), and others have pointed out, it is a form that has flourished throughout South America, with examples found from coastal Peru to Panama. Among the Carib, Arawak, and Tukanoan groups of the Guianas and upper Amazon, where it is probable this tradition became most highly developed, some form of bichromatic plaited basketry was at one time nearly universal. Yet, despite such historical importance, there are almost no studies of it, a situation which, in most cases, is now too late to remedy. For ironically, despite Koch-Grünberg's 1911 warning that "the craft that belongs to the entire Yekuana tribe is beginning to disappear more and more due to a continually expanding relation with the whites" ([1924] 1982:290), the Yekuana remain one of the few groups where this sophisticated art form can still be fully appreciated. Of those studies that do exist, the first and perhaps most important is that of Walter Roth (1924). A colonial officer in the Pomeroon River District of what was then British Guyana, Roth spent over ten years investigating the tribes of not only that country, but also neighboring Venezuela, Surinam, Cayenne, and Brazil. The result was the publication of two monumental works of South American ethnography—*An Inquiry into the Animism and Folk-lore of the Guiana Indians* (1915) and *An Introductory Study of the Arts, Crafts, and Customs of the Guiana Indians* (1924). It is in the latter work that he devotes over a hundred pages to a discussion of the distribution and manufacture of basketry throughout the region. As regards the symbolic significance of these baskets, however, Roth offers very little insight. He merely gives the names of several of the "patterns depicted," stating that for the others "the meanings have been lost, even to the makers them-

selves. They were taught them by their fathers, but they have forgotten what they were supposed to represent" (1924:368).

A much more successful work in this respect is Johannes Wilbert's *Warao Basketry: Form and Function* (1975) in which he not only surveys the full range of this group's basketry but also the manner in which it is used to provide access to another reality.[7] As in other works of his ("To Become a Maker of Canoes," 1976, 1981), Wilbert's main concern is in demonstrating how material artifacts transmit the transcendental values of a culture. In this case he shows the process by which a master basket maker is transformed into a shaman or *uasi* through the dedicated practice of his art. Although the *uasi* may not use these skills to perform healing rites in the manner of other shamans, he is nevertheless guaranteed the same access to the supernatural. In commenting on this unusual phenomenon, Wilbert writes:

> It is remarkable that a craftsman should acquire shamanic attributes for reasons other than practicing shamanism. Like the Warao canoe maker, basket makers acquire shamanic power strictly for personal advancement, reinforcing their social status by attributes pertaining to shamanism without accepting the role of a religious practitioner.
>
> It seems clear, then, that beside the more pragmatic socioeconomic factors and associated positive identities that motivate the production of basketry, we must not underestimate the importance of ideational dimensions as dynamic forces in this respect. *Uasi* craftsmen, going quietly about their business, may have their minds on the Otherworld more often than on "stylistic patterns," subtly and invisibly weaving dreams and visions into their baskets. (1975:83)

The two remaining studies of South American basketry also focus on Venezuelan groups, and while neither approaches Wilbert's insights on the interrelationship between basketry and the metaphysical, it is for quite different reasons.[8] The first of these was conducted among the Yekuana by Raymond and Ilene Hames in 1976. Unfortunately, the village the Hameses worked in was an extremely acculturated one on the lower Padamo where only two individuals—neither of them native to the community—still knew how to make "painted" *waja*. Despite their desire to carry out a study "in its full cultural context," the work is

reduced to a series of simple statements on technology and time alloca-
tion. The core of the work is a computer analysis of 40,123 timed
observations of individual basketmaking, resulting in the somewhat un-
remarkable conclusion that older people spend more time making bas-
kets than younger ones, and that all people spend more time making
baskets than in making anything else (1976:25).[9]

A much more provocative study is the one which Paul Henley and
Marie-Claude Mattéi-Muller carried out during the same period among
the Yekuana's distant neighbors to the north, the Panare. A Carib-
speaking tribe like the Yekuana, the Panare never developed a tradition
of bichromatic plaited weaving as sophisticated as that of the *waja
tomennato*. While they did have a traditional serving tray, it was a
combination of one of three simple weave patterns with a variable
chromatic sequence, a type of *waja tingkuihato* with colored elements
inserted discontinuously to give the illusion of a more diversified de-
sign.[10] Then, in 1964, a Protestant missionary introduced the Yekuana
technique of basketmaking to them as a means of producing trade items
to supplement their economy:

> Around the year 1964, more or less contemporaneously
> with the demise of the tonka bean trade, the Panare began to
> copy the guapawork ["painted" *waja*] of the neighboring
> Yekuana. The Yekuana work was first introduced to them by an
> Evangelical missionary of the Orinoco River Mission, Charles
> Olvey. He brought samples of guapawork from Yekuana commu-
> nities in the Caura river drainage and encouraged the Panare to
> copy them. A number of men from the communities in the val-
> ley of the Colorado River in the southwestern corner of Panare
> territory spent several weeks living in the garden of Olvey's
> house in Caicara attempting to reproduce the Yekuana work.
> Having mastered the basic techniques, they returned to their
> communities where this knowledge was passed on to others.
> Since then the Yekuana type of guapawork has spread further
> afield. The core of the present community of Portachuelo, near
> the criollo village of Turiba, is made up of individuals who previ-
> ously lived in the Colorado valley and brought the knowledge of
> the Yekuana type of guapawork with them. The weaving of
> guapas in other communities that have regular social relations
> with Colorado and Portachuelo has also been affected to some
> degree by the Yekuana type. (Henley and Mattéi-Muller 1978:39)

After several years of experimentation with this new form of basketry, the Panare began to develop a unique style of their own. While it respected many of the techniques adopted from the Yekuana—the manner of weaving complex patterns from continuously-inserted colored elements, the use of finer materials, a more sophisticated finishing band—it used them in new ways. It rejected the geometric abstraction so dominant in Yekuana basketry and replaced it with newly created graphic forms. More naturalistic than the "painted" *waja* of the Yekuana, these new Panare baskets attempted to depict everything from tapir and dogs to trucks and radios. In order to accomplish this, the Panare had to violate the "technical conventions" implicit in bichromatic plaited basketry. Whereas the Yekuana had limited the number of warp elements that could be crossed over by those of the weft to either three or five, the Panare now extended this number to as many as the image demanded. By relaxing this rule, the medium was now capable of incorporating whatever design the Panare wished to weave. It meant, however, that the baskets were no longer strong enough to be used. They were reduced to pure "aesthetic" objects—a type of hybrid of *mesoma* and *tidi'uma*—with no cultural value beyond a commercial one.

Of course, as Henley and Mattéi-Muller point out, these baskets were never meant to be anything more to the Panare than trade items. Liberated from both functional demand and symbolic inhibition, the Panare were free to experiment in any way they liked. They were also encouraged to do so by the criollo dealers trading for their work:

> These dealers frequently urge the Panare to make the graphic figures of their guapawork as naturalistic and anecdotal as possible and to include as many animal figures as they can. In order to comply with this request the Panare are obliged to circumvent technical conventions. (Henley and Mattéi-Muller 1978:101)

Unfortunately, Henley and Mattéi-Muller do not investigate the motivation behind such anti-abstractionism, which also plagues the Yekuana in their commercial dealings; is it the result of aesthetic conservatism among Westerners or simply a ruse by which dealers insure the authentic "Indian-ness" of their products? "Preliterate" peoples, after all, are not supposed to think in abstractions, a fact which should be reflected in the concrete images of their art—frogs, tapir, jaguars, the jungle.[11] But such prejudices are not only self-fulfilling, they are also destructive. As already noted, the Panare acquiescence to this commercial pressure

coupled with the lack of restraints of either use or tradition produced what in a tribal society is a complete anomaly: an objet d'art devoid of any symbolic meaning or function. Ironically, Henley and Mattéi-Muller greet this development as a significant cultural triumph, claiming that through the transcendence of the "technical limitations" of plaited basketry, the Panare have "developed a more versatile medium of plastic expression than any they previously possessed" (ibid.:103). They appear to share in the view that greater representation means greater art, especially when it is done in a medium that resists anything but "angular and linear graphic forms." Convinced that the Panare attach no serious interpretation to any geometric design, Henley and Mattéi-Muller conclude that the real problem is with the form itself:

> Although the figures of the traditional Panare style of guapawork may to a limited extent be the consequence of a prior intention on the part of the artisan to represent specific phenomena and not merely *post hoc* rationalizations, the representational potential of traditional Panare guapawork is highly circumscribed by the fact that only angular and linear graphic forms are possible due to the technical limitations of the style. These forms rarely permit holistic representation. When meanings are attached to traditional Panare figures, the referents are frequently reptiles or fish, not because these classes of animal have any special significance for the Panare but rather because their body markings or body surface textures lend themselves to representation by means of angular and linear graphic forms. (1978:95–96)

While the introduction of Yekuana basketry permitted the Panare to resolve such problems of meaning and form, it did so in a way the Yekuana could never contemplate. Not only are the resulting constructions too weak to be of any utilitarian value, but in destroying the relation between technique and image they rupture the entire matrix of meaning within which the baskets function. To the Yekuana the concept of "transcending the technical limitations" is irrelevant, as the success of a work of art is in the integration of every aspect, wherein no part dominates and none is wasted. This perfect balance between content and form, technique and image, function and material, is what defines a Yekuana basket—it is the language by which it articulates its message. To disturb these relationships would be to undermine the overall meaning of the work, to create a mutant form halfway between a basket and

something else. While one might praise the single element now domi-
nant, the ability to comprehend the work as an expression of the whole
would be forever lost.

THE POETICS OF BASKETRY

As one begins to observe, the problem of understanding Yekuana bas-
ketry is the problem of understanding traditional art forms within the
framework of small, tribal societies in general. Unlike the works of
contemporary Western artists, those produced by the Yekuana are not
so easily dismissed by a formalist discussion. Although the affective
properties of shape, color, and tension are of course issues, they dimin-
ish in importance as one begins to explore the remarkable resonance
implicit in every aspect of the work. At the same time, a functionalist
approach, to which so much of "primitive art" has been reduced, cap-
tures only a fraction of the power and meaning of objects that regularly
resist classification. Commenting on this same problem, Clifford Geertz
writes that the study of these art forms must first uncover "the distinctive
sensibility" out of which they grow:

> This realization, that to study an art form is to explore a sensibil-
> ity, that such a sensibility is essentially a collective formation,
> and that the foundations of such a formation are as wide as so-
> cial existence and as deep, leads away not only from the view
> that aesthetic power is a grandiloquence for the pleasures of
> craft. It leads away also from the so-called functionalist view that
> has most often been opposed to it: that is, that works of art are
> elaborate mechanisms for defining social relationships, sustain-
> ing social rules, and strengthening social values. (1976:1478)

By extending itself into every aspect of the culture, the "primitive"
work of art succeeds in recreating it, justifying Geertz's conclusion that
"a theory of art is at the same time a theory of culture, not an autono-
mous enterprise" (ibid.:1488). Such a conclusion naturally demands
that all analyses recognize the greater dimensionality of this work.
While ignoring neither the formalist nor functionalist concerns, the
main focus must be on the "total system of symbols and meanings"
(Schneider 1976:208) that leads back to the society that produced it and
which it, in turn, reproduces. For ultimately the real question is not

what art means but *how*. In studying the Yekuana baskets this question cannot be fully answered until each of the converging symbolic systems is identified and analyzed. These include the narrative element—the stories the Yekuana tell concerning the baskets and other artifacts. Running like a subtext through each of the baskets' different features, these tales and chants provide us with the closest approximation we have of a native exegesis of these phenomena. Of course, the most striking element to be examined is that of the graphic designs woven into the surface of the baskets. Yet no less important is the technology of the baskets. Organized around the gathering, preparation, and weaving of the various basketry materials, these aspects comprise a separate, but complementary set of symbols to be studied. Finally, there is the question of the basket's use, its function in daily life, the rituals that permit it, the prohibitions that prevent it. Only when all of these elements have been considered—the narrative, graphic, technical, and functional—can the baskets be viewed in their true cultural context. Only then can one begin to recognize the same configuration of symbols constellated around such other cultural forms as the house, garden, and dress. By replicating the organization of symbols articulated in these and other forms, the baskets provide yet another expression of the Yekuana conceptualization of the universe. As such, one might say the ultimate subject matter of the baskets is culture itself. For like "all things made" (*tidi'uma*), they are intended as portraits of the society that inspired them.

5 · ORIGIN AND DESIGN

MYTHS OF THE ORIGINS OF ARTIFACTS

In writing about the nature of origin myths in tribal societies, Mircea Eliade calls attention to what he refers to as an underlying "paradisiac syndrome" (1960:63). He claims that tribal man periodically reenacts these myths in rituals and festivals in order to return (the "eternal return") to the conditions that existed at the time of the Beginning, *in illo tempore.* Characterized by a lack of division between Heaven and Earth, an unimpaired communication between animals and humans, and the absence of both death and physical want, these myths satisfy, however fleetingly, man's endless "nostalgia for Paradise, the longing to recover the Eden-like state of the Ancestor" (ibid.:45). To simply tell them allows one to participate in the eternal state of abundance they evoke. The performance of these myths provides for the sanctification of the event or object for which they are being sung. By introducing the original celestial models upon which the structures of the culture are based, man magically reenters the sacred space of creation that produced them. For Eliade, this immersion into the mythic space of the sacred is the result of a profound need to regularly regenerate Time. Unlike the linear historicity of profane time, that of the sacred mythic is cyclical, requiring annual renewal. For those who set their clocks by this cyclical Time, it is the only one worth recording; hence Eliade's conclusion that the desire for paradise, as represented by the sacred myth, is in essence a desire for the real or, as he states it, "an ontological nostalgia": "In short, through the reactualization of his myths, religious man attempts to approach the gods and to participate in *being;* the imitation of

paradigmatic divine models expresses at once his desire for sanctity and his ontological nostalgia" (1959:106).

While the Yekuana have various origin myths that conform to Eliade's "paradisiac syndrome"—such as the *Adaha ademi hidi* for the garden and the *Atta ademi hidi* for the house—they also have many others which do not. Among the latter are myths describing the origin of such objects of daily use as canoes, weapons, instruments, and baskets. Although the action described in such narratives clearly takes place in a mythic time when animals and humans could still communicate, it is far removed from the idyllic era of the Beginning. Gone now are Wanadi and the other culture heroes with whom he created the first structures. Humans, called So'to or Yekuana, are already a well-defined group, and though they still interact with other species, it is an interaction fraught with danger and hostility. Led mainly by shamans, they succeed in obtaining the objects necessary for culture by either waging war or deceiving those who already possess them. As such, the models these myths portray are not the cosmogonic ones of annual renewal, but rather the cultural ones of daily creation. As the origin myths of objects made daily, they describe the daily making of culture. The access to the sacred which they provide is not reserved for special occasions, but is translated into the everyday creation of culture itself.

Whereas the myths of Wanadi's initial deeds explain the creation of the dualities extant in the world today, the myths describing the origin of man-made artifacts attempt to resolve them. The world they take place in is already deeply divided. Humans, surrounded by the forces of negativity and darkness, are barely able to exist. Hostile tribes of bloodthirsty monsters prey upon them from all sides. To emerge from this state of vulnerability and degradation, humans must both defeat these enemies and gain control of the secret weapons that give them their power. It is not enough to merely vanquish "death," humans must incorporate it into their very being if they are to survive. This then is the message repeated in myth after myth: Culture is a medium of synthesis through which the noncultural—darkness, death, rawness, poison—is converted into it to reproduce the whole. As such, these myths of origin serve as the perfect paradigms of transformation, symbolically depicting the daily operation of culture. The action they describe is inevitably one of movement from darkness to light, from chaos to order, from cannibal to human. In some instances it is not even necessary to return to the mythic era of the First People. For example, one brief account of the

making of the first canoe describes how the Yekuana derived this skill from the Kariña or Caribs. A fierce tribe of cannibals (from whom the English word derives), these people preyed upon the Yekuana until their destruction at the hands of the Spanish at the end of the eighteenth century:

> Before they didn't know. The Yekuana didn't know how to make canoes. They learned from the Kariña. The Kariña know a lot. They really did things well. The Yekuana didn't know.
>
> When the Kariña had a twelve-meter tree, they cut ten canoes from it! They didn't throw the inside away like we do. They didn't waste it. First they carved one canoe, very carefully. Then another and another and another, until they got down to the biggest one at the bottom. The Yekuana just throw all that away and make one canoe.
>
> The first Yekuana to learn how to make canoes was a man who married a Kariña girl. One day his father-in-law sent him out to make five canoes from one tree.
>
> He didn't know how. The Yekuana didn't know how to make canoes. When the father-in-law came to see the work, there were only three canoes. He asked, "Why aren't you working? What are you doing just standing there?" And so he struck the Yekuana across the side of the head and killed him.

While this tale is a somewhat abbreviated one set within a historical context, it nevertheless conforms to the structure of metaphor underlying the origin myths of other cultural artifacts. In it the Yekuana are a defenseless group, possessing none of the skills available to other beings. Portrayed as cannibals, these other groups are able to dominate the Yekuana so long as they maintain their monopoly on the special skill attributed to them. The source of their power is equated with death, either as a weapon or a poison. In the story of the first canoe, it is the boy's contact with canoe-making that must be seen as the cause of his death. In the following myth explaining the origin of the drum (*sambuda*), the parallel between death and artifact is even more explicit:

> Before, when they didn't have it, the drum was a different shape. It was pointed and could run right through a person like a sword. The people didn't know what *sambuda* was then. They said, "They have it over there. Let's go see."

So they went to the village where they had the drum. And they asked to see it. And the chief said, "OK." But first he told them to line up in a long row, like this (indicating single-file formation).

Then he went in and got it and came up to the first one, like this. And he stuck it right in, himself. Not thrown, himself! And he ran it through all of them, the whole row. And he killed them all.

Later on, other Yekuana stole that drum. I don't know how. They stole it. That was a long time ago. Before me. . . . Before there was Simón. Before there was González (the oldest singers in the village). It was pointed . . . like a *yaribaru.*[1]

In order to create culture, as represented by the material forms that constitute it such as canoes and drums, one must be able to integrate into it the wild and untamed. As the Yekuana recognize, this demands much more than simple technical expertise. With every object possessing an invisible double of incalculable power, humans must be able to control the unseen as well as the seen when negotiating the conversion of wild objects into domestic ones. The ritual performance that accompanies every technical activity guarantees that the incorporation of this potentially dangerous new and foreign will not be disruptive. The material transformation of any object—such as tree to drum or animal to food—must be accompanied as well by a spiritual transformation realigning its symbolic structure with that of the human world into which it is being integrated. It is this humanization process, so fundamental to every material activity, that is the real subject of these myths of origin. By recounting how each object was retrieved from the forces of darkness beyond the ordered world of the *atta,* they become models for the process of transformation by which culture itself is created. The story they tell of the dangerous acquisition of forms from their nonhuman (that is, cannibal) owners is the same one reenacted daily by the Yekuana of today.

While culture may be said to represent the controlled and safe, it is nevertheless completely composed of elements that come from without. In this sense, its genius is its ability to successfully mediate between the world of nature and itself, to make whole what is fragmented and divisive. To fail in this mediation results in a form of reverse transformation by which the human is converted back into the animal. And indeed there are many stories recounting how people have been overcome by

animals, disappearing into their world forever. Often these stories of reverse transformation are the result of some broken taboo—a menstruating woman stolen by anaconda while bathing in a river, an impure hunter kidnapped by armadillo while sleeping alone in the forest (Guss 1985a:55 passim). All of these stories are dominated by the same tension that exists in the myths of the origins of artifacts—the conflict of two opposing forces, each determined to transform the other into itself. It is due to this conflict that the animals and other beings in these stories are inevitably characterized as cannibals or "people of Odosha." Referred to as *odokato* (from Odosha plus the suffix *-ato,* "people") or *chuttakomo,* "the people of the bush" (*chutta,* "bush," *komo,* "people"), these beings form a direct opposition to the world of the So'to or humans. In order for humans to continue as an organized species, however, this opposition must be synthesized daily, with "the people of the bush" regularly transfigured into usable, safe, detoxified forms.

The fact that culture depends on elements wrested from the nonhuman (Odoshankomo) for its continued reproduction has been alluded to by several scholars as a determining factor in various mythologies. Eliade claims that the central myth of many paleo-agricultural people focuses on a ritual killing from which both agriculture and the underworld developed. Referring to these sacrificed tuber gods as *demas,* he writes that "the edible plant is not given by Nature: it is a product of an assassination, because that is how it was created at the beginning of time. . . . So that the vegetable world may continue, man must kill and be killed" (1960:46). And in one of his earliest structuralist studies, Lévi-Strauss, after stating that "the basic problem in Pueblo mythology is in discovering a mediation between life and death," concludes that "death has to become integrated so that agriculture can exist" ([1955]1979:193). In both of these examples the origin myth is seen as an act of appropriation from the underworld, a means by which culture renews itself through union with the anti-cultural or Death. For the Yekuana such myths are not relegated to agriculture alone. They exist wherever cultural forms are organized to resolve the basic conflict of dualities inherent within them. Among the best examples of these myths is that of the origin of the *waja tomennato,* the "painted" *waja* baskets woven daily by the men. The following version of this myth was not narrated by a man, however, but by the eldest woman singer in the village of Parupa on the Paragua River. First told to me in 1977, the version that follows is an interlinear translation of another telling by the same singer during a visit six years later:

A long time ago
I'm going to tell a little bit about a long time ago
about how the Warishidi were a long time ago[2]
I don't know that much
but I'll try and tell anyway

A long time ago Warishidi ate many
Then Warishidi ate a So'to
There was a So'to killed
The people went out to hunt
There were two who were found
One man ran off
fleeing
He hid in an armadillo hole
Kadamaadi fled from them because he was afraid
He fled because he was afraid of Warishidi
Then that one who fled screamed for help
" T h e y ' r e b i t i n g m e "
" T h e y ' r e b i t i n g m e " (*very slowly*)
So when he screamed the other hid
He (the hidden one) was looking at the other one
Nothing
There was nothing left
They carried off the two arms
They carried the two arms up in the trees
and just sat there
Warishidi
That's the way Warishidi used to be

Now listen

The other brother Adamaadi
CALLED EVERYONE TOGETHER
They called all the people
They called every person
Ihuruña[3]
They called Ihuruña
They called all the So'to together
To avenge themselves
To avenge themselves with curare
Many people came together

Just as many as the Warishidi
Just as many Warishidi as there were
were there people together
Then each one took his place
There were as many as there are trees in the forest

It was like a huge breeze
when the Warishidi came sweeping down upon the So'to
They shot shot shot shot shot (*very softly*)
Now the Warishidi fell
They thought they would eat So'to again
That there was just one of them
Now there are none
They fell fell fell fell (*softly*)
That's how it was
like that
Now there were just a few
Now there were almost none
Now the Warishidi were completely gone
That's the way it went right up to the chief
Because they killed all the rest
They killed all the rest right up to the chief
It was the Warishidi who made the war
That's really the way it was

Now they had to kill the chief
Now they went up there
They went up there
They shot shot shot
There he was now
There he was
Now he appeared
He actually lived in Mount Ihani[4]
That's where they came from
Where they came from before
That's where they were born
That Ihani was the house where they lived
Okay Now Waña Kasuwai appeared
He was an enormous monster
with great huge *chakara*
the size of suitcases[5]

Now he hung his *kungwa* up from a branch
He hung it up there before he fell
When they shot him it was hanging up there like that
And he fell and died
Now then they were all gone those Warishidi
Those Warishidi were all gone
Because their chief was dead now too
Now there were none left
They were really through

Now they got down his *kungwa*
They took down Waña Kasuwai's *kungwa*
Then they looked to see what was inside
"What does he have in here?"
thinking about what was inside
Very small *waja*
There were miniature *waja* inside there[6]
Well they were all there
Mawadi asadi Awidi
All of them
That's the way they discovered that
That's the way all those things were found out
The So'to saw all those things there
and learned how to make them

Now then
Woroto Sakedi showed it
Woroto Sakedi did it (*very softly*)

And so if it wasn't for that
we wouldn't have all this
None of this would exist
if it wasn't for that
The people wouldn't have learned about that
if that hadn't of happened
And so they went and learned all this
If not for that
we wouldn't have had to do anything
Yes that's the way it is
Well that's what they say

You know that now there are taboos
that today there are prohibitions
Because that wasn't created by people
Odosha invented all that

A woman who has just given birth
who's just had a child
can't put cassava in the *waja*
She can't put anything in the painted ones
The *ahachito hato* the new woman
she can't put anything inside either
It's forbidden for her to put anything
inside the painted ones
That's why the *ahachito hato* don't use painted *waja*
That's what they say

Well now let's see
That's the way I remember it
the way I recall it remember hearing it
Now I don't know how it is today
Those those young ones who are out there yelling
yelling and playing out there
I don't know what those young ones will say in my place[7]
Well now it's not very long
not very long
It's really rather short
very short
But that's why Warishidi is dangerous
Because he ate people
Yes Warishidi is still dangerous
That's all I have to say
That's it
Everything

Like the monkeys in many traditions throughout the world, the Warishidi of this story are symbols of chaos and immorality. Closer to humans than any other animal, monkeys are nevertheless radically different, a fact that may account for their common opposition to the norms of culture (see Ohnuki-Tierney 1987). As has already been noted, Iarakuru, the weeping capuchin (*Cebus* sp.), is held responsible for introducing the night into the Yekuana world, thereby explaining his close associa-

tion with all that is dark (de Civrieux 1980:24). Equally identified with these negative forces is Warishidi who, belying his name of "spider monkey," is a large, muscular animal, with a prehensile tail over three feet long. In the above myth he is described as a fierce cannibal who at one time devoured humans. His chief, in addition, is closely identified with the Devil as his name, Waña Kasuwai (a variant of Kahushawa or Odosha), makes clear. In other versions of this myth, Waña Kasuwai is described as even more monstrous, enormous and hairy with blood gushing from his mouth and two huge shaman's pouches (*chakara*) slung across his chest like bandoliers. The defeat of the Warishidi, creatures of chaos and death, represents the victory of culture over nature. Yet, as already stated, it is not enough for culture to simply vanquish nature. It must also integrate it if it is to continue to reproduce itself.

As in the other myths of the origins of artifacts, the source of power of the Yekuana's enemies is not discarded after their victory, but is transformed into an essential element of their culture. The ability of the foreign and dangerous to destroy is neutralized and converted into a usable object. The memory of these objects' origins is not only recorded in myths, however. It is incorporated into the very design of the objects themselves. By simply manufacturing an artifact one repeats the message encoded in the story of its origin. The organization of its parts reiterates the same synthesis through which all of culture is created. Just as its origin myth successfully resolves the opposition between nature and culture, so too does the construction of the artifact itself. The safe integration of the wild and toxic into a harmonious whole is now restated as a compositional achievement. In the case of the "painted" *waja,* the designs woven into them memorialize not only the history of their origin but also the integrative process that that history represents.

THE DEVIL'S FACE PAINT

To any Yekuana listening to the origin myth of the "painted" *waja* it will be immediately obvious that the real power of the Warishidi lies in the *chakara* of their chief, Waña Kasuwai. As the *arache* or "master" of the spider monkeys, Waña Kasuwai is naturally assumed to be a powerful shaman who, like all shamans, conceals his secret arsenal of magic weapons in his *chakara.* Unlike the small leather pouches of today's shamans, however, these *chakara* are large telescoping baskets (*kungwa*) "the size of suitcases," a detail that can only enhance the enormity of the power that

must be stored inside. When the *kungwa* is finally opened, what is removed is far different from the contents of the *chakara* of the shamans of today, at least on first appearance. There is no *woi* or other magic herbs, no *wiriki* crystals, no leaping *modono* stones, no hallucinogens, not even any tobacco. There are only baskets. Yet upon further investigation, one learns that these baskets are as powerful a weapon as any ever contained in a shaman's pouch, and the symbols woven into them as sure a means to the supernatural.

The fact that the *waja* are discovered in a shaman's pouch is a clear indication of the dangers attached to them. While shamans are responsible for healing, the methods they employ are anything but benign. Rather than dealing with the internal symptoms of a patient, most remedies attack their external, supernatural sources. As a result, the "medicines" carried by a shaman in his *chakara* are mainly poisons and other aggressive weapons used to counteract the enemies of one's village. Such deadly techniques make the shaman an object of constant fear and suspicion, even amongst his own community. As de Civrieux notes, "to fight and to heal are the same thing" (1974b:43). When the *waja* baskets are removed from Waña Kasuwai's *chakara,* one is therefore immediately aware of the sinister properties that adhere to them. Yet the real meaning of these properties is only revealed toward the end of the story, when the narrator mysteriously whispers the name of their true source:

Now then
Woroto Sakedi showed it
Woroto Sakedi did it

Only with repeated tellings and related commentary does one discover that Woroto Sakedi is the *arache* ("master") of the "painted" *waja,* just as Waña Kasuwai is of the Warishidi and Wanadi is of the So'to. He does not merely own the baskets, he actually embodies them. The designs woven into them are the face paints with which he covers himself. Consequently, it is claimed that Waña Kasuwai obtained the baskets by copying the designs directly from Woroto Sakedi's body. Whether this was done surreptitiously or not is never made clear. What is made clear is that the baskets were created in the image of the Devil. Hence, not only does the narrator warn that "Odosha invented all that," but the very name of the baskets' origin proclaims it. "Woroto Sakedi"— which in addition to being the name of the one who "showed" the first baskets to Waña Kasuwai is also that of their principle design—literally

means "The Devil's Face Paint." While *sakedi* (or *isakedi*) means "design" or "painting," *woroto* is a Yekuana variant of the Kariña loan word *ioroko,* meaning Odosha or the Devil. The designs woven into the "painted" *waja* are therefore the actual symbols the Devil paints himself with, a social skin parallel (but opposite) to the *ayawa* worn by humans and brought by Wanadi. As such, Woroto Sakedi might also be translated as "The Mask of Death."

The identification of the baskets with the demonic forces of Odosha is reaffirmed in every story in which they appear. When Kalomera narrated their origin to the French explorer Alain Gheerbrant, the power he ascribed to them was that of Odosha himself. They did not simply signify death, they actually caused it:

> The baskets began to walk, and they entered the water after having eaten many Indians. They are the cayman alligators—you've only got to look at their skins to see that. (1954:220)

And again, in another myth, when Kuamachi and his grandfather Mahanama are seeking revenge upon the Star People for killing their women, it is with baskets that they exact it, first luring the Stars along with their chief, Wlaha (the Pleiades), into *dewaka* trees to gather fruit:

> The Stars climbed right up in the trees. They didn't wait for anyone to tell them. They just climbed up and started eating.
>
> "Okay," said Mahanama. "I'm going to weave baskets for the harvest."
>
> When they heard that, the Stars broke out laughing. They were just eating. There were lots of them. There were just two of the other ones. That's why they forgot about them. They didn't want to gather anything.
>
> "Okay," thought Kuamachi. "The food doesn't matter to me. It's only a trick to kill them."
>
> "I'm going up to gather," he said.
>
> "I'll stay down here and weave the baskets," said the grandfather.
>
> Kuamachi climbed up a tree. He picked a fruit. He dropped it down. When the fruit fell, water came out. It spread. It flooded the forest.
>
> Kuamachi thought: "Canoe." There was a canoe.
>
> "Jump, grandfather," he called. Mahanama jumped into the

canoe with his baskets. You couldn't see the earth anymore, just trees and water.

Now Mahanama stacked a pile of baskets up in the canoe. He started throwing them in the water. He threw in one. It turned into an anaconda. Another, a crocodile. Another, a cayman. Another, a piranha. Another, a stingray. The water was filled with deadly animals and Mawadi. Mahanama was weaving as fast as he could, throwing out baskets.

Those men were up above, watching. They were frightened.

Wlaha thought: "What'll we do? If we go down, the animals will eat us. We can't escape." Now he was afraid.

"What are you throwing those baskets away for?" he called to the old man. "We're up here collecting to fill them. We're working as partners."

When they heard that, the grandfather and the boy burst out laughing. That man was talking out of fear. It wasn't true. He wasn't laughing now. (de Civrieux 1980:110–11)

After the baskets devour a number of the Stars shot out of the trees by Kuamachi, Wlaha constructs a ladder and escapes with his people into the sky to become the constellations we see today. Kaumachi in turn continues his pursuit of them, only to be transformed into Venus, the Morning Star.

In both of these stories baskets serve as prototypes of the shamanic weapon. Transformed into deadly monsters, they carry out the wishes of their masters and destroy their enemies. Like any other object found in a shaman's pouch, they are capable of inflicting unlimited destruction for either good or evil. As symbols, the baskets must therefore be understood as representing the same forces of death imminent throughout the universe. What is essential is that these forces be controlled and, like the shaman's weapons, converted into instruments of life. While the rescue of the baskets from Waña Kasuwai's *kungwa* initiates this control, their weaving on a daily basis perpetuates it. It is a repetition of the same resolution of dualities enacted throughout the culture. As already stated, survival among the Yekuana depends upon the constant recognition of the potentially destructive invisible doubles that control every object. Hence, not only are elaborate rituals designed to accommodate these forces, but the entire structure of the culture is organized to acknowledge them. Reproduced now in the form of the baskets is another image of this reality.

THE DESIGNS

In the story of the baskets' origin, the Yekuana symbolically gain control over the forces of death, the animus of nature without whose integration society cannot be maintained. It is the primordial act of culture-making, whereby the wild and toxic are transformed into the recognizably safe and usable. While this event may be understood as a perfect metaphor for the daily resolution of oppositions underlying all of Yekuana life, the characterization of the natural world as a poison that must be detoxified is also based on an actual model. The danger involved in every contact with the world beyond one's village is not simply an invisible one posed by the forces of the supernatural. Physical survival in the Guiana high-lands demands that the toxic properties of nature be controlled at every level. The ritual process of detoxification required in economic activities is paralleled by an actual technological one. The three major subsistence activities—horticulture, hunting, and fishing—are all dominated by the need to control poison. In gardening, of course, we find it in the labori-ous processing of yuca which can only be converted into edible cassava by removing the deadly prussic acid from the tubers. In hunting, the importance of poison is evidenced by the prominence of its use in the form of curare.[8] In fact, although the Yekuana are said to have had no poisons prior to the capture of Waña Kasuwai's *kungwa,* it is nevertheless claimed that it was with curare that they killed both him and the Warishidi. And finally, in fishing the most popular and effective technique is that of barbasco. Referred to as *ayadi* in Yekuana, it is accomplished by releasing the beaten extracts of any of a variety of vines into a river, with the result being that the water is temporarily deprived of oxygen and the fish forced to the surface either dead or stunned.

In each of these instances, poison is an essence that can be used for either good or evil. Like the "medicines" contained in the shaman's pouch, it can either give life or take it. It is the perfect symbol of nature, a potentially deadly substance that must be controlled and integrated if man is to survive. Yet in this sense it is also a symbol of culture itself, for it is in poison that the polarities of life and death are united. Like culture, poison is an agent of transformation, synthesizing and integrat-ing in order to produce new forms. When a young girl goes through her first menstruation, for example, it is the "menstrual poison" (*munühe*) that leads to her transfiguration as a "new woman" (*ahachito hato*). And when a man is initiated as a shaman, it is the hallucinogenic poison, *kaahi* or *aiuku,* that permits him to travel to Heaven, where he is

reborn as a *huhai*. Yet in all these cases, the poison can only do so if it is controlled. If not, it will lead to death instead of rebirth. It is this same process of control which is acted out in the weaving of the baskets, with the images woven into them organized around the key symbol of poison. For just as the victory over the Warishidi represents the successful integration of the wild and toxic, so too does the daily weaving of the symbols now celebrating the event. Each design, as befits its origin in a shaman's pouch, is informed by its relation to poison, deadly when in its natural state yet life-supporting when in its cultural one.

Although speculative, it is likely that the word *kungwa,* the name of the basket the *waja* arrived in, also has its origin in one of the various terms for poison, perhaps in the Yekuana name for curare—*kumarawa*—or in the *kumwa* blowdarts used to destroy the Warishidi in order to obtain it. In any case, the *kungwa* is viewed as a "poison box," a receptacle in which objects of death are stored.[9] In some versions of the Warishidi story it is claimed that Waña Kasuwai's *kungwa* actually contained physical poisons and not merely the baskets symbolizing them. But this detail simply underlines the power of symbols and the effectiveness sustained by one's belief in them. While symbols may "stand for" other things, they are no less real. In fact, it is precisely this ability to mean so much—what Victor Turner calls "condensation"—that bestows upon them the power of life and death.

Although the *kungwa* of today are covered with any designs their manufacturer may select, there is one that remains more closely associated with them than any other. This is the *Woroto sakedi* design, named for the originator of the baskets and also known as *kungwa menudu* or

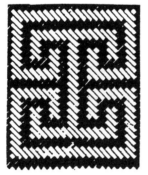

"painted" *kungwa,* suggesting that this may have been the design of the original *kungwa* (see pls. 1–8). While this is impossible to ascertain, the *Woroto sakedi* symbol is undeniably of seminal importance in determining the structure of all basket design. For not only did Woroto Sakedi "invent" all the designs, but the one named for him provides the primary form upon which the others are based. It is this symbol that is in every way the basic design of the baskets. As such, it is no surprise

Woroto sakedi, the *Odoyamo emudu* or "Devil's joints" variation (Roth 1924)

that its name, *Woroto sakedi,* "the Devil's face paint" or "the mask of death," should represent the very essence of poison and death. Encountered in several variations, the design in its most simple form is a single, boxed figure with four L-shaped corners and a line intersecting it in the middle. This isolated figure is also referred to as *Odoyamo emudu* or "Odosha's joints," a name that calls attention to both the form of the symbol and its meaning. When this figure is multiplied, the line bisecting it becomes part of a new counterimage called *tuhukato,* "with legs" (pl. 45). The line itself which runs down its middle is referred to as "its feet," *ihudu,* and is either left with a small gap in between (pls. 2 and 3) or is joined (pl. 4). In all other variations of *Woroto sakedi,* this line disappears completely. However, the number of "joints" is increased. When there is just one elbow added to each corner (pls. 5 and 6), the design is known as *Woroto sakedi ohokomo,* "the large one." And when there are two elbows added to each corner (pls. 7 and 8), it is known as *Woroto sakedi siminasa,* "the thin (or fine) one." In each instance the counterimages increase accordingly. If a third elbow is added, the whole design begins to dissolve into a spiral. It is now no longer *Woroto sakedi* but *Awidi,* the venomous coral snake (*Micrurus* sp., pls. 9–11).

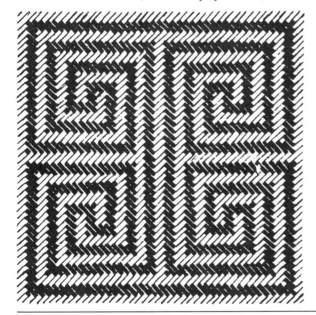

Awidi, the coral snake (courtesy *Antropológica,* 1976)

The Yekuana preoccupation with snakes is realized at almost every level of activity. From the very instant a child is born, precautions are taken to guard against what is perceived to be an ever-present, malevolent danger. As a *yechumadi* chant is sung over the newborn, *tiritoho* gourds are shaken and an herb called *aunko* is mixed with water and salt in order to bathe the baby. While this provides immediate protection against both Odosha and Wiyu (the latter attracted by the blood from the birth), a more permanent immunization against snakes is given in the form of *manyadu*. This moss-like substance is roasted into ash and, before the child is an hour old, placed in its mouth. Said to offer lifelong protection against the effects of snakebite, *manyadu*'s power is derived from the supernatural anaconda, Wiyu, herself. It is her personal *maada* that grows "like hair" on the side of a huge stone located at the bottom of a deep pool in the headwaters of the Orinoco. Guarded by Wiyu and other large snakes ("the size of drums!"), it is obtained by climbing down a long pole and, after exchanging three strands of beads, hooking it with one's little finger. But this innoculation with *manyadu* is only the first step in a never-ending vigil. Throughout one's life, herbs, paints, chants, and gourds will all be used to guard against the preeminent danger posed by snakes.

While the *Awidi* design reaffirms the deadly association with snakes already ascribed to the baskets, it is not the only one to do so. *Mawadi asadi* is also connected to the world of death and poison that snakes represent. In this case it is a supernatural one, located deep below the water where the Mawadi act as the servants of Wiyu. Like Wiyu, they are also enormous anaconda, drawn to land by the smell of blood and the desire to kidnap men and women. In fact, one might say that they are the Odoshankomo or "Odosha people" of the water, as Wiyu their mistress is the ruler (*arache*) of every spirit that inhabits water, from the rivers to the rain. Although Wiyu is perceived as a negative force, she still forms something of an opposition to Odosha, as one symbolizes water and the other earth. It is interesting to look at *Mawadi asadi* with this in mind (pls. 12–14). Literally meaning "Mawadi inside," it is one of the few abstract designs to be given a figurative interpretation. When viewing it, the Yekuana claim it represents the Mawadi "*inside* their home." Tracing the two T's that move toward the center of the image from either side of the frame, it is explained that these are the heads and bodies of the Mawadi, stuck inside their home. They then point to the long line that separates the two Mawadi from one another and state that this represents the *ñunudu,* the centerpost of the house. What was the *tuhukato* counterimage in the *Odoyamo emudu* variation of the

Woroto sakedi design now becomes the principal image of the *Mawadi asadi.* Foreground and background are suddenly shifted, and while the message clearly remains the same ("the Devil's joints"), the visual emphasis is reversed. We are now looking at the other side of Woroto Sakedi and Odosha, the one "inside" the water.

The close association of snakes with Odosha helps to explain not only the visual synonymity of these symbols (*Woroto sakedi, Awidi,* and *Mawadi asadi*), but also their interchangeability in so many accounts of the baskets' origins. Much of this identification, of course, must be attributed to natural modeling. The skins of snakes do resemble the surface of baskets. As Kalomera himself said, "You've only got to look at their skins to see that" (Gheerbrant 1954:220). Hence, when a person dreams he has completed a basket just begun, it is interpreted to mean he will be bitten by a fer-de-lance, "because," it is explained, "a basket resembles the markings of a snake" (Guss 1980c:302). This same relation has been noted among other Carib groups. In *An Introductory Study of the Arts, Crafts, and Customs of the Guiana Indians,* Roth reproduces an identical version of the *Woroto sakedi* design. After commenting that it is commonly found on the side of telescoping baskets (*kungwa*), Roth states "that certain of the Carib recognize in this pattern the famous mythical snake which originally supplied them with their vegetable charms" (1924:355–56). This snake, which he identifies as either Oruperi or Aramari, also appears among the Waiwai where, known as Uruperi, it supplies the design for the *waratapi* basket.[10] Remarkably similar to that of *Awidi,* this design has its origin in the actual marking on Uruperi's body. When a hunter succeeds in escaping from Uruperi after being trapped in his body all day, he magically retains the snake's design. In addition to gaining control of the design, the hunter learns the secret of Uruperi's power and, from then on, is able to hunt like him:

> Uruperi began to roar, and when the man heard this he ran away as fast as he could and kept on running until he fell to the ground from exhaustion. The dragon was just at his heels. It resembled a big serpent, but had hair on its body and fore and hind legs like a jaguar's. Its tail was like that of an anteater, and its whole body was covered by a kind of meander pattern, *waratapi.* When the man fell down the dragon caught up with him and began to swallow him, but he grasped hold of a tree and held on. He must have been very strong, for he held on all day, his arms and head being outside the jaws of the dragon and only his body and legs inside. Shortly before sundown the dragon gave up and

left the man. The whole of his body that had been inside the dragon was partly flayed and he was covered with the same pattern as that of the dragon. He also had lost his hair, as it was so hot inside the dragon that the air from its jaws had singed it off.

As a result of this ordeal the man died shortly afterwards but soon came to life again. He then returned to the village where he lived for some time. His skin continued to bear the *waratapi* pattern.

Some days later the man went out hunting again, and once more he ran into the dragon, but this time it changed into a man when it saw him.

The Uruperi man had a rattle that was also painted with the *waratapi* pattern. When it shook this rattle lightning came out of it, and when the rattle was shaken towards an animal it fell to the ground dead, struck by lightning. This time the Uruperi man was very kind to the man, who did not recognize him as the dragon, and demonstrated the efficiency of the rattle in the case of all kinds of animals, big and small. Finally, he gave the man the rattle saying: "Do not show this rattle to your fellow beings, but use it yourself when you meet game in the way I showed you."

The man never showed anyone the rattle, but brought home quantities of game to the village. When the people asked him how he was able to bring back so much game he merely replied: "I shot it with my bow and arrow."

However, the man died shortly after. Immediately after his death the *ekati* "double" of the Uruperi, which was invisible, came to the village and took back the rattle. (Fock 1963:91–92)

A figure striking equal terror into the hearts of the Yekuana is that of Mado, the jaguar. Fearsome enough for its own physical properties, the main danger posed by jaguars is a supernatural one. As the most common form taken by shamans to seek revenge upon their enemies, many jaguars are but projections of the shamanic double. Impossible to defend against, these

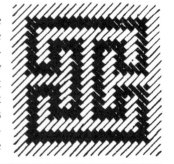

Mado fedi, "Jaguar face" (courtesy *Antropológica,* 1976)

jaguars are yet another expression of the deadly weapons contained in the shaman's pouch. Not surprisingly, the design called *Mado fedi* or "Jaguar face" (pls. 15–17) is nearly identical to that of *Woroto sakedi*. The only difference, when compared with the *Odoyamo emudu* variation, is the absence of the *ihudu* line ("its feet") appearing in the latter. Or viewed another way, *Mado fedi* is exactly like *Woroto sakedi ohokomo* with one less elbow at each corner. The fact that these designs are almost indistinguishable reinforces the close relation between jaguars and Odosha. For while all the symbols woven into the baskets represent an aspect of death, the special parallels between *Mado fedi* and *Woroto sakedi* seem to indicate the preferred form it assumes.

The ongoing conflict with Mado is one of the most popular themes in all of Yekuana lore. Along with his wife Kawau, the toad woman, Mado adopts the orphaned twin heroes, Iureke and Shikiemona. Foiling his plans to eat them, however, the boys kill their stepmother and, after stealing her fire, place her remains in a boiling pot. When Mado discovers what they have done, he goes after them to seek revenge. This begins an endless series of trickster-style adventures in which the boys routinely turn his greed and strength against him. Outsmarted in story after story, Mado becomes the object of laughter and ridicule (de Civrieux 1980:47–82). But the twin hero cycle is not the only series of tales in which Mado appears. He is also the greedy one outsmarted at Marahuaka, the one who helps the Star People kill Kuamachi's mother, the shaman's double who fights the Spaniards.

In still another story, Mado is the owner of a deadly armament called *tamu*, which the Yekuana succeed in stealing away from him. Shaped like a long hourglass with cover basketry (*wayutahüdi*) around its center, this three-foot long club is today one of the three traditional weapons of the Yekuana. The other two are the previously mentioned *yaribaru* and the *suhui*, which like the *tamu* have their origins in forces antagonistic to the Yekuana. In the case of the *yaribaru*, the elegant double-pronged spear (pl. 22), the Yekuana had to steal it from Yawade, the opossum. Although he now appears as a small and harmless animal, Yawade was at one time the chief of a fierce tribe of cannibals who terrorized not only the So'to but everyone else as well. It was only when his weapon, the *yaribaru*, was captured by the Yekuana that he was reduced to the innocent creature he is today. The third and final of the Yekuana weapons, the powerful, dagger-like *suhui* with its distinctive U-shaped head, was (and still is) the property of Karakaradi, the vulture. While the vulture, through both his color and his obvious dependence

on those who kill, is closely associated with Odosha, the Yekuana stole the *suhui* to battle not him but another, far more deadly enemy. The Mawisha, a large tribe of "human" cannibals who, the Yekuana claim, habitually preyed upon them, at one time had finally succeeded in nearly extinguishing them.[12] In order to avoid this disaster as well as avenge those already slain, a shaman goes to Heaven to search for a weapon, a magical remedy that will once and for all rid them of the Mawisha peril. The following is an account of this journey and the way in which the Yekuana obtained the *suhui.* It was narrated by a young man studying to be a singer in the village of Parupa in 1983:

> Look, before, a long time ago, the people who lived here were Mawisha . . : Mawisha, yes, they were just like us people. They weren't like Yawade, an opossum or anything. They were people. They lived all over here before. They were very bad, *koneda.* They killed people, everything.
>
> One day they came to where the Yekuana lived, around the Padamo, Kamasowoiche. This was their only village then. There was only one. And the Mawisha killed them all, every one of them.
>
> Then Karakaradi came. Later, when the bodies began to stink, Karakaradi came to eat them. They took them to where they live in Heaven, and their chief, *arache,* who is called Madiyawana . . . you know, he has a head down to here (indicating the lower rib cage on the left) and another down to here (indicating the same place on the right). He has two heads. So, Madiyawana decided to have a feast. And he called all the vultures together. He invited them.
>
> Now there was a *piache,* a shaman. He was the brother of the chief of that village who had been killed. His name was Yarakuna. He wanted to find his brother, to see him. So he drank *aiuku* for three days.[13] Then he went to Heaven. He went to where the Karakaradi live. He saw a great *kakawadi.* You know, a big heap of rotting meat there. It was the people from the village. His brother was there crying and weeping. He wanted to bring him back.
>
> Now he went back down again. And he changed his heart. That is to say, he became like a Karakaradi. He killed one and took its form, only he kept his own heart.[14] The first time he went to Kahuña, he went as a dead one, dreaming. Now he changed his heart and went back as Karakaradi, as a vulture.
>
> When he arrived to where the vultures were eating, he went

up to them. He saw his brother there weeping. He spoke to him. He told him he had come to get him.

"No. I'm dead. I can't go. I've already been changed. They've taken my heart, everything."

This brother's name was Makadiha. He was Yarakuna's younger brother. He was a *piache* too.

"No, it's not true," said his brother. "You can come with me. You'll see." And he changed his heart. He made him like a Karakaradi and fixed him all up like that.

Now they went to where Madiyawana had his house. It was an enormous village. Like Caracas . . . tremendous. And they hid there, just watching. They stayed hidden there for three days, just watching and spying, seeing how the Karakaradi lived, what they did, watching their festival. Then Yarakuna went out and asked a Karakaradi for a *suhui*. While they were there hiding, they saw that the Karakaradi had them.

"Well, okay, you have to go ask the *kahishana,* the chief." So Yarakuna went to ask Madiyawana.

"I want a *suhui* so I can go kill the Mawisha."

"Well, sure. OK. Fine," he said. And he gave him one. Because he was a vulture. He was a Karakaradi like them.

Then he got his brother and they went back down to their house. It took them four days. It's far. Karakaradi lives three days away. When they got home, Yarakuna's daughter was there. She came out. She was sad. They had been gone so long.

"Where have you been?"

"Over there. Looking," they said. Now she was happy.

Now they decided to have a festival. They invited all the Mawisha to come. Makadiha invited them. They danced the entire night. Then they ate breakfast. At dawn, the Mawisha came. They came with *maahi*.[15] There were five hundred of them. Makadiha came out of the house.

"There's not enough room inside."

Everyone was out on the big plaza there, where they had danced. Now the chief of the Mawisha came up. "Do you have a *suhui?*" he asked. He knew that he had it. He was a shaman. He could see.

"No, I don't have a *suhui,*" said the brother.

"OK. I'm going to kill you."

Then, when the Mawisha came back, that chief came up there and asked to see the *suhui.* "Where is it?"

So the brother went inside and brought it out. "Here it is," he said. And he showed it to them.

"How do you use it? How do you kill?" he asked.

And Makadiha held it up like this, just the way one does. And he said, "Like this." And he killed the chief. Then he killed all the rest too. All the Mawisha.

Then, when they started to rot, in three or so days, the Karakaradi came. OK. They took the meat. And that was the end of the Mawisha. There were no more of them after that.

Yes, the Karakaradi took the *suhui* back. But now the people knew how to make it. And they always had it after that.

As this story makes clear, the *suhui* is no normal weapon. Like both the *tamu* and *yaribaru,* it is capable of performing superhuman deeds. In some stories it actually acts upon its own while in others it passes through one enemy after another, rescuing the Yekuana from what had seemed to be certain defeat. For the Yekuana, these magical powers are directly attributed to the origin of the weapons, for each is said to manifest the secret power of the animal from whom it was taken. As such, these weapons may be seen as the perfect instruments of war, harnessing the power of nature in order to turn it back upon itself. The design called *Suhui wayutahüdi* is an elegant reaffirmation of this idea

Suhui wayutahüdi, "*suhui* handle" (courtesy *Antropológica,* 1976)

(pls. 18 and 19). As the "*suhui* handle" it symbolizes the human covering made to contain the energy inside.[16] Like all the baskets, it is a statement of the need to control the forces of nature, inside and out, to weave them into the world of culture where they will nourish instead of destroy.

These then are the principal designs of the *waja tomennato*— *Woroto sakedi, Awidi, Mawadi asadi, Mado fedi,* and *Suhui wayuta-hüdi.* They are the ones that most perfectly fulfill the meaning of the baskets, their symbolism both nominal and structural. As such, they are the designs to which elders and other knowledgeable craftsmen devote the majority of their time. Yet these are not the only *waja* that were found inside Waña Kasuwai's *kungwa.* There were others that share in the same symbolism and which, while somewhat less demanding to manufacture, provide equal entry into the baskets' overall structure of meaning. Among the most prominent of these other baskets are those incorporating figurative designs, several of which were important characters in the narrative of the *waja's* origin. Hence, one basket is called *Warishidi* and depicts the monkeys who originally owned the baskets (pl. 23). When asked to draw this design on a piece of paper, one man emphasized its connection to the myth by placing arrows in each monkey. He insisted that this was the way it had originally been woven. A basket manufactured more frequently than *Warishidi* is that of *Iarakuru* (pls. 24 and 25). Although similar to *Warishidi,* the tails of the monkeys in this basket curve down rather than up. This detail is important, as it enables the basket maker to create a perfect double-image of the monkey, a fact not only aesthetically pleasing but, as will be discussed further, structurally significant. But the inclusion of Iarakuru signifies more than the resolution of a formal problem. For in addition to his close association with Odosha, deriving from his role in bringing darkness into the world (the night let out of Wanadi's *chakara*), he is also highly toxic. All along his ribs and in his hands are poisons that make him both inedible and dangerous.

Another group of *waja* figures known for its high level of toxins is the Batrachia, the toads and frogs that are such a particular favorite of the younger basket makers. While a variety are included in the baskets, it is not always easy to establish their exact identities, other than to note that the legs of toads are always depicted as two *S*'s (one in reverse) going down (pls. 27 and 28). Among those which the Yekuana do identify with varying degrees of certainty, however, are the toads *Kawau, Kwekwe, Sinyawe,* and *Tuhudu,* and the frogs *Matadi* and *Kutto* (pls. 26–30). As already noted, the venom extracted from toads is an

Kwekwe, the toad, also known as *Wanadi finyamobödö,* "Wanadi's woman," a reference to Wanadi's wife, Kaweshawa, who assumed this form while escaping from Kurunkumo, the black curassow (courtesy *Antropológica,* 1976)

essential ingredient in the preparation of curare, the lethal hunting poison that in Yekuana is called *kuma-rawa,* the name of a toad. The Yekuana additionally use toad and frog poisons as hunting charms, rubbing them directly into cuts made along their arms. What the physical and psychological effects of the introduction of such poisons into the bloodstream may be is not entirely clear. Nevertheless, it is worth noting Peter Furst's findings that the active chemical constituents of the hallucinogenic plant *Anadenanthera peregrina* (*aiuku*) are the same found in toad and frog poisons (*Flesh of the Gods,* 1972:28).[17] Could this then be the first fire stored away in Kawau's body, the one the twin heroes stole when they killed their stepmother and fled from Jaguar's house? Whether it is or not, hunting poisons, like fire, remain an essential ingredient in the conversion of wild species into edible foods. Implicit in the toad and frog symbols, therefore, is the double meaning of the twin heroes' theft: the analogy between fire and poison and the need to dominate the forces that both represent.

A somewhat more stylized design than either the monkey or toad is that of the bat. Known as *Dede* in Yekuana, this form appears as at least four interlocking images, each revolving out in a different direction. The bodies and heads of each bat are represented as two diamonds with the wings spread out like V's engulfing them (pls. 31 and 32). It is a wonderfully simple design that easily conjures up a series of different images. In Surinam, for instance, C. H. de Goeje identified a similar form as either "swallows, bats, or dancers" (Roth 1924:361). And even among the Yekuana it is sometimes referred to not as *Dede* but as *Wasai buba,* a name which, while meaning "head of the cokerite palm (*Maximiliana regia*)," also denotes a small insect that lives off the flowers of *wasai* and yuca, as well as a sardine-sized fish often caught with barbasco. Although this design is claimed to physically resemble all three—insect, fish, and bat—it is most confidently identified with the latter. This would of course make sense, as Dede is an aerial equivalent of many other figures included in the baskets. Unlike the small creatures that rush through the rafters of a Yekuana house, this Dede is a

huge supernatural monster who sweeps down upon its prey to either suck their blood or carry them off. He is another incarnation of Odosha, as dreaded as any of his other allies. In the following tale, which also explains the origin of the name Erevato, a well-inhabited tributary of the Caura, the prototype for all *dede* is described. With little surprise, he is compared to Dimoshi, a supernatural harpy eagle who once preyed upon the Yekuana in a similar way. It was from Dimoshi's feathers and bones that *kurata,* the cane with which blowguns are made, first grew.

> You don't know that story? Dede? He was a huge bat. Ugly. With hair. Like Dimoshi. He ate people. Like this (making motion of hooked claws). He would pick them up and take them back to his house. In Dedehidi. Guaicanima.[18] We call it Dedehidi. He had a huge cave there . . . like a door.
>
> So they asked. They wanted to know, the chief, *kahishana,* "Who's killing So'to?" He wanted to find out.
>
> So he took an old lady . . . like Phillipe's mother-in-law. You know, really old. And he bound up her hands and feet, like this (showing them close together). And they put her outside there. They attached fire to her feet. They tied the coals on and left her out there. And Dede came and picked her up and flew off. OK, she's gone.
>
> Then they went out and saw the fire moving there. They followed it . . . "Ya, ya, ya, ya (pointing along the way). OK, there." Dede went back to his house.
>
> Then they all got blowguns and *kumarawa* (curare). They went up and shot him right here, in the upper part of the back. Here. And he didn't die. He was dizzy, wobbly . . . flying, circling around. Up around there, there, then there (tracing a path in the sky to the south and west). Then he fell in the Erevato. Exactly, *Dede wattä* . . . bat shit.
>
> "What's this place called?" they asked the chief there.
>
> "Dede, Dedevatto . . . Bat, Bat shit."[19]

The final designs included in the central portion of the baskets present the protagonists of the *waja*'s origin story, the So'to or humans who wrested them away from the Warishidi and now control them.[20] In addition to the sticklike figure design of the So'to (pl. 33), this group includes their master, the *So'to Arache,* Wanadi. *Wanadi motai* or "Wanadi's shoulders" depicts the white chevron found on the back of

Wanadi tonoro, the crimson-crested woodpecker (Courtesy Princeton University Press, de Schauensee and Phelps 1978)

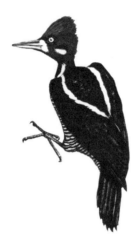

the crimson-crested woodpecker (*Campephilus melanoleucos*), the bird considered to be Wanadi's double. By joining this image to another inverted one (its double), the design assumes the form of a large *X* or cross (pls. 34–36). As will be remembered, Wanadi first took the shape of the woodpecker when escaping from Kurunkomo, the curassow who had kidnapped his wife. From that moment on, Wanadi tonoro or "Wanadi bird," as the crimson-crested woodpecker is commonly known among the Yekuana, has been the physical symbol of Wanadi on Earth. Not only does Wanadi regularly appear in this shape in myth after myth, but the actual feathers of the bird are also used for their magical powers to adorn such objects as shamans' maracas and *suhui*. As various people have acknowledged, the red-crested woodpeckers of the *Campephilus* and *Melanerpes* families are a powerful emblem of generative authority throughout the Amazon. Reichel-Dolmatoff suggests that it is the long beak and red feathers that makes these birds such a common symbol of potency (1978a:150). Whether or not one agrees with this interpretation, it is clear that this group is closely identified with the sun, the prime symbol of procreative energy, in the mythology of a number of different tribes. As de Civrieux notes, the Caribs or Kariña actually refer to the red-crowned woodpecker (*Melanerpes rubricapillus*) as Vetu, the Sun (1974a:76), a description not that far removed from the Yekuana's own conceptualization of the bird which, in the form of Wanadi, is the son of the Sun.

The significance of Wanadi's inclusion in the baskets is much more than just that of "the master of the humans." As the culture hero of the Yekuana he is also the prototype for all shamans, the supreme psychopomp gliding between worlds to unite them into one. Hence, he is not only the bearer of life but, like all shamans, the master of death. It was to demonstrate this power over death that Wanadi killed his own mother, Kumariawa, just moments after giving birth to her. As the *Watunna* states:

Wanadi wanted to give a sign, a show of his power. He did it to show us that death isn't real. . . . He killed Kumariawa as an example. He did it to bring her back to life again. He wanted to show Odosha his power. He was the master of life. His people can't die. (de Civrieux 1980:23–24)

By exposing the illusory nature of death, Wanadi establishes his ultimate power over Odosha, and as such, becomes an ineluctable member in the cast of characters included in the baskets. For if the images woven into them are all symbols of the different aspects of death, it is in Wanadi that they find their most perfect expression. As he himself proclaims, he is the conqueror of death, the one who subsumes it into his very being. After all, Odosha is a product of Wanadi, born from his own umbilical cord and placenta. By reasserting his hegemony over Odosha now, Wanadi attempts to reconstitute that original union. Or, put another way, it is the resolution of these conflicts that is at the very heart of the baskets' meaning.

The story of Wanadi's ongoing conflict with Odosha provides a subtext against which the narrative of the Warishidi can be understood. In both events, death emerges as the key opposition that must be resolved. Death here, however, is not a simple state of non-being that makes all the efforts of life absurd, but the raw energy through which being itself is created. In the world of Wanadi, as well as in that of those who live in his image, there is no non-being. There is only the eternal present, the world of the invisible double that goes on living forever, even after the material form disappears. What appears as real is only an illusion. It is the invisible forms, the things not seen without the lens of culture, that are actually real. Death, rather than being a termination of reality, is therefore an entrance into it. What is acted out in the symbolism of the baskets is the same reversal of these dualities, non-being turned into being through the mediation of culture. By appropriating the baskets from the Warishidi cannibals, the Yekuana reenact Wanadi's epic struggle against Odosha. Once again, the illusion of death is exposed, and the message reaffirmed that reality as we experience it is but a thin mask for the other eternal one that sits unseen behind it.

SHIFTING FIELDS

In both the story of Wanadi and Odosha as well as that of the baskets, death becomes much more than just the experience of non-being. It

becomes the key symbol of all that is anti-cultural. It is the profane and the natural, the wild and the chaotic, the taboo and the toxic, the exterior and the nocturnal, the temporal and the transparent, the visible and the illusory. And yet, as inimical to culture as it may appear, it is also its essential ingredient. For to have meaning, life must contain death, and it must contain it, just as the baskets do, in everything one does and is. As already noted, this synthesis extends from the most practical levels of daily subsistence and transformation to the most existential one of being and non-being. While the narrative of the baskets' origin along with the identity of the individual designs both symbolize this process of synthesis, it is in the actual structure of the images that the underlying dualities are most dramatically revealed. As Victor Turner noted in his discussion of the various forms of symbolic signification, all symbols "rest upon three foundations: the nominal, artifactual, and substantial" (1975:152). The first of these concerns the names associated with the objects, what they are called and how they are represented. The examination of the designs and origin story of the *waja* has shown all the baskets to be related to death, representing in one way or another the toxic properties of a natural world that must be absorbed. The second form of symbolic signification, the artifactual, refers to what is done with the object, how it is used in the culture. While some reference has already been made to the socioeconomic importance of the *waja,* especially as they relate to marriage and individual identity, a more complete discussion of this mode of signification is explored below. What is of immediate concern is the third of Turner's forms of symbolic signification, the substantial, which deals with the shape of the objects, their structure and form.

The symbolism incorporated into the compositional arrangement of each basket's design both amplifies and reiterates that which is signified by its origin, name, physical properties, and use. It does so in two interrelated yet distinctive ways. The first of these is through analogy, the ability to create visual metaphors the meaning of which is sustained through analogical reference to other structurally similar objects in the culture and universe. The most striking example of these structural metaphors is the *waja*'s concentric circle dualism, which replicates that of the house, garden, and dress, thus enabling the baskets to share in the same spatial symbolism found elsewhere in the culture. While the *waja*'s relation to these larger symbolic configurations is the subject of the final chapter of this work, it is important to note here that it is this analogical quality of symbols that, more than anything else, permits one

to speak of culture as a comprehensible "system of symbols and meanings" (Schneider 1976:208). The second form of substantial signification is in the affective properties inherent in each design. Through the aesthetic organization of woven elements, emotional and psychological responses are induced to reify the same symbolic constructions erected elsewhere. While rarely articulated (see Washburn 1983, Wagner 1986), it is this nonreferential visual component that provides the most profound experience of the baskets' innermost meaning. For in the quiet weaving of these images that takes place day after day, it is the hands that transmit the message directly to the eye. Hence, just like the Waiwai hunter swallowed by the Uruperi monster, the designs must first become a second skin before the basket maker can truly understand them.

Like the house, the basket is also round. When it is used, it is laid flat on the ground, a circle of hungry people around it, consuming the cassava it contains. As the meal progresses, the images start to appear from beneath the food. Yet, according to where one is sitting, each view of them will be slightly different. For unlike a Western painting that stands rectangular and upright against a wall, the *waja* has no one perspective. It is meant to be entered (like the culture) from any point, a work of art which sits inside its circle of viewers. There is no right-side-up, no correct view, no level. It is an object that is always perfectly centered. This question of perspective (or the lack of it) is an important part of the *waja*'s message. When a basket maker creates a design, it always emerges diagonally from the corner of the square, presenting an image that is implicitly ambiguous. For depending on the way in which one views the design, one or another of the elements will always dominate. But to keep all of the elements in equal focus at the same time is nearly impossible. Take, for example, the *Woroto sakedi* design (pl. 2). As one looks at it, the field of vision naturally shifts. At first one perceives the larger elements called "the Devil's joints" as dominant. But just a slight jolt will make them recede, and the "legged" *tuhukato* with the lines up the middle will suddenly emerge. And so it continues, with image and counter-image endlessly competing for the viewer's attention. This kinetic play of forms exists in all of the abstract designs with some, like *Awidi,* becoming nearly impossible to view. The problem of where and how to focus one's eyes is much more than just a game, however. It is a metaphor for the same metaphysical challenge upon which every Yekuana's life depends.[21]

In each design the Yekuana concept of the dualism of all forms is skillfully reproduced, thus enabling one to comprehend the message

conveyed through direct experience of the image itself. As already noted, the design called "Wanadi's shoulders" (pls. 34–36) does not simply depict the single chevron from a woodpecker's back, but a second interlocking reversed one as well. This mirror image, which has the effect of creating an *X,* is described as being the *akato* or invisible double of the first. Such doubling can also be seen in the images of the bat, monkey, toad, and frog, wherein is shown not only the visible, physical form of the animal but also its invisible one, which, as every Yekuana knows, is where its real power resides.[22] With the abstract designs, this simultaneous portrayal of a dual reality becomes much more complex. Here image and counter-image are also shown. Yet what is really depicted is the dynamic relation between the two. Unlike the static mirror images of the figurative designs, the kinetic structure of these forms creates an endless movement between the different elements, drawing the spectator into them.[23] Perception now becomes a challenge, with the viewer forced to decide which image is real and which an illusion. The duality signified by the conquest of the baskets is perceptually incorporated into the structure of their design. Here all oppositions in the culture are visually resolved. But it is not a static resolution. It is, like the daily life of every Yekuana, a constant interplay between the physical forms that are seen and the invisible ones that charge them.

While such interpretations of these abstract designs may seem speculative, various statements made by the Yekuana clearly support them. In speaking of the resolution of oppositions that the designs represent, the Yekuana will often use a sexual metaphor. Hence, by the creation of a pun, *tuhukato* becomes *tuwokwato,* "the one who likes to make love." A vulgar expression referring to certain males who do nothing but sleep with women, it is used here to evoke the image of a penis, the *tuhukato,* inserted into a vagina, the *Odoyamo emudu.* In so doing, the image and counterimage of the *Woroto sakedi* design (pls. 1–4) are converted into a symbol of sexual union.[24] A more direct statement of this interplay of forms woven into the baskets is found in the twin concepts commonly referred to as *adadokomo* and *akahünü.* The first of these, *adadokomo,* means either "many" or "separate parts," and is used to identify the structure of the *Woroto sakedi ohokomo* and *siminasa* designs (pls. 5–8). Tracing one's finger along the black paths of these designs a basket maker shows how the two elements of image and counterimage are inter-woven but separate. "They are apart," it is claimed, with each formal element comprising an independent unit.

Detail of a *Woroto sakedi* design with the distinctive *akahünü* structure
(Roth 1924)

Akahünü, on the other hand, is "unbroken." Literally translating as
"doesn't break in two" or "two together" (from *aka,* "two," plus *hünü,*
"unbroken, united"), this term identifies the ideal union of forms found
in the *Woroto sakedi* design with the uninterrupted *ihudu* line (pl. 4).
When one traces his finger along the black outlines of this design, there
is no break. It is a continuous flow of forms with the positive and
negative reproducing one another exactly. For the Yekuana this symbol-
izes the perfect state of unity, a harmonious integration of indivisible
forms. It is therefore significant that a social metaphor should be in-
voked when describing the differences between these two structural
concepts. *Adadokomo,* it is explained, is like criollo society, comprised
of many separate homes (*hamakari*), with each individual working for
his own economic ends. *Akahünü,* however, is like the integrated world
of the *atta,* in which every person lives and works together for the good
of the whole. It is a synonym for the highest values of community and
group solidarity or, in more abstract terms, the process of social synthe-
sis by which the many is transformed into the one.

For the basket maker who weaves these images day after day, it is
not necessary to verbalize the structural concepts of *adadokomo* or
akahünü, nor to invoke the meanings implicit in both the names of the
designs and the story of their origins. In a manner similar to the occupa-

tion of the house and the wearing of traditional dress, the meanings of the *waja* are physically and unconsciously internalized through one's repetitive use of them. Spatial symbolism does not have to be explained (though of course it can be and is), as it suffuses the entire universe it is meant to order. In a world where every moment is symbolically inspired, each practical activity becomes what Pierre Bourdieu calls a "structural exercise" informing every other (1977:91).[25] For the basket maker, who may spend several hours a day devoted to some aspect of his craft, weaving provides an ongoing meditation on the essential nature of reality. This is not to say that the weaving is carried out in an aura of silence and solemnity. It is often done while speaking with a group of elders in the center of the roundhouse or straddling a hammock with the half-finished basket on a bench below and one's family eating and talking beside it. Hence, despite its metaphysical importance, basketmaking remains an integral part of the normal flow of daily activity.

As a basket maker gets older, he devotes more and more time to weaving. The designs he chooses to make become increasingly complicated. It is rare now that he will undertake any but the most abstract designs, those enabling him to demonstrate the most skillful integration of forms. In addition to the complexity and execution of these designs, the work of these basket makers is noteworthy in other respects as well: the perfect roundness of the basket, the centering of the image, the quality of the finishing bands (the edges of which are always concealed) and, finally, the fineness of the strips themselves, the *setadi* which must be as thin and even as possible. When a basket maker reaches this plateau, he is respectfully referred to as a *towanajoni,* "the one who knows," or "the wise one."[26] To be referred to in such a way implicitly recognizes the possession of other skills, both ritual and practical. In this sense, it is similar to the Warao term *uasi,* used to designate the special basket shamans of that tribe (Wilbert 1975:5). It is also similar to the Yupa concept that only those who have completely mastered basketry are permitted to enter the afterworld:

> A soul that produces satisfactory basketry is sent by Kopecho [Mistress of the Underworld] along the path to the Land of the Dead. In contrast, the soul of the inept basket weaver is sent to a river on which there rolls a huge, hollow tree that reaches from shore to shore. The path leads directly into this log and, within it, souls of the "bad" Yupa are tumbled about, to be clawed and devoured by wild beasts.[27] (Wilbert 1974:25)

While the Yekuana *towanajoni* is not credited with possessing any shamanic skills per se, he is nevertheless, like all shamans, a master of death. His ability to dominate the symbols of poison, nature, and non-being is not simply a triumph of craft but rather a part of the total composite of skills necessary to master his environment. As has already been noted, this mastery must include control over the unseen forces or "doubles" that animate every object in the universe. Consequently, all practical activity requires that one recognize these potentially disruptive forces through the performance of obligatory rituals. Every confrontation with nature becomes a highly charged symbolic act, a sacrament in which the anti-cultural is transformed into the cultural. In this sense, culture-making is a constant dialectical process reenacted at every level of society. For there is virtually no activity—economic or ritual, material or spiritual—which does not through its structure identify and resolve these basic dualities. Through the integration of forms achieved in the baskets, the *towanajoni* announces the successful resolution of these same oppositions, whether they are defined as culture and nature, edible and toxic, being and non-being, or invisible and visible. Like the shaman or healer, he too has the power to make things whole. Yet instead of traveling into other worlds to do so, he simply weaves it with his hands. It is for this reason that the Yekuana, like the Warao and the Yupa, say that to weave is to conquer death.

6 · THE FORM OF CONTENT

The classic distinction between form and content that has come to dominate so much of the discussion of the modern work of art quickly disintegrates as one approaches the creations of those living within the framework of a traditional tribal society. The simple dichotomy between the arrangement of materials and the meaning these arrangements convey is undermined by a set of new considerations that the contemporary work of art no longer chooses to address. Dimensions long proscribed by the modernist doctrine of "art for art's sake" resurface as critical elements in the comprehension of any object made within the context of a traditional society. The most obvious of these "rediscovered" dimensions is that of function, the utilitarian or socioeconomic role that is as important an ingredient of an artifact as any other. Ironically, it is usually this element that has dominated the appreciation of "primitive" art. Thus, while Westerners may use the presence of function to discredit the validity of a work of art in their own culture, it remains the primary lens through which they examine the art of others. Unfortunately, these examinations rarely illuminate the expressive genius of a work of art but rather obscure it. Yet, in the end, the functional qualities of an aesthetic object should conform to the same structure of meaning that determines all its other aspects, and therefore possess the same power to reveal it. This is also true of the materials, which rather than forming a simple counterpoint to the intelligible manner in which they are arranged, participate in an independent but parallel system of expression.

Unlike the work of art in our own society, that of the tribal artist tends to be created in all of its parts. One does not purchase prepared materials such as canvas and paint, film or instruments; one goes out

and makes them. In this sense, there is no aspect of the work of art that does not go through some process of creative transformation. In modernist aesthetics, when an artist prepares his or her own materials the work is usually associated with craft, a somewhat pejorative term used to indicate the existence of a functional value. It is what is commonly known as "applied art" as contrasted to either "pure" or "fine art." Underlying this distinction is the notion that only an art released from the formal considerations of function can be truly individual and expressive. Yet in the tribal work of art both function and material are essential modes of expression. Each is a fully created entity constellated around its own set of symbols. The various elements in the completed work are not subordinated to one another in a hierarchy of ideas that are ultimately distilled as content, but share in the independent creation of meaning. Like the entire culture it reproduces, the work of art is the union of a multifaceted set of interlocking statements, each reinforcing and mirroring the other.

The basketry of the Yekuana provides an excellent example of such diffusion of meaning throughout a work of "primitive art." As already noted, the graphic elements in these baskets represent a highly charged and complex set of symbols. Through an analysis of their names, origins, and shapes, they have been seen to reproduce and resolve the most difficult conflicts confronting the life of every Yekuana. For those who weave and use them daily, these designs explore the very nature of reality. Yet they are not the only elements in the baskets to do so. Beliefs surrounding the gathering and preparation of materials provide a complementary set of symbols to support those communicated by the designs. In fact, the structural symmetry between these two sets is so perfect that the form and content, or at least the technical and the graphic, become virtually synonymous.

YODODAI

Like the designs, the materials too have their separate master or *arache*. Yet whereas the designs were wrested away from the Warishidi and their chief, Waña Kasuwai, to be recreated indefinitely, the materials must be secured each time a basket is made. In the case of the "painted" *waja* this process is exacting and dangerous, as the owners of the *wana* (*Guasdua latifolia*) and *eduduwa* (unidentified), the two canes from which they are woven, are a feared species of forest spirits reminiscent of the canni-

bals who once controlled the designs. Known as Yododai, these spirits move through the forest in large bands of up to forty. Invisible to all but shamans and those they wish to see them, the presence of Yododai can nevertheless be perceived by their distinctive song and smell. For as they march through the forest, planting and checking on their large stands of *wana* and *eduduwa,* they emit short cries similar to those of a wood quail. In fact, it is this song—"yo, yoda, yoda, yoda . . . yo, yoda, yoda, yoda"—which gives them their name. It is the same song as their reputed bird double, Kudokado, the wood quail (*Odontophorus* sp.), as well as the origin of the name of their chief, Hodehodeyena, a name that literally means "full of ho, ho, ho." Yet whether this is his real name is unclear, for some claim that Yododai is actually the name of the chief and Mawade the name of his people. Others, however, claim that it is Mawade who is the chief and Yododai the people. Regardless of this confusion, all Yekuana agree that it is Yododai, in one form or another, who is the owner of both *wana* and *eduduwa.*

In addition to their song, Yododai exude a particular smell, alerting hunters and others to their presence. This smell, described as especially fragrant, "like perfume or flowers," comes from the face and body paints with which the Yododai cover themselves. While Yekuana refer to these paints as "Yododai's *ayawa* or *wishu,*" they are quick to assert that they are different from those used by humans and derive from a source known only to these spirits. A hunter walking in the forest will often stop and, after cautiously sniffing the air, exclaim, "*Tahoke,* smells good. It must be Yododai." An even more powerful plant controlled by the Yododai is *awana,* their special magic herb or *maada* that every Yododai carries strapped to his hip at all times. By rubbing this herb over his arms and chest, a Yododai can instantly disappear and reappear wherever he chooses. *Awana* is also used as a weapon against humans and other species. As described by one Yekuana:

> If a human touches it, he goes crazy. He starts thinking different. He doesn't know who he is. He goes off lost, wants to live with Mawade, to be one of them. This plant [*awana*] is around here. Shamans know it. But they don't use it. It's dangerous to them too. Yododai come up to you in the forest and say, "Here, take this. Don't you want some *awana?*" And if you take it and use it, you forget who you are and go off with them, become a Mawade and marry one. You never come back.
>
> Yes, *awana* smells good too, like *wishu.*

Even for those who do not accept the *awana,* an encounter with Yododai can still be fatal. A long fever may often ensue, accompanied by headaches, nausea, and loss of appetite. If a shaman is not brought in to diagnose and remedy the situation, the patient may die. The following is a rather unusual account of such a meeting between a band of Yododai and a Yekuana:

> Well, in Santa María (Jiwitiña) there was one. He saw them there. One day his father sent him out, to the bush, upriver, to make a canoe. He took his canoe. He was going upriver there and Fuena, the tinamou, sang. And so the river rose. They have their chants those people, you know. They have one like a tinamou. It sings for them and the river always rises.
>
> So he got out and he was walking along, up into the mountains. And there was a vine there, a *bejuco.* And he tripped over it. And as he fell, he saw behind there, there was one of them following him, from behind. There was one ahead too. That one behind him had a big club. He was about to club him. But he saw him behind as he fell. And so he fired a shot and knocked him down. I don't know if he killed him.
>
> Then he ran all the way back to his canoe. There were lots of people lined up there, but they didn't touch him. He ran by them. And when he got to his canoe, there were two of them just getting into it. So he shot them too. And he got in and went back to his village.
>
> Then later, the next time he went out around there, he got this tremendous bruise, right here (rubbing the length of his left thigh). It was them. They smashed him with a club. Because of what he did to them. Then when he came back to the village, everyone asked him what had happened. But he didn't say anything.
>
> Later, he told them he had met these people out there. He told them he had shot two of them. They went out to see. And there was blood all around where he had shot them. But they weren't there. They were gone.
>
> He was sick then, when he had his side like that, for a whole week, with fever and everything. But then he got better.
>
> Later, when the sister of that man was going out to her garden, they killed her, those people. They clubbed her and killed her.

No, they didn't find the body. They took it. It was like a vengeance. Because of what that man had done to them they did that to one of his family.

No, I don't think he killed them. Those people can't die.

But most confrontations with Yododai are not the result of chance encounters in the forest. They are related to abuses perpetrated by humans against the stands of *wana* and *eduduwa* which the Yododai jealously guard. In order to cut either of these canes for use in a basket, a man must follow a prescribed course of behavior. The first thing he must do is ask a shaman (*huhai*) to visit the Yododai and gain their permission. This the shaman does with the aid of one of several hallucinogens, traveling to the Yododai's home at the top of Adeshi hidi (Mount Arawa) in the headwaters of the Caura. It is there that the Yododai are said to live much like humans, in three large *atta*. It is also the location of their "factories," where the *wana* and *eduduwa* are produced. After the shaman has received their permission, he tells the man it is safe to proceed with his plan to cut down the cane.[1] Some stands of cane, however, are never permitted to be cut. Like huge reserves, they stand virgin and untouched, too dangerous to even approach.

When the basket maker cuts down the designated cane, he must follow certain rules. If his wife has recently given birth, if she is menstruating, if a member of his family has recently died or is even sick, he cannot cut or touch it. When none of these conditions obtain and the man proceeds, he must do so with extreme care and reverence. It is even more important that he pay the Yododai for what he takes. This is done by leaving the three human face paints—*ayawa, wishu,* and *tununu*—painted on the side of a cane next to the ones he cuts. The form they are painted in is called *emamühödi,* a vertical black zigzag (*tununu*) with small red dots (*ayawa* and *wishu*) running alongside. This design, literally meaning "painted," exactly replicates that used to cover the *ñunudu* or centerpost when it is erected in a new roundhouse. Even more significant, however, is the reciprocity involved in this exchange. For in return for the materials with which to make the "Devil's face paint" (*Woroto sakedi* et al.) the Yekuana leave Wanadi's face paint.

Occasionally other payments are left as well, such as small pieces of loincloth and strands of beads. But this is mainly done by young basket makers who are cutting *wana* and *eduduwa* for the first time and are therefore more vulnerable to their dangers. If the Yododai should discover that these procedures have not been followed, that humans have

either taken their cane without permission or failed to leave the proper payment in exchange, they will search out the guilty offender and "strike" him. If a shaman does not intercede, the fever that ensues may lead to death.[2] The following statement made by a basket maker from the village of Parupa is an excellent summary of the beliefs surrounding the Yododai. In it, he uses the term *ñomo,* a synonym for the *arache* or "master" of a species.

> The *ñomo* of *wana* and *eduduwa* is crazy, *koneda,* really evil. He kills people, makes them sick. When you have a baby, you can't cut *wana* or *eduduwa.* It's dangerous. The *ñomo* will come and harm the baby, kill it, make it sick.
>
> Right now. Yesterday? I just cut *eduduwa* for the first time again. Now the baby is six months. It's OK again . . . little by little. But Carmelo, he can't touch it, can't cut anything.[3]
>
> After a month, San Pablo, OK. Trees, OK. Not for canoes though, that's different. They have their own *ñomo.* But *wana* and *eduduwa* you can't touch for six months, at least. And if you have a sick child, or you're sick, your woman's sick, or she's giving blood (menstruating), then you can't cut *wana* either. That *ñomo* comes and sees and he gets mad. He comes and makes you sick. His name? The *ñomo* of those people? Yododai. You haven't heard of him? When you go in the forest you always hear him, like a bird, "Yo, yoda, yoda, yoda, yoda . . . yo, yoda, yoda, yoda." That's the sound he makes. But he talks just like us. They live just like us those people, look just like us.
>
> They plant the *wana* and *eduduwa,* guard it. When you cut it for the first time, the very first time, like Manolo (his twelve-year-old son), you attach a little strand of beads there. You leave a *guayuco,* a loincloth attached there, and some *wishu* too. You put it on like that (making the motion of painting *wishu* stripes on a cane).
>
> Then he comes. He sees that somebody's been there. "OK, fine," he says. And he takes the necklace and *guayuco.*
>
> He's like us (motioning that he wears necklaces across his chest and beads around his arms and legs). You meet him in the forest and speak to him. He asks you where you're from, your name . . . if he doesn't like it, he makes you sick. He's bad, that *ñomo.* The *huhai,* he knows. He speaks their language. He takes *kaahi* and *aiuku* and goes to speak to him. Yododai tells him if

it's OK to cut. The shaman comes back and tells you. "OK, you can go out and cut *wana* now. Yododai says its OK."

The shaman knows. You go to him to find out. That *ñomo*'s dangerous. That's why we don't cut *wana* or *eduduwa* when the baby is still small. It's dangerous. That *wana* and *eduduwa* are bad. No, they don't have poison. But the *ñomo* does. You have to be careful.[4]

Like the Warishidi who once controlled the designs, the Yododai are formidable enemies capable of inflicting death and disease upon those who offend them. They too are identified as manifestations of Odosha, nature spirits endangering and preying upon the lives of humans. In order to integrate *wana* and *eduduwa* into safe items of cultural use, the Yododai who control them must therefore be neutralized. This mollification does not end with the simple gathering of the cane. The Yododai also watch over the way the cane is prepared and, above all, disposed of. For the part that is not used, the pith and outer shell, must be carefully bundled and returned to the forest. If these should be burned or carelessly discarded, the Yododai will inflict the same punishments imposed for the improper gathering of materials.[5] Hence, at every stage of contact with the materials, the basket maker is made aware of the invisible properties adhering to them. The beliefs surrounding the origin and use of *wana* and *eduduwa* repeat the message incorporated in the symbolism of the designs. They replicate the image of a dual reality in which every material form masks another more potent one behind it. The art that transforms these (and any other) materials into cultural artifacts must impose itself upon each of these levels of reality. In addition to cutting, dyeing, and trimming each length of *wana* and *eduduwa,* the basket maker must perform the rituals necessary to disarm the invisible spirits that control the cane. As such, the preparation of the materials becomes yet another exercise in the nature of reality. It is an event laden with meaning and thus, like every other aspect of the basketmaking process, distinguished by its own form and content.

EDODICHA

Not all materials used in the construction of baskets, however, are controlled by malevolent forces. In fact, most of them have an origin very

different from that of either *wana* or *eduduwa*. The materials used to make the yuca press (*tingkui*), the large, unpainted *waja* (*waja tingkui-hato*), the sieve (*manade*), the firefan (*wariwari*), the women's carrying basket (*wuwa*), the men's backpack (*tudi*), the fishtrap (*mudoi*), the headdress (*fwemi*), and such storage baskets as the *mahidi, dakisa,* and *cetu,* all have their own masters who, unlike the Yododai, are Kahuhana, "People of Heaven." All of these baskets were brought down to Earth by one person—Edodicha, a powerful shaman who lived in Kamasowoiche at the time of the First People. While Kuchi, the kinkajou, had already stolen the first yuca, and Wanato and his bird people had painted it, the So'to were still unable to eat it, as they lacked the basketry for its preparation. It was for this reason, to discover the technology with which to process yuca, that Edodicha decided to travel to Heaven. On his first journey he traveled to Lake Yudigina, where rather than securing basketry materials he obtained the "first food" to be eaten with cassava. This was the *motto* or worms that Edodicha now planted throughout Ihuruña. Considered the most sacred of all Yekuana food as well as the most nourishing, these long earthworms are the first meal eaten by a Yekuana child. They are also the first food that every adult consumes when ending a major life fast and that which the entire community eats when building a new roundhouse or harvesting a new garden. As symbols of new life and purity sent down to Earth by Wanadi himself, the Yekuana grant them superhuman attributes. "Worms are the best food," they say. "Pure vitamins. Better than peccary! No intestines. Pure. Pure blood. Nothing inside. Nothing thrown away. Not like other things. You eat the whole thing. Pure vitamins." With their blood-purifying qualities, *motto* are also the preferred food for the ill, as well as an important immunization against the effects of snakebite.

On his second trip to Heaven, Edodicha located the *tarade* or yuca grater. This was owned by a brother and sister named Fudumañadi and Madukwa, whom Edodicha convinced to come to Earth in order to teach the humans how to make it. Once there, Fudumañadi instructed the men in how to cut and shave the cedar planks and Madukwa the women in how to prepare and implant the hundreds of slivers of stone. Next Edodicha discovered an enormous supernatural being, shaped like a huge boulder and covered entirely with hair. Named Wasamo Wasadi, this being was the master or *arache* of *muñatta* (*Anthurium flexuosum*), the principal cane used to make women's carrying baskets. By using pieces of hair removed from Wasamo Wasadi's body, Edodicha was able to plant the first *muñatta* on Earth. He also planted

amaamada (*Hubebuia pentaphylla*), the heavy vine used to reinforce the insides of the *wuwa*. Then Edodicha returned to Heaven to get the *ka'na* (*Ischnosiphon* sp.), the itiriti cane with which men were to make their own baskets. This Edodicha obtained from several lakes, each corresponding to a particular basket and master: from Mahina or Ka'nama Lake the *ka'na* for the yuca press, from Shidimene Lake that for the *manade,* and from Mayana Lake that for the *waja tingkuihato*. Not only did Edodicha plant these on Earth but he also showed the So'to how to make these baskets. Finally, with all the other technology necessary to process yuca in place, Edodicha showed the Yekuana how to make the *fuitadi,* the enormous grill on which the cassava is baked.

According to the Yekuana, it was the designs brought down by Edodicha, particularly *Fahadifedi* or "armadillo face," which were used to make *waja* before the designs of the Warishidi were discovered. This does not mean, of course, that the techniques revealed by Edodicha were abandoned with the acquisition of the "painted" *waja*. Yet their use as plateware with which to serve cassava and other food was reduced to all but the most ritual of circumstances. Only those Yekuana involved in major life fasts marking the transition from one status to another continued to eat off baskets based on the patterns and materials introduced by Edodicha. When a person fasting uses the special monochromatic *waja* known as *Kutto shidiyu* or "frog's bottom," he or she is thereby transported back to the time of the Beginning, with all its attendant power. The symbols of purity and rebirth, of nurturance and transcendence, coalesce in each aspect of these baskets to dramatize not only the liminal condition of the faster but also the baskets' opposition to the *waja tomennato*.

FASTING

Among the Yekuana the regulation of diet is as much a symbolic act as it is an attempt to insure proper and wholesome nourishment. The numerous fasts that every individual goes through during his or her lifetime communicate information essential to the construction of an identity. These fasts also provide important communication with the supernatural forces to which the individuals undergoing them are particularly vulnerable. Some of these fasts are as short as the day-long one held by those preparing barbasco. In this instance, it is claimed that to eat anything other than warm cassava mixed in water (*tanünë*) will offend the spirit of the vine, rendering it ineffective.[6] A similar fast is held by

women preparing the alcoholic beverage known as *iarake*. If these women should eat any foods other than those that are white during the three days that the *iarake* is fermenting, the resultant brew will be "foul-smelling" and undrinkable. More specific fasts still are the ones held by those who are sick, as each disease must be treated by its own diet. In the case of snakebite, this means eating and drinking absolutely nothing; when one has a cold, it means forgoing peppers, pineapple, and mapuey, as well as staying out of the sun; when one has a fever it means not eating meat; and when one has epilepsy (*anengnë*) it means not only avoiding meat but also salt, fruit, and peppers. Different from these disease and activity-specific fasts are the much longer life-cycle ones that every Yekuana must undergo.[7] Occurring at the most critical points in an individual's life, these fasts help to dramatize the movement from one category of being to another. They also, through their uniform application of restrictions and symbols, assure that this dangerous passage is a safe and healthy one.

While there are three basic life-cycle fasts, an individual inevitably undergoes some of them more than once. Two of these fasts—that for the parents of a newborn child and that for the immediate relatives of a deceased person—are imposed as often as these conditions occur. And even the third fast, that for a young girl going through her first menstruation, while obviously occurring only once, is briefly reenacted with each subsequent menstruation. While each fast has its own set of observances and rituals, the rules surrounding the consumption of food remain remarkably fixed throughout all three. In each of them, the individual relives the first years of a Yekuana child condensed into several months. They follow the same diet an infant does, recreating the order of foods from the most simple and pure to the most complex and toxic. Hence, just like that of a newborn, their first meal is one of warm *tanünë* and worms. Then, depending on the speed with which their guides wish to introduce it, they eat small fish, such as the *matawara* and the *fbadewa*. Next come the larger fish, followed by the birds, particularly those that are white-fleshed, such as toucan and macaw. Finally, the meats are introduced, first deer and tapir and then, much later, peccary and lapa. With each new food, a special *yechumadi* chant is sung, detoxifying it as though it had never been consumed by the person before. For in the minds of the Yekuana, these fasters are as newborns who must undergo the same painstaking process of initiation. The symbolism surrounding these fasts for puberty, birth, and death therefore all emphasize the parallel between these states and that of inception.[8]

During the time an individual is undergoing a major life fast, he or she may only eat from a specially constructed fast basket. As already noted, these baskets are miniature versions of the *waja tingkuihato,* the large, monochromatic *waja* used in conjunction with the sieve in the preparation of cassava. Commonly referred to as *Kutto shidiyu* or "frog's bottom," these baskets are modeled on the first ones brought down from Heaven by Edodicha (pl. 41). As such, when a fast begins with the first meal of cassava and *motto* served on a *Kotto shidiyu* basket, it is a reenactment of the first meal ever eaten by a Yekuana, a sacrament commemorating the very birth of the culture itself. And yet, while the symbolism of this meal may draw on the strength of a paradigmatic First Meal, the power derived from the use of the *Kutto shidiyu* basket is somewhat more complex. For it is not simply what these baskets are, but just as significantly, what they are not.[9]

Among the Yekuana it is clear that immunity, insofar as it exists, is a gift of age. As people grow older, they develop resistance to the same forces that threaten the young. Not only does one's diet become less restrictive, but the general precautions taken to defend oneself are relaxed. One no longer wears the ornaments or charms of a youth, nor does he or she undergo the same prophylactic beatings during dances and ceremonies. This is not to say that elders are not vigilant. Much of the defense of the community depends upon them. Their knowledge of chants and herbs, of rituals and geography, all combine to make them an essential resource in the continual struggle against Odosha and his forces. Yet with age and its many years of ritual observance, one's own defenses are more secure.

On the other hand, the most vulnerable member of a Yekuana community is the newborn. With no resistance whatsoever, a child is threatened by every new object with which it comes into contact. It is not only the different categories of food that must be *amoichadi* or "detoxified," but each artifact the child uses: the first hammock it sleeps in, the baby sling it is carried in, the canoe it rides in, even the face paint it is covered with. Until this protective coating is in place, the child is in constant danger of being taken by Odosha or Wiyu. It is a truly "transitional being" (V. Turner 1967:95), still not "human" and yet no longer "other." Every action taken during this period of cultural gestation is therefore directed toward establishing a secure human identity, firmly differentiated from the natural world. Consequently, conditions imposed during this period are very close to those involved in the therapeutic situation. Seclusion, fasting, herbal baths, chants, taling, all are

basic ingredients to both the healing environment and the arrival of a newborn. Like the patient who is ill, the infant is threatened by unpredictable supernatural forces that must be restrained. In both instances, the individual is kept as far away as possible from these negative spirits and surrounded by symbols that provide an antidote. The therapeutic environment established attempts to maximize one's contact with an invisible world where there is no death or disease, a sacred universe existing outside the structures of our own.

Those undergoing major life fasts are in transitional states similar to those of the ill and newborn, and the language used to describe them is derived from both.[10] The young girl going through her first menstruation, for example, is simultaneously referred to as an *abachito bato* or "new person" and as *amoihe,* contaminated and polluted. The blood that makes her condition so dangerous to herself and to those around her also figures in the situation of a newborn and its parents. For it is the blood produced on both occasions that attracts Odosha and his riverine counterpart, Wiyu. To avoid exposure to the latter, neither a menstruating woman nor a new mother is permitted to either bathe in a river or draw water from it. In addition, the new mother is cautioned to sleep lightly, thereby preventing Odosha from entering her dreams to steal both her and her child. A member of the household rouses her each time she falls asleep, and a large torch of *ayawa* is kept burning at all times by the head of her hammock. As will be remembered, it was *ayawa* that was originally brought down from Heaven by Wanadi to cure his own daughter of her first menstruation. Another substance originally brought from Heaven to cure menstruation but now used by both the mother and her newborn is a fragrant watercresslike ground cover called *aunko.* Unlike the remedies brought by Wanadi, *aunko* was procured by two brothers, Makwe and Makwenadi, who were sent to Heaven to discover a cure for their menstruating sister. During their journey, they met Wiyu and asked her if she had a remedy for menstruation. Although she showed them *aunko,* she refused to let them have any. Nevertheless, the brothers were able to steal a single leaf, which they then transplanted on Earth. Known also as Wiyu *aunkucho,* "Wiyu's *aunko,*" and *medeca teto,* "for bathing young ones," this herb is no longer used to treat menstruation but to ritually bathe a mother and her newborn during the first three months after birth. In addition to cleansing them of blood and other "noxious" body fluids attractive to Wiyu and Odosha, *aunko* builds up a patina of resistance, allowing the mother and child to safely reintegrate into the community.

A further use of *aunko* that helps to tie the three life fasts together in a single web of interconnecting metaphors is its role in purifying the dead. When a Yekuana reaches Heaven his mother bathes him with the same *aunko* she used when he was born. Only then is the deceased considered sufficiently cleansed to reenter Heaven. By carrying out this ritual the full cycle of life, death, and rebirth is completed. The children who are left behind become like parents to those who have died and as such begin an appropriate fast.[11] The following story recounts the way in which the Yekuana learned how *aunko* is used in Heaven:

> When a person dies, he goes to Heaven and Wanadi asks him, "Have you come for good?" If not, he goes back down. Gets better. But if he says yes, then they take him and bathe him all over, purify and cleanse him. You know, they wash him with that same plant they wash the babies with. You've seen it. *Aunko*. All riiight! It's the *aunko* of up there. Kahuña. When the dead person comes to Heaven they wash him with it. We know that because once a person went up there live. She was alive and went up there.
>
> This woman was living with her husband. He was very sick, dying. He was in his hammock. She had to go out there. When she left, she saw her husband over there walking. Yes, he had died. He was over there, walking, going to Kahuña.
>
> So she followed him, from behind, walking after him. And he followed the path there into the *conuco*. And it became large, like a highway, beautiful. And they went to Kahuña. She behind there.
>
> When they got there, Wanadi asked, "OK, have you come for good?"
>
> "Yes."
>
> So they took him to his mother's house. That's the way they do it when you die. Like, for example, my mother and father are dead. When I go up there, they'll ask me if I've come to their house, to stay there.
>
> Then they saw the woman standing behind there like that, not knowing what to do. So they didn't say anything. She just followed her husband along to her mother-in-law's house. When they got there the mother took her son and washed him all over with *aunko*. That's right, cleaned and purified him.
>
> She saw the wife standing there and didn't know what to

do. So she took her inside the house and put her in a room. "What are we going to do with her?" they asked. The mother-in-law told her she would look for something, a way to fix it.

"Stay inside and don't go out at all," she told the girl.

The girl was there three, maybe four days. I'm not sure. You know in Kahuña the sun never goes down. It's always light, always day there.

And the mother was out, looking. So she decided to go outside into the street. She saw—you know, this is kind of funny this story—she saw an *akudi,* a capybara. And she asked him, "Where are you going?"

"Down to Earth, to eat."

"Me too!" she said. And she followed the *akudi* down. It was like a movie then, how they move very fast, the way they got there.[12] And then the light changed and they were back on Earth. The *akudi* was going down to eat there. Wanadi had sent him.

And so, that's how the girl got back. If not, she would have stayed there, if she had obeyed her mother-in-law and stayed inside. Her mother-in-law was looking for a way to keep her there. She was looking for *aunko* to bathe her with.

I can't remember the girl's name. She had one, but I can't remember it. But that's how we know about bathing with *aunko* up there, how it is when the dead arrive looking for the homes of their mothers.[13]

The Fast Baskets

Each major life fast is a response to an extreme state of vulnerability. The conditions signaling a transition from one social status to another expose an individual to dangers that routine daily precautions are no longer able to control. As Audrey Butt Colson observes among the Akawaio of neighboring Guyana, these states, similar to that of illness, represent an "imbalance" that can only be rectified by the imposition of their opposites.[14] The healing of a patient or initiate "through the use of binary oppositions" is therefore induced by the creation of what Butt Colson refers to as the "neutralizing" or "mediate state":

> Thus the mediate condition is one in which that which is inappropriate, dangerous, or in excess may be avoided, or it is that condition in which an imbalance may be counterbalanced,

mitigated or rectified by special treatment. However, it is also a condition in which an imbalance, or an intensification of certain categories, may be deliberately created, under control, for specific purposes. It is the condition requisite for the building up of energy and power for such ends as the re-charging of the hunter, the preparation of the shaman for his breach of the spirit world during trance, equipping the curare poison maker, endowing women with qualities of sweetness in the preparation of strong drinks. The mediate state, represented by the practice of *jeruma* [fasting], provides the setting for the control and manipulation of the different forms of power and energy for certain ends. Contradictory forces have sometimes to be separated, and sometimes to be combined, for creative purposes or to avoid destruction of the individual and his society. The ultimate aim is the attainment of a new synthesis or equilibrium appropriate to the circumstances. In the case of the sick this is the return to a balanced and harmonious condition which is the norm of good health. To achieve this the mediate state of *jeruma* is an essential preliminary. (1976:493–494)

In addition to the initial fasting and seclusion of the mediate state, the patient or initiate must submit to a number of treatments prescribed to correct the imbalance that has occurred. Among the Akawaio this imbalance is primarily conceptualized as an opposition between hot and cold, bitter and sweet. A fever, for example, is diagnosed as an excess of heat and must be treated with a complementary dose of cold, administered in the form of baths. Blood, on the other hand, is associated with excessive cold and, in the case of menstruation and birth, is treated by avoidance of all cool liquids and foods.[15] Poisonous bites, however, are said to be bitter, thus demanding a sweet remedy, such as sugar (ibid.: passim). While these categories do not necessarily obtain among the Yekuana, the system of thought inspiring them does. The fast situation with its accompanying period of seclusion creates a safe environment in which the individual is able to restore the harmony that has been disrupted. In the case of an initiate this may mean creating an entirely new identity. Nevertheless, the treatments administered, from herbal baths to chanted *aichudi,* are all designed to counteract the supernatural forces that threaten these individuals. As such, the basic principle underlying their effectiveness is that of opposition. Each action is performed as a counterbalance offsetting the disequilibrium that

has occurred. It is within this context of binary oppositions and restored harmonies that the role of the fast baskets must be understood.

As will be recalled, the *Kutto shidiyu* fast baskets are distinguished from the "painted" *waja* in more than design. The technique with which they are woven and the materials used also differ. Unlike the *waja tomennato,* constructed from either *wana* or *eduduwa,* the fast baskets may be woven only from *ka'na,* the sacred cane brought down from Heaven by Edodicha. By eating off baskets woven from this celestial material, a faster is brought even closer to the purifying and curative world of Wanadi. At the same time, he or she is shielded from the threatening world of Odosha, as both *wana* and *eduduwa* are canes of earthly origin, controlled by Odosha's allies, the Yododai. It is for this same reason that fathers of newborns are prohibited from even touching *wana* or *eduduwa* for at least six months after the birth of their child. In addition to the taboo against cutting and weaving these canes, it is forbidden to play them in the form of the long *wana* flutes. As may be observed, the primary mythic opposition between Wanadi and Odosha is faithfully reproduced in the selection of materials used to manufacture the baskets. Whereas those used to make the "painted" *waja* are aligned with Odosha through both their origin and master, that used in the *Kutto shidiyu* is identified with Wanadi. For those immersed in the liminal state of transition imposed by a fast, it is important that all items handled be as closely associated with the sacred world of the invisible as possible. The *ka'na* of the *Kutto shidiyu,* with its origin in Heaven, assures that all food eaten by a faster is consumed off materials that are pure, and that the contaminated and profane does not touch it.

An interesting parallel to this opposition of basketry materials is a similar belief discovered among the Warao by Johannes Wilbert. Living at the opposite end of the Orinoco with no relation to the Yekuana whatsoever, the Warao also believe that *ka'na* or itiriti is a sacred cane with supernatural properties. The material it is contrasted with, however, is neither *wana* nor *eduduwa,* but the moriche leaf-stem. In the origin story of these plants it is explained how the itiriti is "orderly and proper" while the moriche is lewd and incestuous:

> The Itiriti people began a quarrel with the Moriche Leaf-Stem people.
> "It's all your fault," said the Itiriti people. "You will always be looked down upon, because of your revolting ways of life. We are scandalized by your appalling practice of copulating in

public without any constraints. Why, your women even go
through their periods without isolating themselves from the rest
of the community."

And so it came to pass. The Itiriti people were very orderly
and proper. They observed customary rites and rules and were
well known as industrious makers of baskets. The Moriche Leaf-
Stem people, on the other hand, remained a lowly lot who
never straightened out their ways of life. (Wilbert 1975:5)

While the opposition between these plants clearly parallels that
recognized by the Yekuana, the Warao attribute an even greater power to
the itiriti. For it is through the constant handling of this material that the
Warao basket maker eventually comes into contact with the spirits who
will initiate him as a shaman. In this sense, it is the material component of
Warao basketry that forms its most charged and expressive aspect. Conse-
quently, the transmission of its most sacred knowledge (translated into
shamanic power) is not associated with the domination of certain designs
nor even with the skillful completion of different baskets, but rather with
the preparation of materials. As explained by Johannes Wilbert, this pro-
cess occurs in the following way:

The basket maker observes that his palms become whitened
with time, and he believes that eventually a small hole, visible
only to himself, will appear in each. This hole is the spiritual
emblem of the master *uasi*. It is the pithy interior of itiriti that
causes these changes. Through continuous handling of the cane,
the *uasi* is believed to be converted by the spirit of itiriti into an
itiriti shaman (*sehoro a bahanarotu*). The spirit appears in the
artisan's dream in the shape of a serpent and presents him with
a cigar and a set of tutelary spirits.

Each time the craftsman splits an itiriti stem, he feels the
pith pass by his finger. Often he also sees a tunnel coming up
from the roots that has been dug by the itiriti snake (*sehoro a
huba*). This the artisan considers symbolic of what the Itiriti
Spirit is gradually accomplishing within his arms. He is burrow-
ing a tunnel that leads from his chest, where his nascent tutelary
spirits reside, through both his arms to the (imagined) openings
in the palms of his hands. In other words, the craftsman is aware
of the fact that the Itiriti Spirit is at work in his own body, just as
the itiriti worm is tunneling through the cane. Some day the

artisan will behold the exit holes in his hands and know that his transformation from ordinary man to shamanic craftsman (*uasi a bahanarotu*) has been accomplished. (ibid.:5–6)

If Warao basketry is dominated by a single aspect, it may be due to its limited monochromatic vocabulary, one devoid of any of the geometric complexity of that of the Yekuana. Speculating on the reasons for this lack of comparable development, Wilbert suggests that this tradition may be the result of recent borrowing, perhaps from the Carib neighbors who forced the Warao into their present Delta location (personal communication).[16] In contrast to this basketry, the "painted" *waja* of the Yekuana remains a harmonious union of elements in which material, technique, design, and function all participate in a single complementary system of symbols and meanings. As a result, the elements of the fast basket which are meant to counteract them are also equal participants in the new message now being articulated. Hence, it is not only the materials that form a contrast to the *waja tomennato* but each of the other components as well. The technique used to weave the *Kutto shidiyu* basket, for example, also forms a clear opposition to that used in the manufacture of the "painted" *waja*. While both baskets are plaited, each is finished in a different way: the one using a finely woven, separately attached band (*chahiyü*) and the other a crude, self-selvage technique improvised from the basket's own body. Although this difference may appear subtle, it nevertheless clearly defines the origin of each form. Finishing bands or *chahiyü* represent a technique adopted from the Warishidi and are therefore as dangerous to a faster as the materials *ka'na* and *eduduwa*. The self-selvage technique, on the other hand, was introduced to the humans by Edodicha. Not only does it have its origins in Heaven, but it is also the "original" basketry technique, preceding that learned later from the Warishidi. As a result, the basket using this technique guarantees the safety of all who use it, while at the same time providing an anamnesis, a memory of what went before.

But the most dramatic opposition between the fast baskets and the "painted" *waja* is neither the materials nor the technique. It is the designs (or absence of them) with which the two are woven. As the name *waja tomennato* makes clear, this basket is a "painted" one, with black and white elements contrasting with one another to create a variety of well-defined theriomorphic and geometric images. Even more significant, however, is the origin of these images, as they are said to derive from the face and body paints worn by the devil in his incarna-

tion as Woroto Sakedi. It is therefore little surprise that those in the vulnerable condition of fasting should be prohibited from coming into contact with designs of such an explosively negative origin. As the creation story of the *waja* itself explains:

> Now there are taboos
> Today there are prohibitions
> Because that wasn't created by people
> Odosha invented all that
>
> A woman who has just given birth
> who's just had a child
> can't put cassava in the *waja*
> She can't put anything in the painted ones
> The *ahachito hato* the new woman
> she can't put anything inside either
> It's forbidden for her to put anything
> inside the painted ones
> That's why the *ahachito hato* don't use painted *waja*
> That's what they say

In contrast to the "painted" *waja,* the *Kutto shidiyu* is monochromatic, with the few designs woven into it a subtle play of interlocking squares and alternating lines. The opposition it creates is similar to that noted by Victor Turner between the non-ritual state of *societas* and the anti-structural ones of the liminal (1967:93 passim). As representative of the former condition, the "painted" *waja* are well-defined, abstract, hierarchical images of everyday life. The fast baskets, on the other hand, with their simple purity, reflect the more concrete (if less visible), status-free world of the sacred. Such distinctions are not irrelevant to the Yekuana's own interpretation of this basketry. For if the *waja tomennato* may be said to represent the face paint of Odosha, then the *Kutto shidiyu* surely represents that of his opponent, Wanadi. It is the antidote to the Devil's face paint, which as every Yekuana knows, is *ayawa.*

The condition of the faster is one that has either been caused by Odosha or is severely threatened by him. As will be recalled, menstruation, one of the three fast states, was the result of Odosha forcing Wanadi's children to commit incest. In order to cure his daughter, Wanadi brought the first *ayawa* down to Earth. It is this same *ayawa*

that is used today to cover the newborn and its parents before they emerge from the roundhouse for the *Sichu hiyacadi* ceremony. And while *ayawa* is not used to treat the dead, a condition invariably ascribed to Odosha, another menstruation cure, *aunko,* is. In each instance, the initiate or afflicted is covered with a substance of divine origin, providing a new layer of defense against those forces determined to destroy them. *Ayawa,* with its origin in the invisible, is also its symbol. Literally meaning "light," which it is also used to produce, *ayawa* is the face paint worn by Wanadi himself. In his incarnation as Wanadi tonoro, the crimson-crested woodpecker, his entire head is covered with red feathers, identical to *ayawa* mixed with *wishu.*[17] The faster covering him- or herself with this material therefore joins with Wanadi in the same primordial struggle against Odosha. Bathed in the curative substances of the invisible, they become one with it. For *ayawa* is not merely a physical light used to illuminate the night, but also a spiritual one, dispelling the darkness of chaos, incest, and disorder.

The opposition between the fast baskets and the *waja tomennato* reproduces, in a highly visual form, the identical conflict between Wanadi and Odosha. Whereas the "painted" *waja* reflect the dangers presented by the devil and his forces, the fast baskets represent a counterbalance or solution. As such, the contrast between them mirrors that between the two antagonists. Like Odosha, the designs modeled on his face paint are dedicated to the illusion of form. Abstract and dualistic, the formal resolutions they achieve are all of this world. The fast baskets, on the other hand, resonate with the presence of the invisible. As reflections of Wanadi's face paint they are imageless. Like *ayawa* itself, the power of these baskets is in their essence and not their form. This concept has sometimes been difficult for ethnographers to understand. One recalls in particular Lévi-Strauss's frustration at being unable to decode the meaning of the Caduveo's elaborate facial designs (1977:93 passim).[18] Yet, like the Yekuana's, they may have been of such secondary importance as to remain unclassified. For among the Yekuana, facepainting is a question of essence, never to be confused with form. It is the power within the material itself and not the manner in which it is applied that gives a face paint (be it *ayawa, wishu,* or *tununu*) its strength. A good illustration of this is in the painting of the new centerpost. As previously stated, these drawings, composed of several long zigzag lines with dots running alongside, are simply identified as *emamühödi* or "painted." In referring to them as such, the Yekuana make unequivocally clear that what is important is the paint itself and

not the graphic design. If this should seem contradictory, one must remember that when the message is invisibility it is enough to simply be covered.

In the *Kutto shidiyu* baskets it is the same qualities of *ayawa* which are important. The formless images evoked in them provide the faster with the same magical access to the healing world of the invisible as do the face paints. The opposition they create with the *waja tomennato* is a therapeutic one, similar to that noted by Butt Colson. It is an acting out in symbolic form of the crisis that the patient or initiate is going through. In substituting fast baskets for "painted" *waja,* one removes all images of contamination and impurity and replaces them with those of wholeness and well-being. The faster is immersed in an environment where every aspect is designed to maximize his or her contact with the restorative energy of the infinite. As such, every element of the fast basket—material, technique, design, and function—must be coordinated to communicate the same message. And so, just like the baskets they are meant to oppose, these too achieve a unity of expression echoed in all of its parts.

WEED OUT MAWADI: THE *TINGKUI YECHAMATOJO*

One may ask why, given their origin in Odosha, the *waja tomennato* should be used by the Yekuana at all. After all, if the fast basket is pure and sacred with its origins in Heaven, why not use it exclusively? But the answer to this question is revealed in the baskets themselves. For if the society is to continue reproducing itself, the profane and contaminated must be converted on a daily basis into the safe and cultured. As such, the story of the origin of the designs recounts how the images of Odosha were transformed into those of practical, everyday use. Of course, in some instances, personal crises demand that special therapeutic conditions be invoked and that the objects of daily life be replaced with those of the sacred or supernatural. Even in these circumstances, however, certain dangers are recognized and the appropriate precautions taken. For no object, no matter what its origin, is ever integrated into the Yekuana world without first being purified by the corresponding chant.

In the case of the large, communally constructed house and garden, these chants are performed by the community at large. Referred to as *ademi,* they may take anywhere from two to three days to perform

and are the occasion of great collective drinking and dancing. Yet as the Yekuana point out, their main function is to "detoxify" (*amoichadi*) the new materials or areas to be occupied and used. The reason they take so long is because "each post, each piece of thatch, each vine, everything, has to be *amoichadi*," or as one Yekuana phrased it, "vaccinated." Chants used to purify objects of individual use, on the other hand, are performed in much shorter, private rituals. Called *aichudi,* these chants are invoked to cleanse everything from weapons and canoes to baby slings and hammocks. For again, regardless of the origin of the new object, it must be properly sung over before it can be safely integrated into the community.

Of all the *aichudi,* the most common are those used to "detoxify" a new food being ingested for the first time. Whether it is for a small child or a person undergoing a major life fast, each new species of food consumed must first be purified with the appropriate *aichudi.* To do so, a small sample of the food in question is taken to an *aichuriaha* or ritual specialist, who folds it inside a single piece of cassava. Next he takes a short vine and wraps it tightly around the bundle, leaving just enough to form a short handle.[19] Retiring to the privacy of his hammock or a low bench set off from the house, the *aichuriaha* now performs the appropriate chant with the small packet dangling between his fingers. With each few phrases, he stops to let out several short puffs of air, sending the words deep into the invisible world they are meant to influence. When the chant is completed, the bundle is sent back to the person for whom the ceremony has been conducted. As a symbol of the entire species being purified, it is now ready to be eaten.

While there are as many food-related *aichudi* as there are foods, they are all variations of the long *Tunumä yechamatojo,* the "food" or "game chant." Invoking the same spirits and powers, each *aichudi* is slightly altered to accomodate the particular species at hand. Another category of *aichudi* organized around a single class of objects is that used to purify woven goods. Referred to as the *Tingkui yechamatojo* or "*Sebucan* chant," this *aichudi* must be sung over each woven item—regardless of materials, technique, function, or design—before it can be used. If not, the consequences may be even more severe than those for failing to detoxify a newly ingested species of food. For while the failure to sing a *Tunumä yechamatojo* is said to result in a bad stomachache, the penalty for improperly cleansing a new basket is often death. It is caused by an invisible being inhabiting the basketry materials which, unless removed, contaminates any food coming into contact with the

basket. Called "mawadi," these beings are conceptualized as microscopic worms which, once inside a human's body, continue to grow until the individual dies.[20] As described by one Yekuana: "You eat meat, fish. You don't eat anything. It eats it. You grow and grow. It kills you. You don't eat. It does."

The first human stricken with mawadi was actually Edodicha who, unbeknownst to him, had all the canes he brought from Heaven impregnated by Odosha. It is for this reason that *ka'na, muñatta,* and *amaamada*—all of heavenly origin—must be as carefully detoxified as *wana* and *eduduwa,* the canes of the Yododai. But it is not only as materials that they are purified. It is as woven goods as well. Hence, when *wana* is used in a "painted" *waja,* it is cleansed with the *Tingkui yechamatojo.* But when it is used in the form of a flute, it is cured with another chant.

According to the Yekuana, the *Tingkui yechamatojo* was discovered by Edodicha in order to save his own life. On the verge of death due to mawadi, Edodicha created the chant and then passed it along to other humans to use thereafter. With its main purpose being the destruction of all mawadi, the chant's recurrent refrain is, not surprisingly, *wani mawadi chaye,* "clean" or "weed out the mawadi." The spirits invoked to do so are a powerful group of *wiriki* people, formerly of the Earth but now living in Heaven. The same figures called upon in the *Tunumä yechamatojo,* this group represents the greatest condensation of purity and energy known to man. They are the actual incarnations of the shaman's crystals, the same which Shi, the Sun, used to create Wanadi and the First People. As such, they are symbolized by the uncontaminated white feces they leave behind. Called *kananasi,* this pure, limelike feces is said to be proof of the absence of any toxins whatsoever. It also explains why these beings are the ideal custodians of all new foods and food-processing implements:

> They never get sick. They eat well. They're healthy. You can tell.
> You see the white feces of the birds, not all of them, just the
> ones that eat pure, that don't eat just anything. The heron, the
> cormorant, they eat fish. But the vulture, it eats rotting things.
> Also the hawk. Their feces is not like that of any animal. It's
> pure. Solid. White. You see it there on the rocks. That's the way
> the feces of these people is. That's why they're so healthy. That's
> how you know. *Kananasi,* the white feces.

In the *Tingkui yechamatojo,* each *wiriki* person is invoked, along with his *kananasi.* They are told to "enter in" to the basket, the food, and the chant itself. "Teñeku *kananasiyu enasiyu wakudawasiyu akane,*" sings the *aichuriaha.* "Teñeku with *kananasi.* Add that in too. Be just as clean as that." As a counterforce capable of destroying the malevolent mawadi, the *wiriki* people and their *kananasi* operate much like the *ayawa* and the fast baskets. Their effectiveness depends upon the same resolution of oppositions that pits Wanadi against Odosha and Edodicha against the Yododai or, alternatively, the high against the low and the sacred against the profane. Hence, in insuring the safe integration of all new baskets, the *Tingkui yechamatojo* counteracts the dangers of the unfamiliar and natural by reproducing the same structure of meaning articulated elsewhere.

While the words of the *Tingkui yechamatojo* remain the same, each performance is subject to a certain amount of variation, depending on the basket being purified. In some instances the basket, after being washed, is filled with the materials it will be used for. A *waja tomennato,* for example, will be completely covered with a large loaf of cassava, a *sebucan* stuffed with grated yuca, a *wuwa* filled with raw tubers, a *manade* heaped with flour. Yet in other cases the *aichuriaha* finds it more effective to simply pour boiling water over the baskets as he or she chants. As succinctly explained by one singer, "This definitely kills the mawadi." Regardless of how the basket is prepared, the chant is regularly interrupted by short bursts of breath, a taling technique that speeds the words to their target, the invisible yet deadly mawadi.

The following *Tingkui yechamatojo* was recorded from an elderly woman in the village of Parupa in February 1984. The translation follows as closely as possible the structure of the original, with particular respect paid to the non-translatable vocables. As will be noted, the *aichudi* is an interweave of short narrative fragments with longer, repetitive incantations.

Weed out mawadi he[21]
Weed out mawadi he
Weed out mawadi he
Weed out mawadi he

Edodicha made it
Edodicha made it
Made it for us

Weed out mawadi he
Weed out mawadi he
hmmm eee
eee

In Heaven it was made
With mawadi inside

Weed out mawadi he
Weed out mawadi he
In Ka'nama Lake
it was made
In Mayana Lake[22]
Weed out mawadi he

Edodicha made it
Weed out mawadi he
Yehe yeta ye hmm
yee e

Don't hurt
the young ones
Weed out mawadi he
Weed out mawadi he

From Heaven
it was brought
Edodicha brought it down
Edodicha made it happen
Weed out mawadi he
Weed out mawadi he

Teñeku with *kananasi*[23]
Add that in too
Be just as clean as that
Weed out mawadi he
Weed out mawadi he

Teñeku with *kananasi*
Add that too
Be just as clean as that
Weed out mawadi he

Don't hurt
the young ones
Don't let mawadi grow
Weed out mawadi he
Weed out mawadi he

Kananasiwedu with *kananasi*[24]
Add that too
Be just as clean as that
Weed out mawadi he
Weed out mawadi he
Ahe yahi yahe'che
he hmm

Weed out mawadi he
Men made it
Weed out mawadi he
Weed out mawadi he
Made *yaweku*[25]
Made *yaweku*

Weed out mawadi he
Weed out mawadi he
Weed out mawadi he
eee

Made *wayuweyoingma*
Weed out mawadi he
Weed out mawadi he
e yehe yeche he hmm
e yehe yeche he hmm

Weed out mawadi he
Weed out mawadi he
e yehe yeche he hmm
Wove *kasidima*

Weed out mawadi he
Weed out mawadi he
That mawadi inside
So the food feeds
the young ones
Weed out mawadi he

Weed out mawadi he
Weed out mawadi he
Teñeku with *kananasi*
Add that too
Be just as clean as that

Weed out mawadi he
e yehe he he he
Weed out mawadi he
Weed out mawadi he
Weed out mawadi he

e yehe he he hmm
e yehe yeta he hmm
e yehe yeta he hmm

Weed out mawadi he
That mawadi inside
Weed out mawadi he
Don't let mawadi grow
inside the young ones

Weed out mawadi he
Weed out mawadi he
e yehe yeche he hmm
Weed out mawadi he
mm hmm hmm mm hmm hmm

Tamenamasi with *kananasi*[26]
Add that too
Be just as clean as that
Weed out mawadi he

Kahuyawasi[27]
Add that too
Be just as clean as that
Weed out mawadi he
Weed out mawadi he

Kahuyawasi
Add that too
Be just as clean as that

Weed out mawadi he
Weed out mawadi he
that mawadi inside
Men made it
Weed out mawadi he
Weed out mawadi he

Kahukawasi[28]
Add that too
Be just as clean as that
Weed out mawadi he
That mawadi inside
Weed out mawadi he
Weed out mawadi he

Don't let mawadi grow
inside the young ones
Weed out mawadi he
Men made it
Weed out mawadi he
Men wove it
Weed out mawadi he

Weed out mawadi he
e yehe he he he
e yehe he he he
Weed out mawadi he
Weed out mawadi he

Sewi with that crystal[29]
Make it just as clear as that
Weed out mawadi he
Sewi with that crystal
Make it just as clear as that
Weed out mawadi he

Wawi with that crystal
Make it just as clear as that
Weed out mawadi he
e yehe yeta he he
e yehe yeta he he

Crystal People
with their crystals
Make it just as clear as that

Weed out mawadi he
Weed out mawadi he
e yehe yeta he hmm
Weed out mawadi he
Weed out mawadi he
e yehe yeta he hmm
e yehe yeta he hmm

Fatakoingma with that crystal
with *kananasi* inside[30]
Weed out mawadi he
That mawadi inside
Don't let mawadi grow
inside the young ones
Weed out mawadi he
Don't let mawadi grow
inside the men
Don't let mawadi grow
inside the women

Weed out mawadi he
Weed out mawadi he
e yehe yeta he hmm
e yehe yeta he hmm

Weed out mawadi he
Inside the gourd[31]
Inside the head
Weed out mawadi he
Weed out mawadi he
e yehe yeche he he

Men made it
Men made it with their hands
Weed out mawadi he
Weed out mawadi he
e yehe yeta he he

Weed out mawadi he
Weed out mawadi he
e yehe yeta he hmm
e yehe yeta he he

Weed out mawadi he
Weed out mawadi he
Don't let the Snake People[32]
Don't let the Snake People
plug up the mouth
Unplug it quick

Men made it
Weed out mawadi he
Weed out mawadi he
e yehe yeta he he

Young ones
Young ones
Don't plug up their mouths
Unplug them quick
Unplug them quick
ahi yehe yeta he hmm
ahi yehe yeta he he
Unplug them quick
with *kuwaha*[33]

Men made it
with mawadi in it
Weed out mawadi he
Weed out mawadi he
a yehe yeta he he
a yehe yeta he he

Weed out mawadi he
Weed out mawadi he
Weed out mawadi he
e yehe yeta he hmm

Kawütawa with *kananasi*[34]
Add that too
Be just as clean as that

Weed out mawadi he
Weed out mawadi he
e yehe yeta he he

Kakuyawa with *kananasi*[35]
Add that too
Be just as clean as that
Weed out mawadi he
Weed out mawadi he

Don't let mawadi grow
Inside the young ones
Weed out mawadi he
e yehe yeta he he
e yehe yeta he he

Kakuyawa with *kananasi*
Add that too
Be just as clean as that
Weed out mawadi he
Weed out mawadi he

Don't let the food
give the young ones stomachaches
Weed out mawadi he
Weed out mawadi he
ahi yehe yeta he he

Edakiyuwa with *kananasi*
Add that too
Be just as clean as that
Weed out mawadi he
Weed out mawadi he
e yahü yeta he hmm
e yahü yeta he hmm
e yahü yeta he ho

Iyaduwo with *kananasi*
Add that too
Be just as clean as that
Weed out mawadi he

Men made it
Weed out mawadi he
Men made it with their hands
Weed out mawadi he
e yehe yeta he ho

Iyaduwo with *kananasi*
Add that too
Be just as clean as that
Weed out mawadi he
Don't hurt
the young ones
Weed out mawadi he

Dohütowa with *kananasi*[36]
Add that too
Be just as clean as that
Weed out mawadi he
ahi yehe yeta he ho
e yehe yeta he hmm

Don't hurt
the young ones
e yehe yeche he he
Weed out mawadi he
Weed out mawadi he

Don't let mawadi grow
inside our brothers
Don't let mawadi grow
inside our men
Don't let mawadi grow
inside our children
Don't let mawadi grow
inside our women
Weed out mawadi he
Don't let mawadi grow
inside our spouses
Weed out mawadi he
Weed out mawadi he

Edodicha made it
Weed out mawadi he
Weed out mawadi he
ahi yehe yeche he ho
ahi yehe yeche he ho

Weed out mawadi he
Wajaniyuwa's *waja*[37]
he made
Weed out mawadi he
Wajaniyuwa's *waja*
Weed out mawadi he
Weed out mawadi he

Men made it
Weed out mawadi he
Weed out mawadi he
e yehe yeta he he
e yehe yeta he ho

Weed out mawadi he
Weed out mawadi he
Yanadewa's *manade*
Weed out mawadi he
Yanadewa's *manade*
Weed out mawadi he
Weed out mawadi he
e yehe yeta he ho

Don't hurt
the young ones
Don't let mawadi get inside
Weed out mawadi he
Weed out mawadi he
e yehe yeta he he
Weed out mawadi he
e yehe yeta he ho

Weed out mawadi he
Women made it[38]
Weed out mawadi he
Weed out mawadi he

the woven thing hanging down their back
Weed out mawadi he
Weed out mawadi he
Women made it
Weed out mawadi he
Weed out mawadi he
Made it with Wasamo Wasadi
Weed out mawadi he
Weed out mawadi he
That mawadi inside
Weed out mawadi he
e yehe yeta he he

Don't let mawadi grow
inside the young ones
Weed out mawadi he

Women made it
Made it with *wasamé*
Weed out mawadi he
Weed out mawadi he
Made it with *yowada*
Weed out mawadi he
Made it with *yowada*
Weed out mawadi he
Weed out mawadi he
That mawadi inside
Weed out mawadi he
Women made it
The woven thing hanging down their back
Weed out mawadi he
Weed out mawadi he
That mawadi inside
e yehe yeche he he
e yehe yeche he he

Made it with *yowada*
Weed out mawadi he
Weed out mawadi he
e yehe yeta he he
e yehe yeta he he
e yehe yeta he he

Women made it
Made it with Wasamo Wasadi
Weed out mawadi he
Weed out mawadi he

Teñeku with *kananasi*
Weed out mawadi he
e yehe yeche he he
e yehe yeche he he
e yehe yeche he ho

Made it with *yowada*
Weed out mawadi he
Weed out mawadi he
That mawadi inside
Weed out mawadi he
Weed out mawadi he
Made it with Wasamo Wasadi
Weed out mawadi he

Teñeku with *kananasi*
Weed out mawadi he
Weed out mawadi he
e yehe yeta he he
e yehe yeta he ho

Don't let the Snake People
plug up the mouth
Unplug it quick
with *kuwaba*
Unplug it quick

Women made it
Weed out mawadi he
e yehe yeche he he
e yehe yeche he ho
Weed out mawadi he
Weed out mawadi he
That mawadi inside
e yehe yeche he he
Weed out mawadi he
The woven thing hanging down their back

Weed out mawadi he
Weed out mawadi he
Women made it
Weed out mawadi he
That mawadi inside
Weed out mawadi he

With the completion of the *Tingkui yechamatojo,* the basket is finally ready to be used. Like the origin myth of the designs, this ritual also converts the natural and dangerous into the cultured and safe. The removal of the mawadi through the intercession of the *wiriki* people reenacts the same conquest of the "other" as that over the Warishidi and Yododai. By integrating the finished baskets into the same order of symbols, the *Tingkui yechamatojo* completes the cycle of creation initiated in both the preparation of the materials and the weaving of the designs. In each instance, the natural and chaotic, both associated with Odosha, are transformed into a recognizable human configuration. As already noted, this humanizing process, which can be defined as the actual creation of culture, can only occur through the effective mediation of the supernatural. At every level of the basketmaking process, the individual is forced to confront and resolve the major conflict that defines his world. The need to transform nature into culture, to organize reality into a comprehensible structure of meaning, is translated into the symbols of opposition that are successfully incorporated into each aspect of the basket. Hence, as a paradigm for the process of cultural creation, the basket remains, like culture itself, a work of art created in all of its parts.

7 · TO WEAVE THE WORLD

Through the magic of a world of objects which is the product of the application of the same schemes to the most diverse domains, a world in which each thing speaks metaphorically of all the others, each practice comes to be invested with an objective meaning, a meaning with which practices—and particularly rites—have to reckon at all times, whether to evoke or revoke it. The construction of the world of objects is clearly not the sovereign operation of consciousness which the neo-Kantian tradition conceives of; the mental structures which construct the world of objects are constructed in the practice of a world of objects constructed according to the same structures. The mind born of the world of objects does not rise as a subjectivity confronting an objectivity: the objective universe is made up of objects which are the product of objectifying operations structured according to the very structures which the mind applies to it. The mind is a metaphor of the world of objects which is itself but an endless circle of mutually reflecting metaphors.

— Pierre Bourdieu,
Outline of a Theory of Practice

When a Yekuana weaves or uses a basket, the range of meanings evoked is constellated in much more than the choice of design, the preparation of the materials, or the use to which it is put. The configuration of symbols that are elaborated draw their power from not only their own explication but, more importantly, from the larger cultural order to which they refer. In each instance, the symbols reproduce the same organization of reality that structures every other aspect of the society. Hence, just as the basketry symbols are informed by the larger cultural patterns to which they refer, so too are these larger cultural patterns informed by them. It is a process of mutual reflexivity in which meaning is continually being created from a shared context of forms. In order to

understand how symbols actually operate, therefore, one must identify the underlying key that unites the entire system of metaphors.

As already discussed, each aspect of the baskets—design, material, technique, and function—recapitulates the messages incorporated in the others. Through their own vocabulary of symbols, they explore the terrain of Yekuana consciousness, mapping a world of conflicting dualities that culture alone is empowered to resolve. Each defines an identical space, wherein visible realities must be penetrated in order to contact the unseen ones that control them. Only in this way can the forces of nature be transformed into the necessary objects of cultural use. Hence, just as the conquest of the Warishidi is memorialized in the structure of the designs, so too does the preparation of the materials convert another, unseen reality (the Yododai) into a safe, usable form. It is this same process of transformation which is acted out when the fast basket is substituted for the "painted" *waja* to facilitate the reintegration of a "contaminated" (*amoihe*) or liminal person. In each instance, a synthesis is achieved which brings the foreign and toxic into harmony with not only the other elements of the basket but also with the over-arching structure of the entire culture. It is the primary act of humaniza-tion by which the chaotic and natural, whether external or subcon-scious, is organized into a pervasive, comprehensible pattern of reality or, as David Schneider calls it, a "culturalogic" (1976:219).

While it has been shown how the various symbolic elements of the baskets reflect the ethos and values that permeate all of Yekuana society, it remains to be demonstrated how these elements conform to the actual structures by which these systems of thought are integrated else-where in the culture. For the ability of these symbols to evoke and organize depends on a multireferentiality which, although seldom ver-balized, extends to every configuration of cultural expression. As such, meaning results from a layering of experience wherein every action recapitulates the whole yet is only explained by the accumulation of all the parts. One example of this interconnecting web of metaphors is the relation between the baskets and the house. As already noted, the roundhouse or *atta* is the expression par excellence of the Yekuana conceptualization of the universe. Each architectural element corre-sponds to a different aspect of the cosmos, creating a unified vision of the world or, as Victor Turner stated it in another context, "the symbolic template of the whole system of beliefs and values" (1967:108). It is a structure repeated in myriad forms throughout the culture, in each instance enhancing its own meaning as it informs that of the other.

Hence, the concentric-circle floor plan of the house, based on the same model found in Heaven, is reproduced as well in the structure of the garden and the organization of adornments of a human. It is also reproduced, along with many other architectural references, in the design of the baskets.

Although the "painted" *waja* are composed of a square set inside a circle rather than two concentric circles, this distinction is predetermined by the limitations of the medium. For bichromatic plaited basketry can only generate designs that are set at right angles to one another. As a result, the Yekuana clearly recognize the close parallel between the designs of the *waja tomennato* and that of the house. Beyond the observation that these forms are based on the same dual structure, the Yekuana also use a great deal of common terminology to describe them. The most significant of these shared terms is that distinguishing the relation between inner and outer spaces. In the case of the roundhouse, the inner circle is reserved for all sacred and ritual activity. It is where shamans heal and festivals take place. As such, it is associated with wholeness and access to the invisible. It is referred to therefore not simply as *annaka,* "in the center," but also as *ñunudu,* "the very center" or "centerpost." For it is this long pole rising from the middle of the house to the very roof and beyond which connects the Yekuana like an umbilical cord (*fonudu*) to the celestial world of Wanadi and his spirits. This same preoccupation with wholeness and unity dominates the inner space of the "painted" *waja.* As noted in the discussion of the designs, the forms bounded by the central square strive for a harmonious interplay in which the positive and negative are joined in a seamless union. In contrast to this formal resolution, the outer space remains, like that of the *atta,* one of compartmentalization and division. Calling attention to these parallel sets of relations, the Yekuana refer to the *waja's* inner square as *ñenudu,* a term which, though varying slightly from *ñunudu,* identifies the same symbolic space, an integrated and sacred inner core concealed within a visible and profane outer ring.

In addition to the general spatial analogy between the house and the baskets, many specific designs also utilize the *atta's* architectural vocabulary. In the case of the *akahünü* variation of the *Woroto sakedi* design, for example (pl. 4), the long lines crossed by the *ihudu* or "feet" are referred to as *hiononoi.* As will be recalled, these "sky trees" are the main beams upon which the roof of the *atta* rests. Like these beams (and their namesakes that hold up Heaven), the *hiononoi* of the baskets are "crossed" by the various elements they are designed to support.

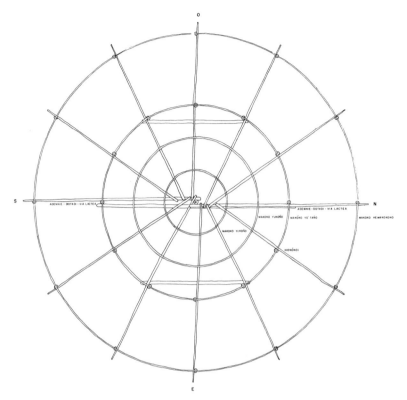

Detail of the *atta* roof with *macoco* and *hiononoi* (courtesy *Antropológica,* 1966)

Infrastructure of the *atta* roof, showing the *atantowoto* pattern with *macoco,*
hiononoi, and *yaradi* (courtesy *Antropológica,* 1966)

Another example of this shared terminology emphasizing the structural relationship between house and baskets is the use of the word *macoco*. Any of the four rings sitting directly upon the *hiononoi* to complete the infrastructure of the roof, the term *macoco* is also used interchangeably with *chähudu* to identify the circular frame to which every *waja* is attached. And finally, *yahudu,* the term used to identify the very center or peak of the roof as seen from the inside, is also used to locate the center of such designs as *Wanadi motai* and *Woroto sakedi.*

Even without an established language of correspondences, however, the house is capable of generating a fresh vocabulary with which to describe new forms introduced into the baskets. Thus, when several Yekuana began manufacturing a Panare design observed while trading in Ciudad Bolívar, the language that was used to describe it derived directly from the house. While sometimes referred to disparagingly as simply *cuya cuya* or "zigzag" (pl. 40), elders immediately recognized in it the overall structure of the *atta*'s inner roof. The way in which all of its lines converged in the center or *yahudu* was identical to the placement of the *hiononoi* and smaller *yaradi* ("fingers"). As a result, the basket became known as *atantowoto,* a term which, while primarily used to describe the infrastructure of the roof, can be translated as "when all lines come together in the center."[1]

Examples such as these illustrate the power of the house in providing a coherent language with which to organize one's reality. It is a system of closed metaphors and structural relations which can be applied over and over again throughout the culture. In the baskets as well as in the garden and personal dress, it is the house that offers the interpretive key. Such an observation was also made by Pierre Bourdieu while working among the Kabyle of North Africa:

> In a social formation in which the absence of the symbolic-product-conserving techniques associated with literacy retards the objectification of symbolic and particularly cultural capital, inhabited space—and above all the house—is the principal locus for the objectification of the generative schemes; and through the intermediary of the divisions and hierarchies it sets up between things, persons, and practices, this tangible classifying system continuously inculcates and reinforces the taxonomic principles underlying all the arbitrary provisions of this culture. (1977:89)

And yet, while the roundhouse is unquestionably the principal model generating spatio-temporal metaphors within the Yekuana world, it is important to remember what gives these metaphors their unique organizing power. For the structure of the *atta* itself, as every Yekuana knows, is based on a divine model brought down to Earth by Wanadi. Its ultimate authority therefore rests in its ability to evoke a much larger cosmic order, one both preexistent and all-embracing. Hence, if the central square of the basket refers to the center of the roundhouse, it also, by association, refers to the center of Heaven, Lake Akuena, the paramount symbol of eternal life and shamanic power. As for the other elements of the basket, they too may be directly related to the invisible geography the house is said to manifest. In such a scheme, the outer ring of the basket or *chähudu* would be equated with the edge of the known world, and the lines of rain (*konohokudu*) that run in from it with the *sidityadi*, the "star supports" that hold up not only the roof but also the firmament.[2]

While the basket derives much of its metaphorical power from its structural relation to the house, the flow of reference is not simply from one to the other. The ability of the basket to contain the image of the universe, as translated through the house, is itself but a metaphor for the entire process of cultural creation. For if every action has the power to reproduce the whole, it also has the power to incorporate all of its parts. Hence, just as the basket contains the house, so too does the house contain the basket. This mutual reflexivity is readily appreciated by the Yekuana, who in addition to speaking of the basket as a house also speak of the house as a basket. They point out the fact that the *atta* is also woven—not only its enormous thatched roof but also the walls, which are twined with cane before a final layer of mud is applied. The image of the house as a huge basket, however, is especially evoked by its comparison with the *tingkuiyedi*, the elaborately constructed device for suspending the yuca press. This is done when speaking of the two rafters that jut out beyond the roof line. While sometimes referred to as *hiyanacachi* or "deer horns," the Yekuana more commonly call them *tingkuiyedi*, pointing out that they are exactly like the "teeth" (*yedi*) from which a yuca press (*tingkui*) is hung. Of course the "press" in this case is the house itself. Suspended from its own rafters, it becomes a *sebucan extraordinaire*, the ultimate basket charged with detoxifying its human contents of all poisons and contaminants.

The level of metaphor at which the house and basket meet is the same one that joins them to every other artifact in the culture. The preoc-

cupation with the transformation of reality—visible and invisible—into a coherent and recognizable human order is as determinant to the structure of these objects as the practical ends to which they are put. As such, the image of a basket extracting all foreign and toxic elements in order to render its contents safe becomes the perfect symbol for the dual process of humanization, at one and the same time practical and ritualistic. But it is not simply external objects that must undergo this process of metamorphosis. As already noted, humans too, in dress and action, conform to the same symbolic order into which each artifact is structurally organized. This does not mean, of course, that the individual is seen as an object, but rather the reverse. For the process of synthesis realized in the construction of any artifact is simply a reflection of the personal integration toward which all cultural energy is directed. The restructuring of the natural or wild that is such an essential part of every cultural activity may also be seen as a paradigm for the creation of individual identity, in which the natural world parallels that of the subconscious.[3] While the Yekuana may not verbalize such connections, the active engagement of artifacts in dramatizing life-cycle transitions certainly makes them clear. As has been demonstrated, the use of the baskets responds to the major phases through which every individual must pass—birth, puberty, marriage, and death. They therefore not only present an image of integration and wholeness in their designs, but through their intersection with every life-cycle transition also help to create it.

The baskets and other artifacts do not simply communicate their messages in moments of life crises, however. By conforming to a common symbolic language, they are able to sustain a coherent and meaningful dialogue at every plane of activity, whether it be weaving a basket, beading a skirt, building a house, hollowing a canoe, painting a drum, preparing barbasco, or undergoing a fast. Like the circularity of the baskets themselves, it is a discourse that can be entered into at any point. Or, put another way, the symbolic organization of all Yekuana behavior provides each member of the tribe with the opportunity to penetrate the core of cultural belief at each instant of their lives. Whether or not one does so may, of course, be questioned. Yet what is important is the realization that all activity is inspired by the same patterns of meaning. For in a world where the categories of art, ritual, and religion no longer adhere, every action takes on a sacred and initiatic character. It is in this context that the multireferentiality of symbolic forms repeated in one cultural manifestation after another must be understood. In place of an independently identifiable doctrine

or catechism of beliefs, we now find a diffuse configuration of symbols and, underlying this configuration, an ethos that permeates every aspect of the society. To become a Yekuana therefore is not reducible to the memorization of a list of prescribed tenets. Rather, it is what Bourdieu has called "the em-bodying of the structures of the world" (1977:89), the unconscious assumption of a world view and code of behavior through simple participation. It is a way of life, shaping one's universe at the same time as it explains it.

In a society such as the Yekuana's, every event is suffused with meaning. Each action, through its translation into a recognizable symbolic order, is imbued with the same power to reveal the most profound truths concerning the Yekuana conceptualization of the universe. For the conscious person, therefore, each instant holds the possibility of illumination, of entrance into another reality as indicated by the structures of this one. A master craftsman such as a *towanajoni,* "the one with wisdom," approaches his life accordingly. For him each task is a work of meditation, a way of being present or conscious in all that one does. He recognizes that the expression of unity achieved in the baskets is the same realized in every other cultural manifestation. The ability to reconstitute the whole with every artifact, every gesture, every ritual is more than just an ideal for him. It is a pervasive, daily, ongoing reality. In short, he not only weaves the world when making a basket, but in everything he does. And yet, it is not simply the *towanajoni* who are involved in this creative process. Every member of the society, regardless of their level of esoteric knowledge or technical expertise, is actively engaged with the same creation of culture in everything they do. For meaning is relegated neither to the special event nor the special person. It is the light that illuminates the human universe, a light that must be brought into being every day, in every action, by every person.

A GALLERY OF BASKETS

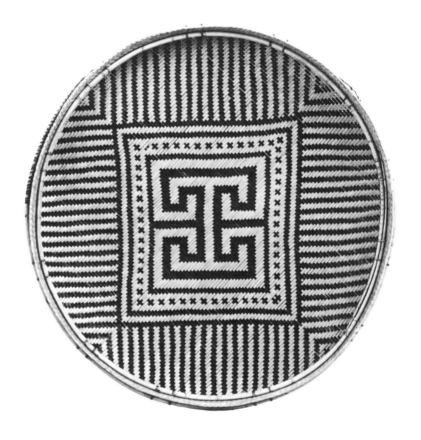

PL. 1. *Woroto sakedi, Odoyamo emudu* or "Devil's joints" variation

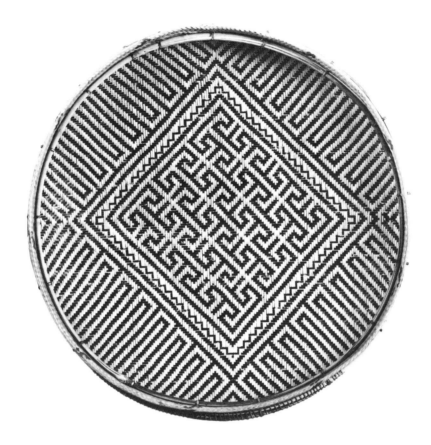

PL. 2. *Woroto sakedi*

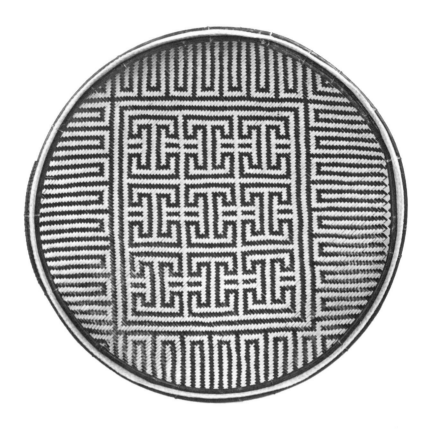

PL. 3. *Woroto sakedi*

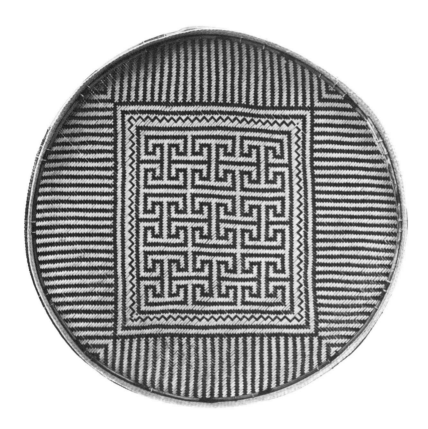

PL. 4. *Woroto sakedi*

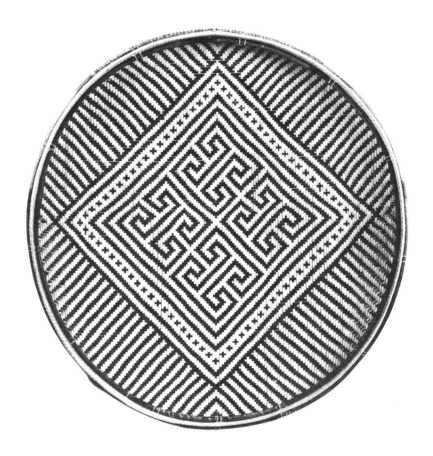

PL. 5. *Woroto sakedi ohokomo*

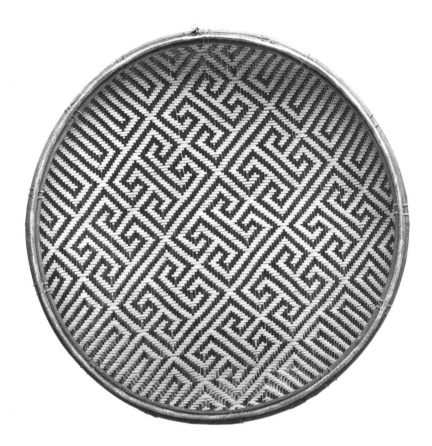

PL. 6. *Woroto sakedi ohokomo*

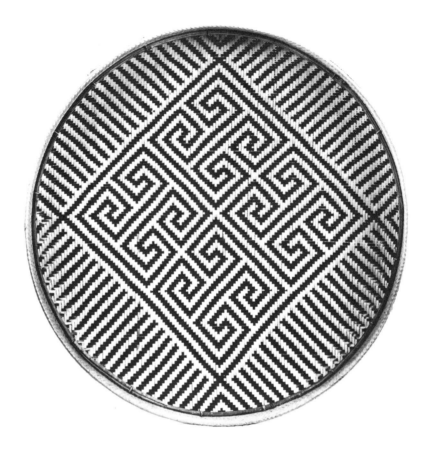

PL. 7. *Woroto sakedi simiñasa*

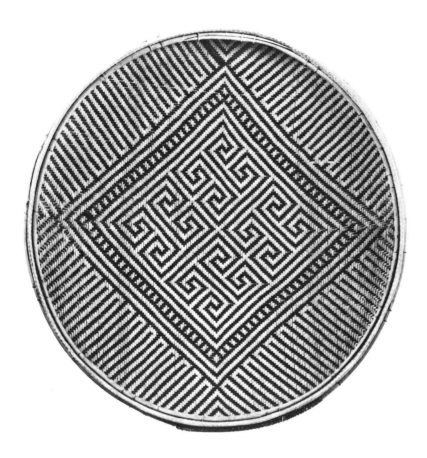

PL. 8. *Woroto sakedi siminasa*

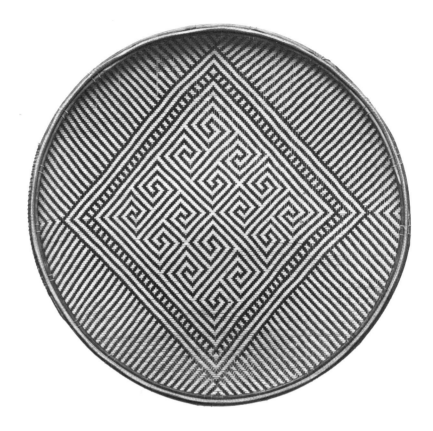

PL. 9. *Awidi,* the coral snake

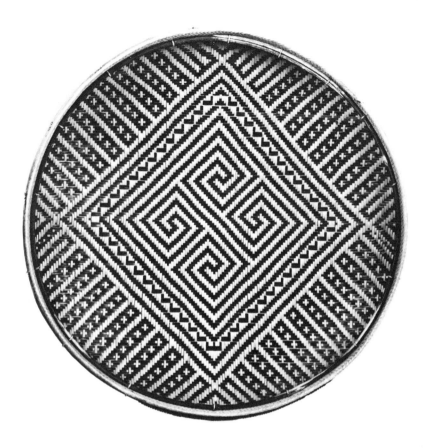

PL. 10. *Awidi,* surrounded by *Ahisha,* the white heron, and a combined motif of stars (*shidiche*) and rain (*konohokudu*)

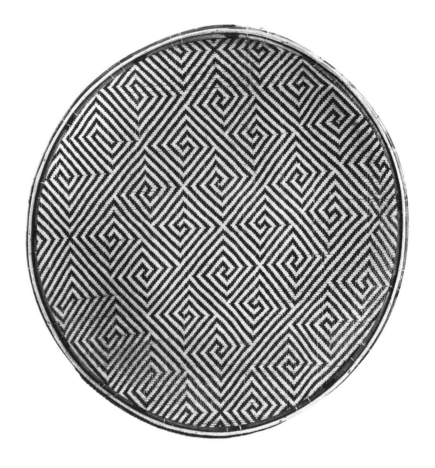

PL. 11. *Awidi*

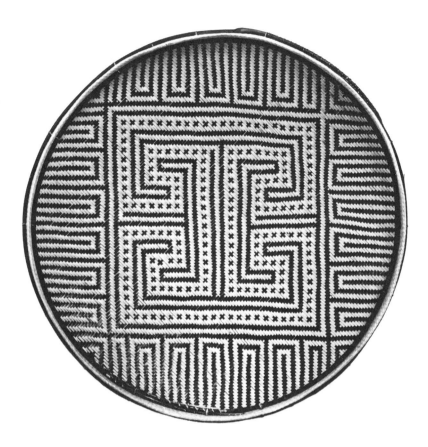

PL. 12. *Mawadi asadi,* "Mawadi inside"

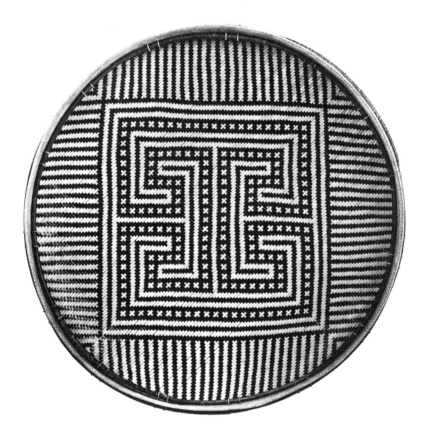

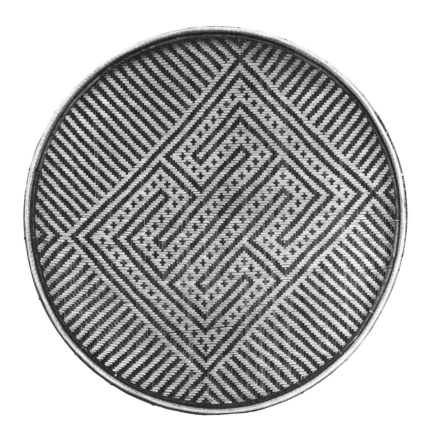

PL. 14. *Mawadi asadi*

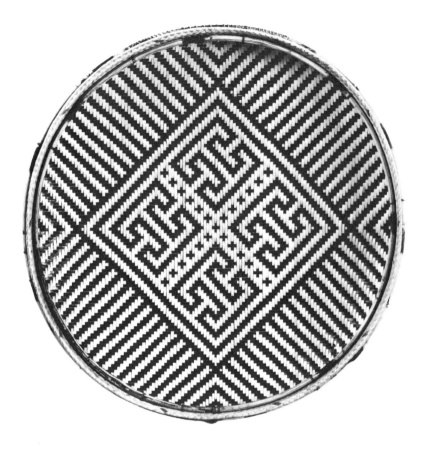

PL. 15. *Mado fedi,* "Jaguar face"

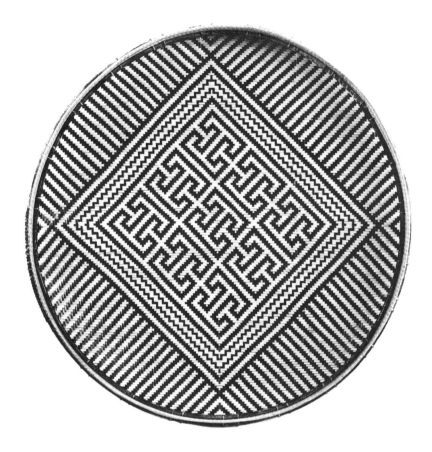

PL. 16. *Mado fedi*

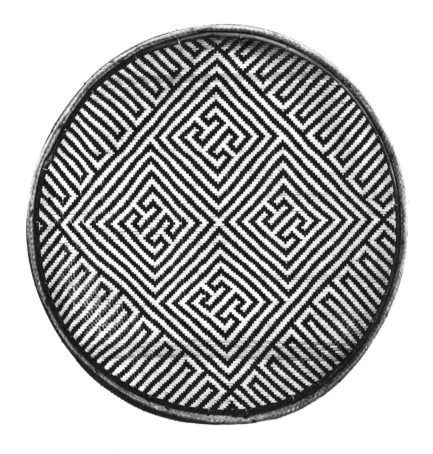

PL. 17. *Mado fedi*

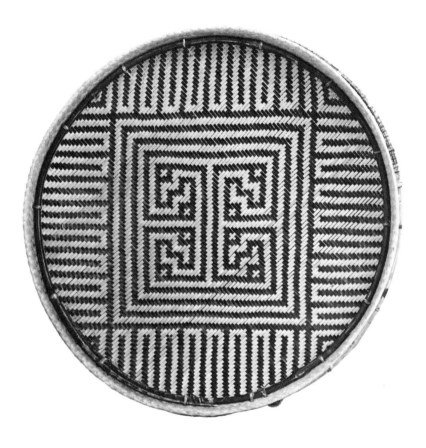

PL. 18. *Suhui wayutahüdi,* "*suhui* handle"

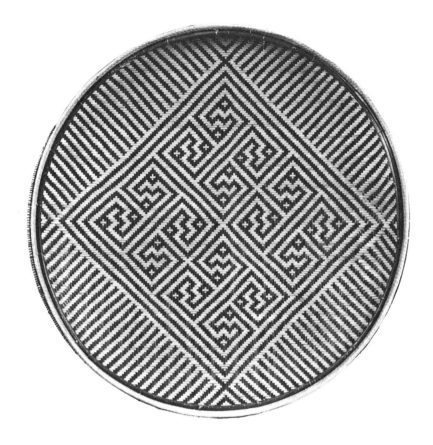

PL. 19. *Suhui wayutahüdi*

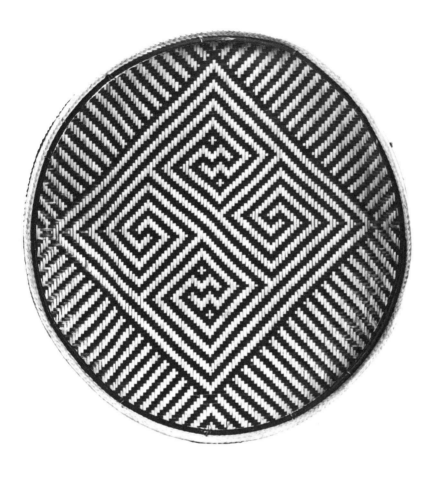

PL. 20. *Suhui wayutahüdi* and *Awidi* combined

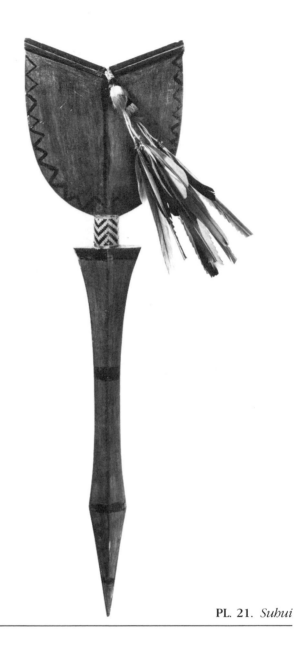

PL. 21. *Suhui*

PL. 22. *Yaribaru*

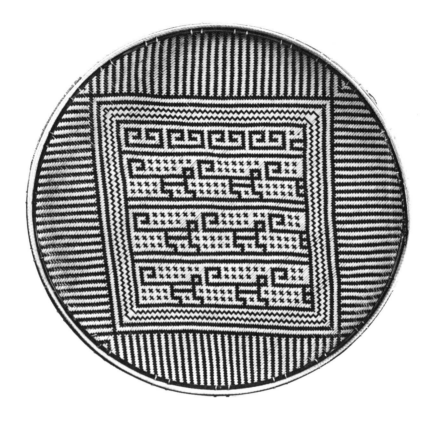

PL. 23. *Warishidi*

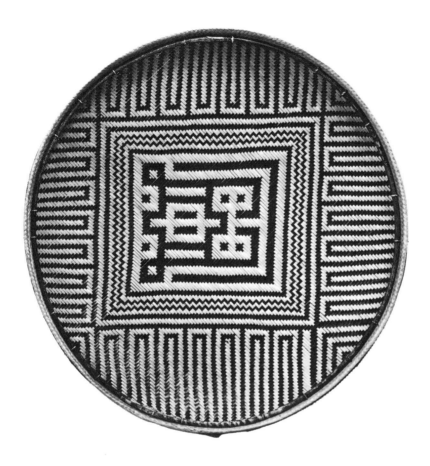

PL. 24. *Iarakuru*

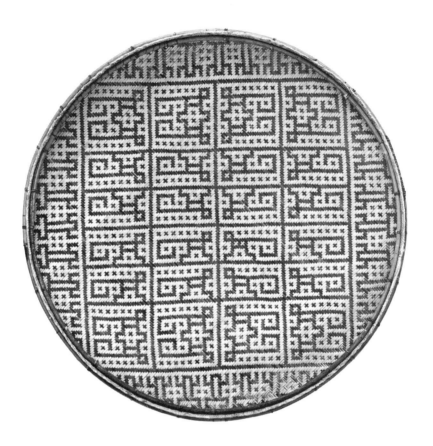

PL. 25. *Iarakuru* with toad border

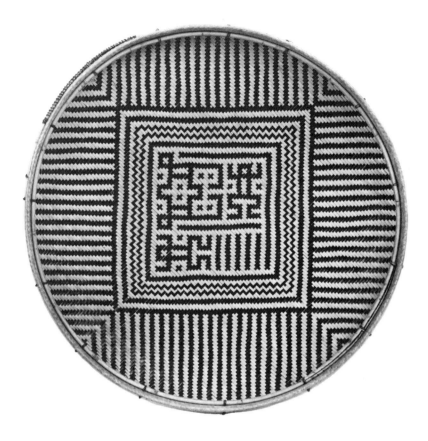

PL. 26. *Iarakuru* with *Sinyawe,* the toad

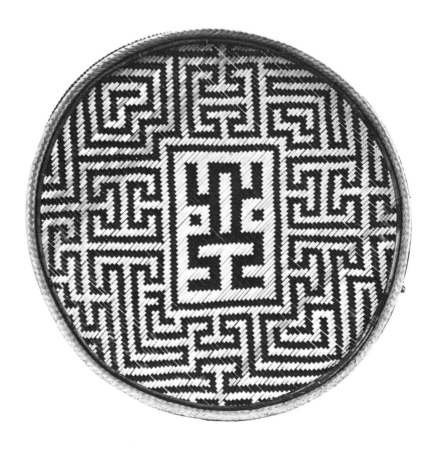

PL. 27. *Kawau,* the toad, with the scorpion, *Mönetta,* below left and right, and *Mado fedi* on all four sides

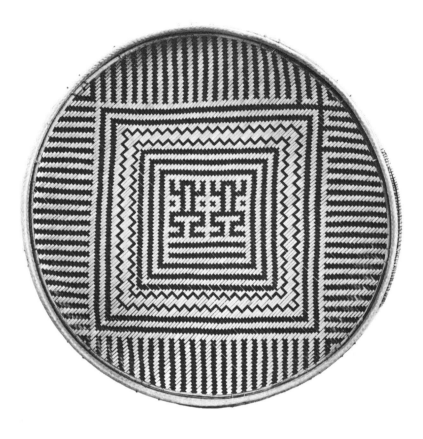

PL. 28. *Kwekwe,* the toad, also known as *Wanadi finyamohödö,*
"Wanadi's woman"

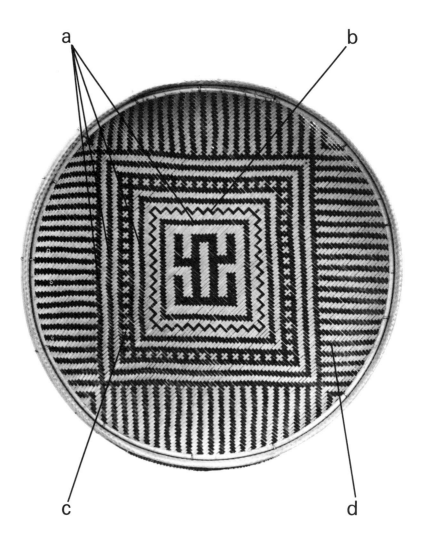

PL. 29. *Kutto,* the frog, with: a. *ishacudu,* the square b. *Ahisha,* the white heron c. *shidiche,* the stars d. *konohokudu,* rain

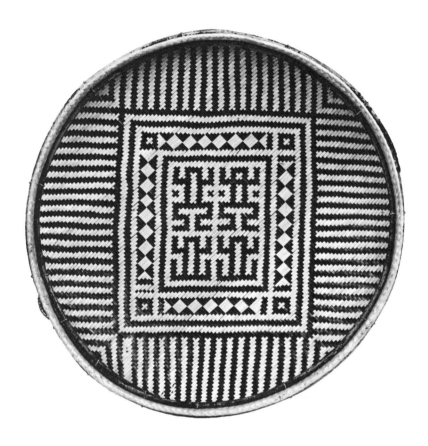

Pl. 30. *Kwekwe* above and *Kutto* below, surrounded by an hourglass variation of *Ahisha*

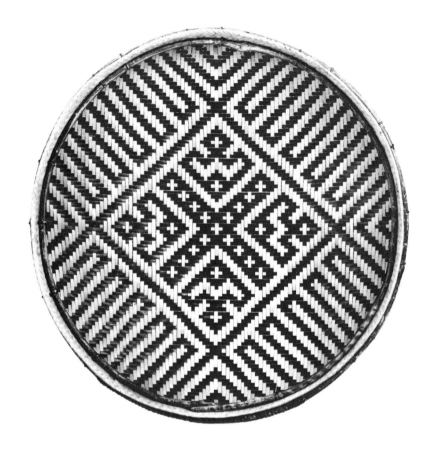

Pl. 31. *Dede,* the bat, intersected by *Wanadi motai,* "Wanadi's shoulders"

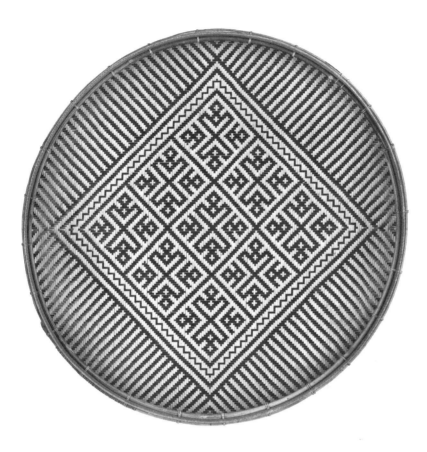

PL. 32. *Dede*

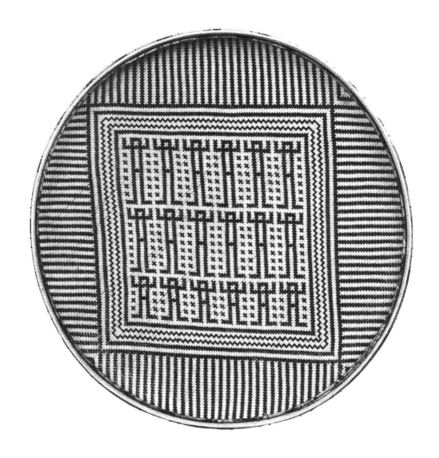

Pl. 33. *So'to*

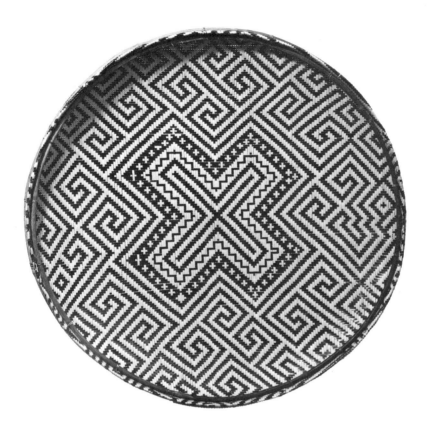

PL. 34. *Wanadi motai,* "Wanadi's shoulders"

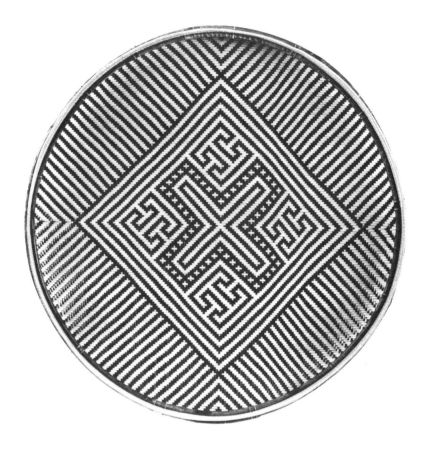

PL. 35. *Wanadi motai* and *Mado fedi*

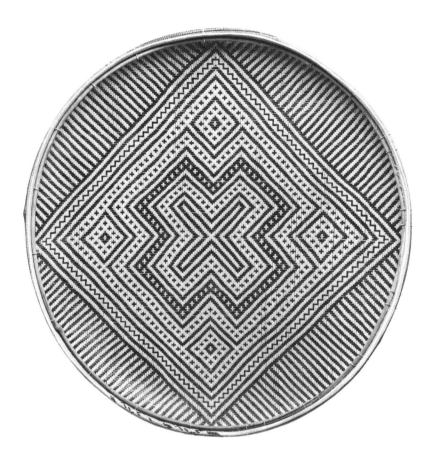

PL. 36. *Wanadi motai*

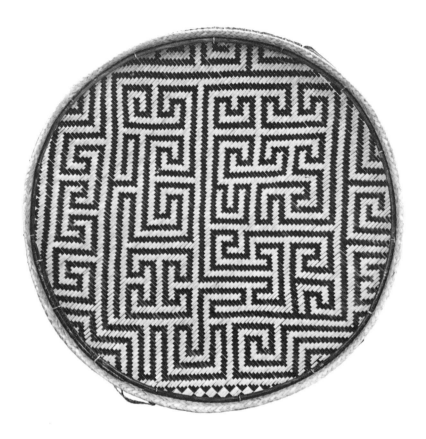

PL. 37. A labyrinth with *Mado fedi*

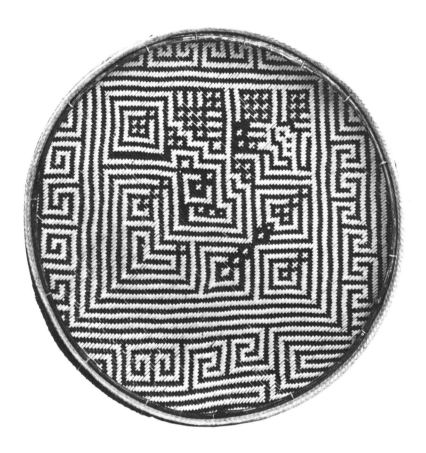

PL. 38. Unidentified labyrinth design

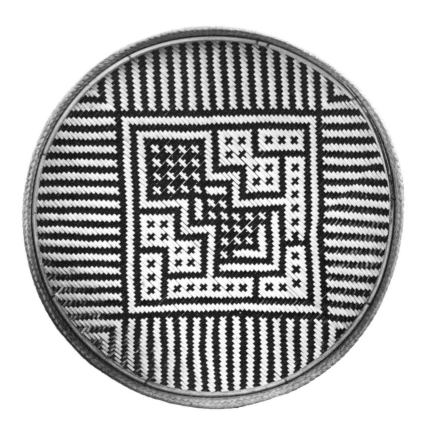

PL. 39. Unidentified labyrinth design

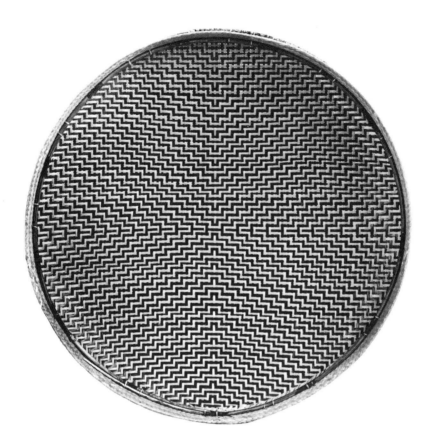

PL. 40 *Atantowoto,* also known as *cuya cuya*

PL. 41. *Kutto shidiyu* or "Frog's bottom," the fast basket

PL. 42. *Waja tingkuihato*

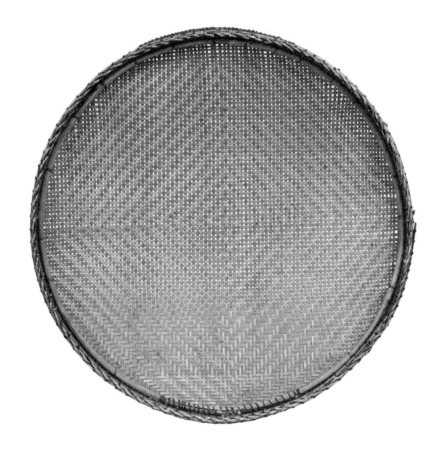

PL. 43. *Manade*

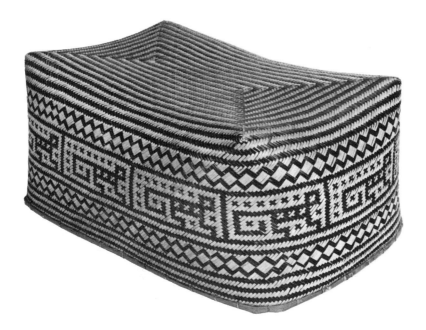

PL. 44. *Kungwa* with *Iarakuru*

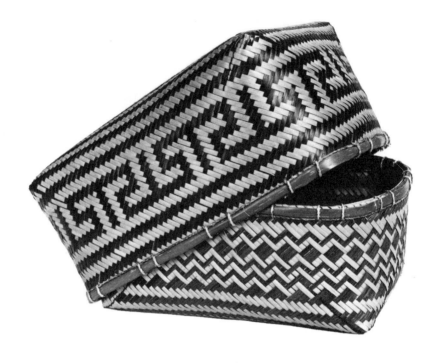

PL. 45. *Kungwa:* top, *Woroto sakedi (tuhukato)*; bottom, *Ahisha*

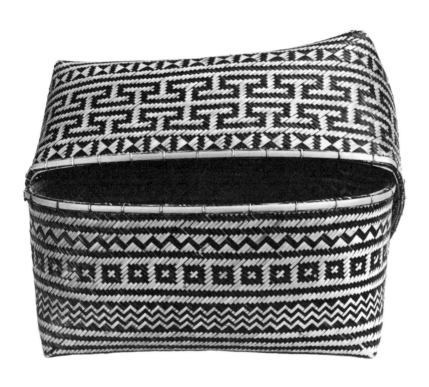

PL. 46. *Kungwa:* top, *Ahisha* variation, also known as *Wiyu* or "snake markings," and *Woroto sakedi*; bottom, *Ahisha* and *Wayamo cadi,* "tortoise back"

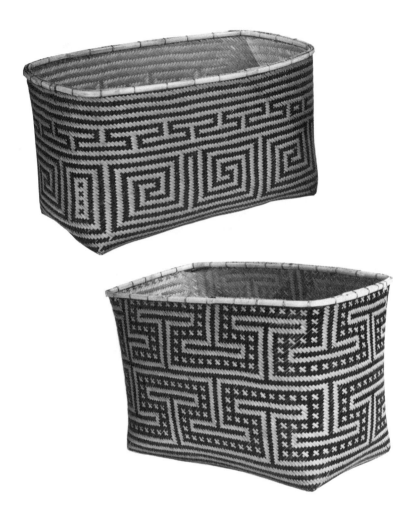

PL. 47. *Kungwa:* top, left, *Woroto sakedi* and *Awidi*; bottom, right, *Mawadi asadi*

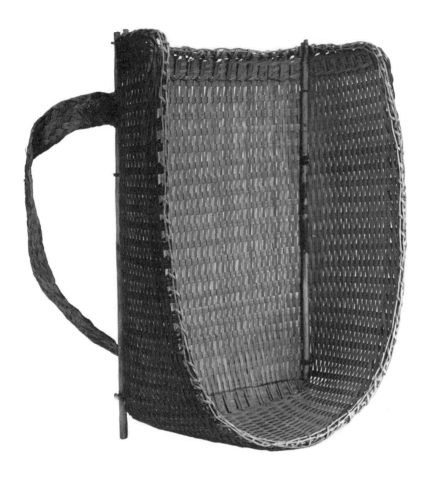

PL. 48. *Tudi,* men's backpack

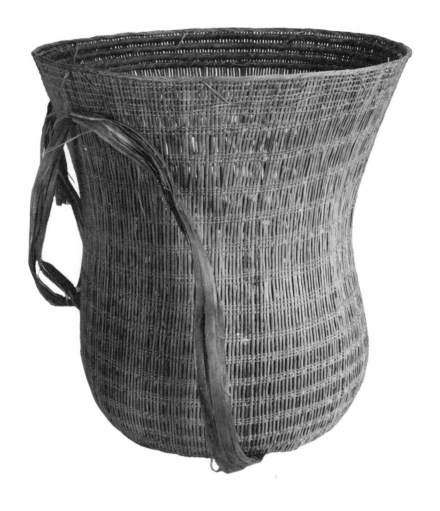

PL. 49. *Wuwa*, women's carrying basket

PL. 50. *Tingkui,* yuca press

Notes

1. Introduction: THE SYNTAX OF CULTURE

1. In addition to each individual's Spanish name—a form that has only recently arisen with increased contact and the need to take civil names—every Yekuana also has a secret name, a teknonymous marital name, a nickname, and the various kinship names by which he or she is usually addressed. Of all of these, however, it is the "unspeakable" secret one that remains the most sacred and true. Revealed to the *aichuriaha* or "master of song" soon after birth, this name is always associated with some aspect of *Watunna* and, like it, is also in a special shamanic language. While it is possible to learn many of these names, it would certainly be inappropriate to use any of them in a text such as this.

2. A highly feared form of black magic widespread among the Carib-speaking Indians of eastern Venezuela and Guyana, Kanaima was brought to the Yekuana by the first traders traveling to Amenadiña (Georgetown) at the end of the eighteenth century. Versions vary as to what a Kanaima actually is, but most agree that it is a person turned-into a monster, jaguar, snake, etc., who ruthlessly kills for revenge, hire, or pure pleasure. While the word may derive from one of the various terms for Carib (Basso 1977:23), the Akawaio claim "Kanaima means one who murders suddenly" (Anthon 1957:61).

2. THE PEOPLE

1. Among the many recorded spellings of Maiongkong are Majongon, Mayonggong, Maschongcong, Maingcong, Maiongking, Mañongon, Muñangon, and Majuyonco. In addition, de Civrieux (1959:101) suggests that the name "Guayancomo" is also a phonetic variant. The problem of nomenclature and orthography is so extensive in Yekuana studies that both Fuchs (1962:170) and Salazar (1970:29–30) were able to compile separate lists of at least fifty different names and variations. And finally, Arvelo-Jimenez reports that Marshal Durbin and Haydée Seijas "in an exhaustive review of the literature

have found fifty-three different names by which the Ye'cuana or De'cuana have been referred to" (1973:21).

2. Another ethnographer advocating such a division is Helmuth Fuchs, who claims that the real tribal division is not four but five and that "it appears probable that we're dealing with clans and lineages and perhaps eventually 'sibs' " (1962:173).

3. The exact number of Yekuana reported in the *Censo Indígena de Venezuela* (Oficina Central de Estadística 1985), the most thorough indigenous census ever undertaken in Venezuela, is 3,038. Previous population estimates for the Yekuana have ranged from 1,500 (Coppens 1981:27) to 7,794 (Fuchs 1962:170).

4. The only author attempting to set the date of the Yekuana's entrance into Venezuela is de Barandiarán who fixes it at 1400 or "some three hundred years before the date of their first contact with Manuel Román" (1979:749). As to the reason for choosing this date, de Barandiarán gives little indication, other than to state that it took the Yekuana three centuries to gain possession of the Padamo area and to absorb the Arawak groups already there.

5. More commonly known as the Caribs or "True Caribs," the Kariña were one of the largest tribes in South America at the time of the Conquest. In Venezuela, their territory stretched from the Caura and Paragua south of the Orinoco all the way to the Guarapiche near the Caribbean coast. Due to their identification as the Caribs, confusion has often existed between the tribe and the large linguistic family of the same name.

6. Ankosturaña is a variant of the original Spanish name Angostura ("Narrow"), the town the Spaniards founded in 1864 at the narrowest point of the lower Orinoco in order to defend the river against foreign penetration. Its official name was changed in 1866 to Ciudad Bolívar to honor the "Liberator," Simón Bolívar, who formed the first government of the Republic there in 1819. As to the origin of the word "Iaranavi," it would appear to derive from the Puinave, the inhabitants of the area around San Fernando de Atabapo where the Iaranavi are said to have originated.

7. Fañuru, the word used to denote the evil race of whites as opposed to the honorable Iaranavi, derives from the Kariña *Pañoro,* which in turn derives from *Español* or "Spanish."

8. The principal Dutch fort located in the mouth of the Essequibo River in what is today Guyana, Amenadiña actually refers to several different locations. Originally called Kijkoveral, it was moved from Kaow Island to Flag Island in 1738 and renamed Fort Zeelandia. After Guyana switched from Dutch to British control in 1814, the new commercial center of activity (or Amenadiña) became Georgetown, located slightly to the southeast at the mouth of the Demerara.

9. This account of the Yekuana discovery of Amenadiña is both paralleled and reversed by Christopher Columbus's description of his arrival at the mouth of the Orinoco on his third voyage to the New World. Encountering

such a large body of fresh water flowing into the Caribbean, he became convinced that he had come to "one of the four rivers of Paradise":

> For I believe that the earthly paradise lies here, which no one can enter except by God's leave. I believe that this land which your Highnesses have commanded me to discover is very great, and that there are many other lands in the south of which there have never been reports. I do not hold that the earthly Paradise has the form of a rugged mountain, as it is shown in pictures, but that it lies at the summit of what I have described as the stalk of a pear, and that by gradually approaching it one begins, while still at a great distance, to climb towards it. As I have said, I do not believe that anyone can ascend to the top. I do believe, however, that, distant though it is, these waters may flow from there to this place which I have reached, and form this lake. All this provides great evidence of the earthly Paradise, because the situation agrees with the beliefs of those holy and wise theologians and all the signs strongly accord with this idea. (Cohen 1969:221–22)

10. For a full discussion of the concept of historical incorporation and how it operates within the context of Yekuana culture, see Guss 1981c, 1986a, 1986b, where it is examined in relation to the legend of Amenadiña and the origin of Western materialism. In both instances, the Yekuana use this process to appropriate the power attributed to the Europeans, relocating it within the origin of their own world.

11. Along with so many other firsts, Alexander von Humboldt may also be credited with being the first scientist to come into contact with the Yekuana. During his 1800 expedition up the Orinoco and then via the Casiquiare down the Río Negro, von Humboldt briefly visited the nearly abandoned community of La Esmeralda ("A colony composed of elements altogether heterogenous perished by degrees" 1852,2:434). The most memorable aspect of his account of the "Maquiritares" is his vivid description of the preparation of the hunting poison known as curare (ibid.:438–48).

12. A tributary of the Caura, the Erevato is quickly becoming the "Maquiritare river" the Padamo once was. In addition to the concentration of Yekuana around Santa María, there are also large Yekuana communities at Chajuraña and Cusimi, making this the most populated Yekuana river.

13. For details on the development of the community of Cacuri, see Frechione 1986.

14. For the best summary of this debate, see the collection of essays in Mosonyi et al. 1981.

15. Nelly Arvelo-Jimenez pays special attention to this conflict between upriver and downriver Yekuana, emphasizing that:

> . . . the sociological (but not political) dichotomy is between the inhabitants of Ihuruña, the Ihuruñancomo [Ihuruana], who are still the faithful observers of Ye'cuana traditions and customs, and the settlements in aneiña (downstream territory) or aneiñancomo, who have somewhat modified their traditional lifestyle. (1971:21)

3. CULTURE AND ETHOS: A PLAY OF FORCES

1. Yekuana pronominal forms also enable speakers to underline the distinction between community and other. One may therefore speak of a "we" (*inya*) that includes only those present in a village or a "we" (*canwanno*) signifying all Yekuana, present or not. Far more exacting are the forms for "they," which consist of five different pronouns: *canno,* they who are nearby; *mäcämo,* they who are far away yet visible; *ñanno,* they who cannot be seen; *ñada,* they who cannot be seen but are capable of being located; and *tunwanno,* the indiscriminate "they" so popular in vernacular English.

2. A hallucinogen made from a malpighiaceous vine of the genus *Banisteriopsis* (there are various species), *kaahi* is prepared and taken in liquid form. As with the Yekuana's other two hallucinogens, *aiuku (Anadenanthera peregrina)* and *akuhua (Virola calophylla),* the use of *kaahi* is restricted to shamans, who take it in order to travel to Heaven to make contact with the spirits of the invisible world. Closely related to the word for Heaven, *Kahu, kaahi* is its equivalent, growing at its center beside Lake Akuena and mixing with its waters. One of the most widespread drugs in use among the native peoples of South America, it is also known as *caapi, yage,* and in Ecuador as *ayahuasca,* the "dead man's vine."

3. The symbolic import of concentric circles has also been noted by Lévi-Strauss (1963*a*:128) and Crocker in their discussions of Bororo residential patterns:

 > The Bororo village expresses a concentric dualism: the male-dominated sacred center over against a feminine, domestic, profane periphery. Through this center pass all the symbolic and material transactions uniting the social categories differentiated around the village circle. These prestations include all the game and other food secured during the collective expeditions.... The concentric dualism thus establishes and mediates an ecological process. (Crocker 1985:33)

4. Several Yekuana indicate that the *Aschano caadi* ceremony is not performed with the same regularity as previously, due to the increased instances of both intermarriage and "friendly" contact. Hence, during the *Atta ademi hidi* house festival I attended, it was explained that the *Aschano caadi* could not be sung, lest it harm either myself or my wife, Iaranavi ("whites") against whom it is normally directed. A similar chant called the *Kahiuru wache* is sung during the Garden Festival in order to provide the same protection for the new gardens being inaugurated.

5. New communities are also established when a chief or shaman dies, at which time the *atta* is converted into a mausoleum for the deceased and the entire village abandoned. As previously discussed, relocation patterns are beginning to change with the establishment of such stable communities as Santa María, Cacuri, and Acanaña. For an excellent discussion of rain forest demographics and the relationship between slash-and-burn agriculture and settlement patterns, see Meggers 1971.

6. The species of barbasco most commonly used by the Yekuana are *Lonchocarpus sericeus* and *Piscidia guaricensis*. As Roth notes (1924:202), varieties of barbasco are used with great specificity to trap certain fish while leaving others unaffected. For a survey of over one hundred species of barbasco in South America see Heizer [1948] 1963:227.

7. The life of each garden is usually three to four years, by which time productivity begins to decline dramatically. Although it is difficult to estimate the number of gardens in each village, especially because of their differing states of use, a survey in the community of Parupa with 135 inhabitants revealed upwards of forty. Further complicating this issue are the additional gardens created to meet the demands of trade as contact increases.

8. The term *siwo* is derived from the word for the lower windpipe or thorax. It is said that Wanato, the first human, discovered this music when he overheard a group of fish singing in the Orinoco headwaters, a startling claim, as the remarkable sound of the *siwo* resembles nothing so much as the recently recorded music of sea mammals.

9. The *Watunna* records that the first yuca brought down to Earth did not grow when planted in Mount Roraima. It was only after the kinkajou Kusui, in his new incarnation as Iurukukuwi, returned to Heaven to get the *awanso catajo* that yuca was successfully grown in Marahuaka. Seen as a mountain today, Marahuaka is remembered as the "tree of life" from which all edible plants originated. Its name is undoubtedly derived from the word "*maada*" as in "*maadahuaka*," the letters *r* and *d* being interchangeable in Yekuana. The common interpretation of "Marahuaka" as "little gourd" therefore most likely refers to the little gourds or *tiritojo* that women use to conceal their *maada*.

10. The secrecy of men's and women's *maada* from one another is enforced by the variety of negative symptoms resulting from the handling of magic herbs of the opposite sex. While men do make use of certain female *maada*, they can do so only after the herbs have been properly prepared by the women with chants, paints, and gourds. If such proprieties are not observed, the herbs can produce fever, dizziness, loss of appetite, headaches, insanity, and eventual death. Although improper handling of men's herbs may similarly affect women, their symptoms are usually associated with menstruation. Thus, if a man with *maada* touches a menstruating woman or even happens to brush against her hammock in the dark, the woman's bleeding will increase significantly and terrible stomach pains ensue. It is also claimed that even if a woman is not menstruating, but a man in the house is handling *maada* when another person suddenly enters, causing the woman to startle with fright, the woman will suffer "asusto" (*wakaton kana*) and instantly begin to menstruate.

11. Cf. Victor Turner's discussion of "rituals of status reversal" (1969:176). While the *Adaha ademi hidi* conforms to many of Turner's observations, it is questionable as to whether it functions as reaffirmation of the old order

("the hierarchical principle"), as he claims these rituals do, or actually succeeds in creating a new one.

12. Bourdieu's concern with kinetic body language, while not discussed at length here, is equally relevant to each Yekuana's individual assumption of the structures of the universe. The heavily socialized values of restraint, obedience, self-control, and avoidance all reinforce a world view characterized by the conceptualization of each village as a separate world. The ideal Yekuana who is reserved and quiet and always speaks in a soft voice, who maintains his dignity and composure at all times and never becomes angry or argumentative is the best insurance that the primacy of village autonomy will not be threatened from within. Closer to my own discussion perhaps is that of Terence Turner, who, in examining the symbolism of body adornments among the Gê-affiliated Tchikrin of Brazil, writes:

> Lip plug, earplugs, penis sheath, hair style, cotton leg and arm bands, and body painting make up a symbolic language that expresses a wide range of information about social status, sex, and age. As a language, however, it does more than merely communicate this information from one individual to another: at a deeper level, it establishes a channel of communication *within* the individual between the social and biological aspects of his personality. (1969:59)

13. Wiyu is a polymorphous anima-animus figure appearing as either male or female, depending on the tale in which he or she is invoked. In the story of her creation, however, Wiyu is clearly portrayed as a woman—Wanadi's lover as well as the sister of the Moon, whose attempted rape of her leads to her flight below the water. It is there that she assumes her permanent form as the feathered serpent and the mistress (*arache*) of the water and all that inhabits it.

14. Fenefene is a short-billed honeycreeper (*Cyanerpes nitidus*) and Madima is a Euphonia (*Euphonia* sp.), both extremely colorful and beautiful birds which, like Wanato (*Cotinga cotinga*), have a great deal of celestial blue in their plumage.

15. For more on this pivotal event see Guss 1982*b*, 1985*b*. A possible indication of the function of the rags worn by the initiate is Kloos's observation among the Maroni River Caribs that girls going through initiation rites wear old clothes in order to avoid the attention of the lustful *oko:yumo* water spirit (1969:901). It may be that Yekuana women do the same thing to repel Mawadi, a species of water spirit known to kidnap menstruating women. Whatever its purpose, this costume emphasizes the extreme liminality through which the initiate is passing, a state transcended only when the *ahachito hato* or "new person" is fully dressed in the proper attire of a mature woman.

16. Rather than marriage, it is the birth of a woman's first child, the cyclical transition from daughter to mother, that officially marks the termination of the *ahachito hato* state. The synonym often used for *ahachito hato* is *hunkwai,* meaning "childless" or "barren."

17. "The effectiveness of symbols would consist precisely in this 'inductive property,' by which formally homologous structures, built out of different materials at different levels of life—organic processes, unconscious mind, rational thought—are related to one another" (Lévi-Strauss 1963*b*:197).

18. For a detailed discussion of Yekuana dream interpretation and its various levels of codification, see Guss 1980*c*.

19. De Civrieux writes about this same phenomenon of soul differentiation among the neighboring Kariña or Caribs. By transposing the terms *akato* with *aska*, *damodede* with *vorupua*, and *arache* with *tamu*, we gain an excellent insight into the Yekuana distinction between the "doubles" of ordinary humans and those of shamans and animal masters:

 The shaman has more power and wisdom than the Kariña (ordinary man) because his soul is not of the earth. It's not an aska (double, shadow) but a tamu (a grandfather), a sky spirit (kapu akarü). The shaman himself gives his soul the secret name of vorupua (vorupuaruroro, voropuatoskororo) during his invocations. It cannot be frightened or captured by the nono akurü or tuna akurü (earth and water spirits). When the shaman dies, his "companion" doesn't turn into an akaton or ioroskan (elemental earth spirits) but goes back to the Mountain where it has its home. The Kariña can't control the impulsive journeys of their askari and this is why they are always behaving so capriciously and wildly, leaving their bodies and becoming frightened and agitated. Askari are impetuous and ignorant and when they go out they can only turn themselves into forms of their own species. Many tamurü or shamans hurt the Kariña askari to take vengeance for some offense or merely cruel pleasure. In contrast, the shaman's vorupua is obedient, wise, and efficient because he can take the form of any animal. The shaman knows how to govern his vorupua. When it leaves his body, it's never just a whim, but because the shaman wants it to go out and sends it to struggle against some enemy. When he wants it to return, he calls it and it comes right away. The shaman's soul always obeys and is a true Guardian Spirit, a tanko, a Master of Wisdom. (1974*b*:72–73)

20. Although interchangeable, "Odosha" is the general name for all the evil and negative forces in the universe, whereas "Kahu" or "Kahushawa" is the secret, specific name of the devil himself. While nearly identical to the word for sky (*kahú*), "Káhu" is distinguished by its initial syllabic stress.

21. De Barandiarán claims that the correct name for this second incarnation of Wanadi is Enaadi Wanadi (1979:802). Translating this as "Wanadi's womb," from the root *náa* or "uterus," he goes on to suggest that its origin lies in the fact that it was this Wanadi who brought the First People to Earth enclosed in a great uterine-like egg called Huehanna. Supporting this hypothesis is the fact that it was also this Wanadi who gave birth to his own mother, Kumariawa.

22. As is common in shamanic battles, of which this story is a paradigm, combat is carried out by the doubles of the antagonists. While Odosha takes the form of the black curassow, Kurunkumo (literally "Black People"), Wanadi assumes that of the crimson-crested woodpecker, Wanadi tonoro (*Campephilus melanoleucos*). As such, the original oppositions are restated in a conflict pitting a black, earthbound bird against a red, skyward one. For a complete version of this narrative, see de Civrieux 1980:32–43.

23. A hallucinogenic snuff in wide use throughout the South American rain forest, *aiuku* is variously known among other tribes as *ñopo, yopo,* and *vilca.* Made from the inner bark scrapings of a large leguminous tree (*Anadenanthera peregrina*), the Yekuana restrict its use to shamans, who ingest it four times after completing a three-day preparatory fast. The Yekuana identify at least five varieties of *aiuku,* some of which are also used as hunting poisons (especially by the neighboring Yanomami) to cover the tips of their arrows and spears.

24. Although the Yekuana have traditionally roofed their houses with thatch, many of the younger tribal members have been attempting to obtain the laminated sheets of tin so common in the criollo border towns. "No tin" is an ironic reference to this roofing material and the conflict of lifestyles it has come to symbolize. The narrator is making fun of these structures while at the same time acknowledging that the fourth and final city that Wanadi built for Odosha is not an ordinary, criollo one, but rather an otherworldly, supernatural one. For this reason it is claimed to be constructed entirely of *wiriki,* the small quartz crystals that every shaman receives during his initiatory journey to Heaven. By making this claim, Wanadi hopes to deceive Odosha into believing he is already in Heaven and thus convince him to give up his pursuit. For a full discussion of "Wanadi's Flight from Odosha," and the way in which the objects of modern technology, including literacy and tape recording, have been incorporated as negative symbols into the Yekuana cosmos, see Guss 1986*b* and de Civrieux 1980:147–164.

25. Although shamanism is of course the form par excellence for penetrating and controlling the invisible, it is not included in this discussion, as it deals primarily with instances of aberration. What is of concern here are the daily ritual skills available to and required of every member of society. It is only when such "controlled access to the supernatural" (Dumont 1972:82) breaks down that disease occurs and the specialized services of the shaman are demanded. Nevertheless, one should not forget that the healing event is the most acute reenactment of the symbolic order, which the shaman's intervention alone can restore (Lévi-Strauss 1963*b*, Kleinman 1974).

26. For related studies in the use of herbal magic among other Guiana groups, see Roth 1915:281–88, Butt 1957, 1961, Kloos 1971:218–26, Lizot 1985:106–23.

27. A fourth body paint is extracted from the pods of a small, bush-like tree called *da'di (Genipa americana*), which grows along the shores of rivers.

Also referred to by its Pemon name, *caruto,* this tree was not brought from Heaven by Wanadi but rather is said to be "Wiyu *natödi*" or "Wiyu's seed." Due to both its relation to this water spirit and its natural black color, the use of *da'di* is highly questionable, with some people claiming that it is actually taboo (*amoibe*). Nevertheless, the five-day durability provided by its heavy oil base makes it a coveted substitute for the other paints, the applications of which last no longer than three days.

28. Cf. Terence Turner's observations among the Tchikrin of Brazil:

> Body painting at this general level of meaning really amounts to the imposition of a second, social "skin" on the naked biological skin of the individual. This second skin of culturally standardized patterns symbolically expresses the "socialization" of the human body—the subordination of the physical aspects of individual existence to common social values and behavior. (1969:70)

29. Permanently taboo animals are often associated with shamans, who alone have chants powerful enough to control them. Hence, while certain hawks are said to be *amoibe* because "they eat snakes and are friends to humans," these same hawks are also important as shamanic helpers. Though some animals falling into this category are not a physical threat to humans at present, myths often reveal a cannibalistic past, as is the case with both anteaters and opossums. Another class of these animals is those introduced by the Spanish. Although no domestic animal is ever desirable as food to a Yekuana, only those associated as doubles with the evil Fañuru are expressly forbidden. An example of this final group is the pig, referred to as "Odosha's offspring."

4. "ALL THINGS MADE"

1. It is this same congruence of ritual and technical skills that Arvelo-Jimenez refers to when she discusses the attributes required of a chief:

> There are two ways in which a headman is distinguished from the commoners. The first is the duties he has to the villagers; the other is the unusual combination of wisdom in handling people, technical proficiency and ritual wealth. This enables a man to aspire for village headmanship and to lead his political followers to believe he is well suited for that office. This is why a headman has to be really proficient in the arts and crafts of his society. He has to be a hard worker. He has to be ritually affluent and perform ritual services at the request of his fellow villagers. He is supposed to be a wise and peaceful individual capable of influencing people to adjust differences. . . . He must be a generous man and have a natural following. (1971:233)

2. All basketry terminology follows as closely as possible that of J. M. Adovasio, *Basketry Technology: A Guide to Identification and Analysis* (1977). In agreement with Adovasio as well is the definition of basketry as a "technique of manufacture. Specifically, all forms of basketry are manu-

ally assembled or woven without a frame or loom" (ibid.:1). In putting the emphasis on technology and materials rather than function and form, this simple definition closely parallels that of the Yekuana. It also permits the inclusion of such "un-basketlike" forms as hats, firefans (matting), and covering basketry. For more detailed descriptions of the actual manufacture of the different baskets, see Roth 1924, Hames and Hames 1976, and Henley and Mattéi-Muller 1978.

3. As various people have pointed out, to speak of a true warp and weft, that is, an inflexible, passive element and a pliable, active one, may be more of a convention than anything else when discussing twill plaited basketry, as each element is capable of a certain amount of movement and manipulation. Cf. Roth: "Each element of the weft passes over and then under two or more warp elements; in Guiana twilled basketry the warp and weft would appear to be sometimes indistinguishable" (1924:140).

4. For a full discussion of Koch-Grünberg's complicated relationship with the Yekuana see Guss 1986*b*. So ambivalent is his attitude that even his praise of Yekuana basketry is undermined by his subsequent statement that "their weavings do not owe their origin to any conscious artistic sentiment but to a simple manual dexterity they have learned from tribes of a higher level, perhaps the Guinau, now degenrated" ([1924] 1982:292).

5. For a detailed description of the preparation of these cane strips, see Roth 1924: 137–39.

6. If a man has more than one wife, as permitted by the Yekuana rules of polygamy, he makes each one a basket with her own design. As such, the emphasis is placed on the identity of the couple rather than on that of just the husband.

7. A linguistically independent group of approximately 19,500 individuals (Oficina Central de Estadística 1985:38), the Warao live along the waterways of the Orinoco Delta, subsisting mainly on gathering and fishing.

8. Not until the completion of the present volume did Reichel-Dolmatoff's recently published monograph on the basketry of the Desana Indians of Colombia come to my attention. As in his earlier studies of this Tukanoan group, Reichel-Dolmatoff emphasizes the relationship of iconography to strict marital rules of exogamy, as well as the images' origins in the hallucinatory visions of shamans. Equally important, however, is his insistence that baskets, like all artifacts, be viewed as "vehicles for the transmission of cultural values" (1985:5):

> [Tukanoan] basketry contains a complex body of symbolic structures which relate it to other aspects of culture and make it an essential part of the Tukanoan adaptive system and world view. To speak of basketry as a craft, a technology, at best, as an art, gives a wholly one-sided view in that it disregards the essential trait of *information* encoded in the artifacts. (ibid.:43)

9.
> Men and women devote more time to basket manufacture than to all other handicraft activities combined. The amount of time spent by any individual in basket production is a function of

his or her age. The amount of time devoted to making any particular basket is determined by whether it is used in manioc processing or not. These relationships are quantitatively described in the tables and figures below.

Yekuana males spend an average of 18.9 minutes per day making baskets, or 115 hours per year. Married males spend 26 minutes per day and unmarried males 8.3 minutes per day. Age generally determines the amount of time an individual spends making baskets. Using the Pearson product-moment formula, we find that the correlation coefficient (r) is 0.87 for men. By squaring this figure (r^2) we get 0.75 which means that three-quarters of all the variation in minutes per day for basketmaking is due to the independent variable of age. The significance of this relationship is that as one ages, one is not able to engage in the active pursuits (hunting, clearing gardens, etc.) of able-bodied men and, as a consequence, one must devote more time to sedentary economic activities in order to make a contribution to the household economy. (Hames and Hames 1976:25)

10. The difference between traditional Panare and Yekuana styles of basketry is described by Henley and Mattéi-Muller as follows:

In the traditional Panare style, variation in the graphic pattern is achieved by manipulating the chromatic sequence whilst the weave pattern is held relatively constant. Since the chromatic sequence is discontinuous and colored elements occur in both axes, the chromatic sequence generally masks the weave pattern. In some traditional Panare guapas, the weave pattern and the graphic pattern have different visual centers which compete for the attention of the viewer's eye, thus giving rise to a slight kinetic effect.

In contrast, in the Yekuana style, the graphic pattern is varied by manipulating the weave pattern whilst the chromatic sequence is held constant. Since the graphic pattern and the weave pattern covary, they are in effect identical in this style. (1978:89)

To distinguish the Yekuana style from that of the Panare, Henley and Mattéi-Muller propose the term "Guianese Tesselate Tradition." Inspired by a comparison with the small rectangular "tessera" of mosaic construction, they claim that Yekuana baskets adhere to four basic rules: (1) a set of colored elements forms one continuous axis of the weave, while an uncolored set forms the other, (2) the manipulation of the weave pattern determines the graphic form while the chromatic sequence remains constant, (3) no element may span across five of any other, (4) all elements are inserted at right angles to one another, thus prohibiting the appearance of diagonal lines.

11. The imposition of Western aesthetic values to determine the "authenticity" of primitive artistic expression has been noted among other traditions as well. As Karen Duffek has observed among contemporary Northwest Indian artists:

Consumer definitions of authentic Northwest Coast art as traditional are generally reflected in the marketplace. Stewart [1979:69] cites the example of a 1973 print by [Robert] Davidson which was originally titled "Abstract," and at first did not sell. She notes that "evidently such a modern art term was not acceptable for a work of Haida art, which is renowned for its classic traditionalism." Since there were few buyers for the print, Davidson renamed it "Killer Whale Fin" and raised the price. The edition sold out. (1983:107)

Yet another example of an indigenous art form that has responded to the pressures of a European market by emphasizing figurative over abstract elements is that of Australia's Aborigines. In this case, however, it appears to be a means by which the secrecy of sacred material is protected while at the same time giving the illusion of revelation. As explained by Morphy and Layton:

By converting the geometric content of the secret art into a figurative form, the multivalency of the symbolic motif is lost. Munbal [an aboriginal artist], by modifying the form of his paintings, can at the same time withold his secret paintings and fit in with the demands of the European art market. This is partly due to the inherent contradiction in the demands of that market, which requires paintings which are at the same time secret and aesthetically pleasing. Part of the aesthetic appeal (as perceived by European buyers) has been in the number of figures, but in Yolngu terms the more figurative content a painting has, the less it is secret or sacred. But figurative paintings are perfectly consistent with what Europeans understand by sacred art, that is, paintings which can be attributed on the basis of designs to artists of particular clans and which have accompanying stories which relate to well known themes in Arnhem Land mythology. (1981:60)

5. ORIGIN AND DESIGN

1. The *yaribaru* is a slender, double-pronged weapon carved from a single piece of hardwood (see pl. 22). An interesting variation of the drum origin story recounts how the first *sambuda* was borrowed from the Warishidi monkeys. After using the drum's hypnotic beat to put a group of visiting enemies to sleep, the Yekuana slew them.

2. Known as *marimonda* in Spanish and "long-haired spider monkey" in English, the Warishidi (*Ateles belzebuth*), one of the New World's largest primates, travel in multi-male groups and subsist on a diet of fruit (Tello 1979:52).

3. Literally meaning "the Headwater Place," Ihuruña is the homeland of the Yekuana. Its name is derived from its dramatic location at the headwaters of several Orinoco tributaries that include the Padamo, Kuntinamo, Erevato, Ventuari, and Caura. In some versions of this tale, other tribes join

with the Yekuana in their battle against the Warishidi. However, when the *kungwa* is opened and its contents divided, the tribes use their new powers to wage war upon one another. In these variations the tale is also used to explain the origin of war and the enmity between the tribes.

4. A small mountain sometimes referred to as Mount Marimonda, Mount Ihani is located in the uppermost headwaters of the Caura and Ventuari rivers near the Brazilian border. It should not be confused with Mount Warishidi, in which the Erevato has its source.

5. Normally a small leather pouch in which shamans store magic remedies, the *chakara* of this tale are described as *kungwa* baskets "the size of suitcases." Although the use of the word *medetta,* from the Spanish *maleta,* is used with some humor here, it emphasizes the enormous shamanic powers that Waña Kasuwai must possess to own *chakara* of this size.

6. In some versions of this tale the *waja* miniatures are referred to as "snapshots," a description that is not surprising, since the *waja* contained in the *kungwa* are meant to be *muestras* or "samples." The Yekuana term used here for these small baskets is *waja nakomokwa.*

7. Commenting upon the tradition itself, the storyteller wonders whether young people will still tell *Watunna* when they are as old as she is. "What will they say when they are my age?" she ponders. Such musings are not unique to this story but are part of a lengthy, self-reflexive "sign-off" common to many of the tales told by this narrator.

8. Common among many groups throughout the Amazonian Basin for tipping both arrows and blowgun darts, the Yekuana either produce their curare from an admixture of strychnines and toad poisons or trade for it with the neighboring Piaroa (de Civrieux 1974*a*:83).

9. While the *kungwa* of today are used by both shamans and nonshamans, they remain most closely associated with the former, a result no doubt of their role as containers for sacred maracas (see Koch-Grünberg [1924] 1982:324 for a description of a Yekuana healing session with *kungwa* present). This relation between shamans and telescoping baskets has been noted among other northern Amazonian tribes (Roth 1915:329, de Goeje 1943:108–9, Reichel-Dolmatoff 1971:137, Reichel-Dolmatoff 1978*a*:3–6). Among the Warao of the Amacuro Delta, for example, these baskets are called *torotoro,* and are used to store shamans' rattles, magic stones, and small wooden dolls which "can be sent out by the shaman as a pathogenic agent to kill the children of a neighboring village" (Wilbert 1975:67). When a Warao shaman prepares a *torotoro* to receive a rattle, he first lines the inner walls with *caranna* incense and chants:

> See here, my rattle.
> This basket is for you.
> You can occupy this *torotoroida.*
> No longer
> Do you have to lie on the floor
> Wrapped in a piece of cloth.
> Now you have a house of your own. (ibid.:63)

10. A small Carib-speaking tribe located along the Brazilian-Guyana border in the headwaters of the Essequibo and Mapuera rivers, the Waiwai, despite heavy acculturation caused by missionary activity over the last thirty years, remain one of the most closely related groups, linguistically and culturally, to the Yekuana (see Fock 1963 and Yde 1965).

11. Another interesting connection to serpents is that of the extraordinary geometric designs of the Shipibo of Peru, who attribute the origin of these designs to a Wiyu-like anaconda figure named Ronin: "Central to contemporary Shipibo-Conibo design perception is the symbolic complex of the cosmic anaconda, Ronin. Being the mythical donor of the designs, this world snake combines all conceivable designs in its skin pattern. Hence, all designs may be called *ronin quene*" (Gebhart-Sayer 1985:149).

12. De Barandiarán claims that Mawisha is actually the Yekuana term for the Carib or Kariña cannibals who once preyed upon them:

> The Carib cannibals of the Caura, called Mawisha (who appear with the same name in the maps of Cruz Olmedilla and Surville) remain a bloody and horror-filled chapter in current Yekuana tradition. The ferocious Mawisha cannibals swept down the Caura and Erevato all the way to the Padamo, taking hundreds of Yekuana slaves, and, after killing all of the men, fled with the captured women. All of these women were eventually sacrificed in Mawisha festivals once back in their own Caura communities, and, according to Yekuana tradition, the only part of these female victims which were eaten in these orgiastic ceremonies were their genital organs. The rest of the women's bodies were thrown to the dogs. (1979:778)

It should be noted that in Yekuana mythology one does not have to be a human to be classified as a cannibal. Warishidi monkeys and other species who once preyed upon human flesh are referred to as cannibals because they were carnivores during the amorphous time before fixed speciation. It is only when humans or So'to begin to eat meat that definitive speciation takes place and each animal assumes its final form. If this were not the case then the So'to too would have to be considered as cannibals.

13. A hallucinogen prepared from the inner bark of the *Anadenanthera peregrina, aiuku* is variously known among other South American groups as *ñopo, yopo,* and *vilca.* Its use among the Yekuana is restricted to shamans.

14. The word "heart" refers to the *ayewana akano akato,* "the *akato* inside the heart," and is used here as a synonym for "soul" or "double," the essential part of each person.

15. *Maahi,* as previously described, are small packets woven from San Pablo leaves which contain pieces of game or fish. They are used in a ceremony known as the *Waseha* in which those returning to or visiting a village promenade about the central square until, at a given signal, the residents of the community attack them, wrestling the *maahi* bundles away.

16. *Suhui wayutahüdi* is a symbol of the handle and is not meant as a representation of the actual cover design. The designs used in weaving the cover

basketry of not only the *suhui* but also the *tamu* and *yaribaru* are the simpler border motifs such as *ahisha* (the white heron) and others.

17.　　　　This hallucinogenic drug [*yopo* or *Anadenanthera peregrina*] is also present in the skin of poisonous toads, e.g., *Bufo marinus*. Such toads have long played an important role in mythology and ritual art, not only in Mesoamerica (especially among the Maya) but in Central and South America, a circumstance that I suggested in a discussion at the International Congress of Americanists in Stuttgart, Germany, in 1968, might possibly be related to the hallucinogenic properties in toad and frog poisons. A number of South American tropical-forest tribes are known to use frog or toad poison to induce ecstatic trance states akin to those resulting from the various botanical hallucinogens; in these cases, however, the drug is introduced directly into the bloodstream through self-inflicted burns or wounds rather than ingested orally. M. D. Coe (personal communication) found large quantities of *Bufo* remains in the important Olmec ceremonial site of San Lorenzo, Veracruz (1200–900 B. C.); these might have served as food but it is equally possible that the Olmec used poisonous toads as additives or "fortifiers" for fermented ritual beverages. This practice, first reported after the Spanish conquest from the Maya highlands by Thomas Gage in the early 1600s, survives to the present day among the Quiché-Maya of Guatemala (Robert M. Cormack, personal communication). It should be noted that the action of bufotenine on the human brain is not as yet well understood—for example, it appears that, unlike other hallucinogens, bufotenine does not fully penetrate the blood-brain barrier—nor is it known whether there might be some special effects from the combination of alcohol and toad poison, with its relatively high content of serotonine (a substance found in the human brain), as well as bufotenine, in the ritual beverages of Mesoamerica. (Furst, *Flesh of the Gods,* 1972:28)

18. Dedehidi, "Bat Mountain," is the Yekuana name for this peak located on the mid-Paragua, whereas Guaicanima is the original indigenous name appearing on most official maps. In a curious way, this tale presents an inverted version of the Yekuana's own migration to the Paragua from the Erevato and Caura. The narrator, acknowledging that the Yekuana are latecomers to this region, notes that it was not the Yekuana who killed Dede but Sape or Kaliña, the original inhabitants of the area:
Kaliña Wache, that's who killed him. Kaliña. They were Indians like us. Another kind. Black, you know. They used to live around Guaicanima. "Wache" is what they call *piache,* a shaman. Kaliña Wache. That was the chief who killed Dede.

19. Although this is the way the narrator told it, the etymology of Erevato, as based on this story, would appear to be more properly "bat fire," as *watto,* the word for "fire," is much closer to *-vato* than *wattä* or "feces." It might also make sense, since it was fire (*watto*) that was used to trap the bat. Yet what might be in evidence here is a folk etymology as evolved through

narrative, for "bat shit" certainly makes a more dramatic and humorous punch line to the tale. It should also be noted that Yekuana has no hard "d" or "r" but rather a single consonant falling somewhere in between. Thus (d)ede and ere are identical in pronunciation.

20. In addition to the designs located in the central portion of each basket, there are many peripheral or border designs as well. While many of these perform the critical structural function of keeping the weave tight by maintaining the necessary alternation of warp and weft, they also participate in the same symbolism found in the central designs; in every instance, they represent some aspect of poison or death. Ahisha, for example, the zigzag pattern that commonly rings the box around the central design (pls. 2, 4, 10, 16, 29, ect.) is the white heron (Casmerodius albus egrettus), symbol of both the Iaranavi or "whites" threatening and surrounding the Yekuana and of the hallucinogenic drug aiuku. Ahisha's leg bones, when hollowed out, are joined together to make a V-like snuffing tube with which the drug is inhaled (ahisha yehë, similar in shape to the design). Other border designs include: konohokudu ("rain"), parallel lines reaching from the outer rim of the basket to the central design; shidiche ("stars"), small X's used as either a border (pls. 1 and 29) or as a motif within the central design (pls. 12–14, 18, 25–28); Mönetta (both Ursa Major and "scorpion," literally translating as "blood house"—pls. 27 and 34); Kudaidai (the name of a small toad), a serrated tooth design used like ahisha to create a border around the central box; and Masacani jömödi ("Masacani's stripes," representing the markings of a lizard), a series of white squares set in a black background, also used as a border for the principal design (pls. 8 and 9).

21. Roe also notes "this ability to shift back and forth between a figure and its background as alternate figure" in the art of the Shipibo of Peru. Referring to this aesthetic tendency as "visual ambiguity," he claims that it is fundamentally "a symptom of a larger emphasis on 'mental ambiguity' " (1987:5–6).

22. While this structural dualism is built into the Wanadi motai and Dede designs, it is an optional feature of the more figurative ones, such as the monkeys, frogs, and toads.

23. It should be mentioned that this same kinetic abstraction, so prominent in the designs of the waja, has been the dominant aesthetic force in contemporary Venezuelan art for the last thirty years. Whether there is any connection is difficult to determine. Nevertheless, it is curious that in Venezuela alone of all the South American nations kinetic abstractionism has been the most durable and influential movement in both painting and sculpture. For examples of this widespread tendency, one is referred to the work of Alejandro Otero, especially his Coloritmo series; Narcisco Debourg, whose wall sculptures of squares and circles recall the same repetitive motifs of the baskets; Carlos Cruz Diez, whose enormous floor-to-ceiling mosaic in the new Caracas airport is the first thing one sees upon entering Venezuela; and finally, the most prolific and famous of all of Venezuela's artists, Jesus Soto. It is in Soto, an artist raised in the Orinoco town of Ciudad Bolívar, that kinetic art finds its most eloquent expression as a form of "popular abstraction." For

not only do his large paintings and sculptures inevitably draw the viewer into the vibrating movement of their surfaces, but some of his work is constructed so that the audience must physically enter into it. These are the enormous hanging environments of pendulums and bars which the viewer, walking through and touching, also helps to create through his or her shifting perspective and participation.

24. It is interesting to note a similar reference made by Reichel-Dolmatoff in his investigation of the geometric designs of the Tukano Indians of the Vaupes area of southern Colombia. After identifying the central portion of a classic hourglass design (called *Ahisha* in Yekuana, pl. 30) as representing a female organ, he goes on to state that "to perceive the negative, empty spaces and to attribute to them special importance are not infrequent in Tukano culture" (1978:32). This concept of "negative spaces," which so aptly characterizes the Yekuana designs as well, is also a vital part of the Tukano designs' message which, as Reichel-Dolmatoff asserts, lies "in the compatibility of complementary forces, the central theme of their cosmological system" (ibid.:148).

25. "All the actions performed in a space constructed in this way are immediately qualified symbolically and function as so many structural exercises through which is built up practical mastery of the fundamental schemes, which organize magical practices and representations" (Bourdieu 1977:91).

26. There are a small group of basket makers at this level of competence who choose to create completely aberrant designs. Although these creations may refer in some way to such traditional forms as *Mado fedi* or *Woroto sakedi,* they are primarily asymmetrical labyrinths with no precedents whatsoever (pls. 37–39). While other basket makers tend to dismiss this work, it is claimed that this freer style of creation was the way in which the outer portions of all baskets, the part now dominated by the *konohokudu* or "rain" motif, were formerly finished (pls. 27 and 34). Hence, despite disparagement, it is only the most skilled craftsmen (i.e., the *towanajoni*) who attempt to weave such baskets.

27. Also known as the "tame Motilones," the Yupa are a small Carib-speaking group living in the Perija Mountains between Colombia and Venezuela. Concerning Kopecho and other related toad figures—all of whom are distant cousins to the Yekuana's Kawau—Wilbert writes: "Kopecho is the Yupa version of Toad Grandmother as Mistress of the Earth and the Underworld. Among the Tacana she herself devours the dead, just as does Tlaltecuhtli, the personification of the earth as a monstrous toad in Aztec Mexico" (1974:25). For more on the ubiquitous toad figure in Meso and South American mythology, see Métraux 1946, Furst, "Symbolism and Psychopharmacology," 1972, and Kennedy 1982.

6. THE FORM OF CONTENT

1. The Panare also believe that a shaman (*i'yan*) must gain permission from a half-human, half-animal figure who owns the basketry materials before

they can safely cut the cane down. While this similar custom is by no means surprising, the conclusion of Henley and Mattéi-Muller that it is the only acknowledged "metaphysical belief associated with basketmaking" is (1978:46).

2. The major remedy for attacks by Yododai is the *maada* or magic herb called *woi*. Describing this large-leafed caladium that Wanadi originally brought to Earth to cure his daughter of menstruation, one Yekuana said:
 It kills people. It's dangerous. Those leaves are its arms. It's a person. It can kill Yododai. You know, when you come in and hurt all over, everything! [rubbing along his arms and legs] . . . Yododai. Grate a little of that *woi* and rub it all over, everywhere. It stings like crazy. It hurts. It's poison, Yododai dies.

3. The speaker refers to Carmelo Dominguez, another villager whose wife had just given birth.

4. It is emphasized by the Yekuana that *wana* are actually the Yododai's "armaments," just as *tamu* are the weapons of the jaguar, and the drums or *samhuda* the weapons of the Warishidi. However, as a weapon *wana* is more associated with the three-foot-long horn which is made from it and also bears its name. These horns, always played in tandem, male and female, are the most familiar instruments, along with the drum, of the *wanwanna* drinking festivals. Although similar to the sacred flutes of the Yurupary cults found throughout the Amazon (see S. Hugh-Jones 1979), these horns have none of the taboos or secrecy associated with them.

5. Wilbert reports that among the Warao, improper disposal of the unused parts of itiriti results in "boils in the anal or pubic regions or else with an excruciating toothache":
 To discard itiriti refuse in a secluded part of the forest is quite proper, as is disposing of it in the river. But itiriti stems must never be treated as garbage. In fact, as explained in the itiriti origin myth, neatness and proper conduct are the most characteristic features of the Itiriti people and, therefore, the trademark of the basket maker's profession. (1975:6)

6. In addition to these dietary restrictions, those casting barbasco are also forbidden any sexual contact (de Barandiarán 1962a:28). This prohibition, along with that forbidding the participation of menstruating women, is also imposed upon hunters.

7. The Yekuana also distinguish between these different fasts, referring to the incidental, disease-related ones as *chätami'yehe* and the much longer, life-cycle ones as either *wänimana* or simply *amoichadi*.

8. The other life-cycle fast that should be noted, despite its restricted character, is that for an apprentice shaman. Lasting anywhere from five to ten years, the difficulty of this fast is said to be the major obstacle in becoming a shaman. During the entire period, an apprentice's diet is restricted to cassava mixed in warm water (*tanünë*), stale cassava crackers, and small fruit-eating birds, the most prized of which is Tukuiyene, the purple

honeycreeper (*Cyanerpes caeruleus*). Once initiated, the shaman repeats this fast for at least two weeks each time he imbibes an hallucinogen.

9. It should be recalled that in addition to these three fast states, the *Kutto shidiyu* basket is also used by newlyweds during their first months of marriage. As such, the same symbols of birth and transition are invoked, particularly on the wedding night when the couple dines on their first meal of warm *sukutuka*. In a discussion of the Dayaks of Borneo, Eliade points out the recurring similarities in the symbols surrounding birth, menstruation, death, and marriage:

> During the ceremonies of marriage, the couple return to the mythical primeval time. Such a return is indicated by a replica of the tree of life that is clasped by the bridal pair. Sharer was told that clasping the tree of life means to form a unity with it. "The wedding is the reenactment of the creation, and the reenactment of the creation is the creation of the first human couple from the Tree of Life." Birth also is related to the original time. The room in which the child is born is symbolically situated in the primeval waters. Likewise, the room where the young girls are enclosed during initiation ceremonies is imagined to be located in the primordial ocean. The young girl descends to the underworld and after some time assumes the form of a watersnake. She comes back to earth as a new person and begins a new life, both socially and religiously. Death is equally conceived as a passage to a new and richer life. The deceased person returns to the primeval era, his mystical voyage indicated by the form and decorations of his coffin. In fact, the coffin has the shape of a boat, and on its side are painted a watersnake, the tree of life, the primordial mountains, that is to say the cosmic/divine totality. In other words, the dead man returns to the divine totality which existed at the beginning. (1984:143–44)

10. One might compare this situation to that described by Victor Turner (1967:96), wherein the "liminal personae has a twofold character . . . at once no longer classified and not yet classified." As a result, Turner observes, the symbols that surround them are a mixture of those of death and decomposition and gestation and parturition.

11. Only blood relations such as children, parents, and siblings undergo the death fast. Affinal ones such as husbands and wives do not.

12. The young narrator of this story was familiar with movies from the cinema (a few steep benches banked in front of a concrete wall) in the trading-post town of La Paragua.

13. For interesting parallels to this story see "Live Woman in the Underworld" in Christine Hugh-Jones 1979:110–13, and "The Journey to the Beyond: A Guajiro Eurydice" in Perrin 1987:9–20.

14. The Akawaio are a Carib-speaking group living in the northern part of the Pacaraima Mountains in Guyana and the headwaters of the Cotingo in Brazil. Their estimated population is 5,000 (Butt Colson 1978:5).

15. While I have never heard this idea articulated as such, the Yekuana do inaugurate all fasts with a drink of warm cassava and water.

16. If this is the case, then the creation story of these baskets is actually based on an historical model, as the Warao claim that they originally learned how to make baskets from a group of cannibalistic neighbors called the Siawani (Wilbert 1975:7).

17. In keeping with this natural model, Warishidi, the spider monkey, has a black face (like the designs of Woroto Sakedi) framed by an otherwise brown body. Hence, if *ayawa* or red is associated with Wanadi, Heaven, and birds (the ones who first taught humans how to use it), the "Devil's face paint" or black is associated with Odosha, Earth, and the monkeys. Or, put another way, the opposition is consistently one between the high, pure, and sacred and the low, contaminated, and profane.

18. Such a misreading of the relation between face paint and design was unquestionably responsible for Koch-Grünberg's unsympathetic appraisal of the Yekuana's artistic abilities:

> Outside of their woven art, the spontaneous expressions of art among the Yekuana are very few. Only a handful of their utensils have any crude paintings on them. The designs and the figures of men and animals that they paint on their bodies, or on the outer walls of their houses or on the inner bark ones are almost all at the lowest artistic level, which is proof that even the flat plates [*waja*] with their fine designs, the only works of art that their weaving produces, do not owe their origin to any conscious artistic sentiment but to a simple manual dexterity they have learned from tribes of a higher level, perhaps the Guinau, now degenerated. ([1924] 1982:292)

19. These packets are referred to as *saneke emidi,* "hanging bundles."

20. These mawadi should not be confused with the other supernatural Mawadi, the giant anaconda who are the servants and people of Wiyu. And yet, while the Yekuana distinguish between the two, it is difficult to ignore their various similarities. Not only are both related to Odosha and a threat to humans, but they are also characterized as serpentine. Furthermore, while the "painted" *waja* design called *Mawadi asadi* or "Mawadi inside" is said to represent the larger Wiyu-related Mawadi, it nevertheless recognizes the sinister presence of the other mawadi as well. It is for this reason that this design alone among all the *waja* is permanently forbidden from being used in connection with food. For, as the Yekuana say, "It causes stomachaches."

21. "Weed out mawadi he" is a translation of the *Tingkui yechamatojo's* principal refrain, *wani mawadi chaye.* While *wani* is a shamanic term reserved for sacred song which means "to cleanse, purify, weed out, root out, destroy, or empty out," *chaye* is a strictly terminal form with no translatable meaning. Depending upon its placement in the chant, the singer may sometimes pronounce it "chaye," "chaiye," "chaiymm," or "chaymmm." In an attempt to recreate the rhythm, meter, and sound of the phrase, I have

translated it with the equally meaningless word "he," pronounced like the English word, "hay."

22. In a variety of ways, the chant invokes every woven item or a part of them, directing the *wiriki* people "with their *kananasi*" to "weed out the mawadi." It begins with Ka'nama Lake and Mayana Lake, where Edodicha discovered the *ka'na* for the *sebucan* yuca presses and *waja tingkuihato* baskets respectively.

23. "Teñeku" is the name of the principal *wiriki* person invoked throughout the chant. As already noted, *wiriki* are small quartz crystals that serve as the shaman's primary healing stones. Hence, upon his initiation, each shaman must travel to Heaven to receive his own *wiriki*, which he then puts in his maraca along with the roots of the shaman's drugs, *aiuku* and *kaahi*. When a shaman dies, his maraca remains on Earth but his *wiriki* return to Heaven with him. The *wiriki* people summoned in the *Tingkui yechamatojo* are also said to have once lived on the Earth but now dwell in Heaven. In addition, many of those who are invoked are recognizable as shamans' helpers from other chants and rituals.

24. Another of the *wiriki* beings, the name "Kananasiwedu" can be translated as "dry *kananasi*," as *wedu* means either "dry season" or "year," and one of the characteristics of *kananasi* is its very pure, hard, dry texture.

25. *Yaweku, wayuweyoingma,* and *kasidima* are the sacred names for the three types of *sebucans* which Edodicha brought to Earth. *Yaweku,* called a *deweke humudu* by the Hameses (1976:9), is the small one and *wayuweyoingma* and *kasidima* the large, full-sized ones.

26. Like several of the other *wiriki* beings, Tamenamasi was unidentifiable.

27. Translatable as "lives in Heaven," Kahuyawasi is identified as a small owl said to be the brother of the great potoo, Müdo.

28. Kahukawasi is the secret or shamanic name for the great potoo (*Nyctibius grandis*) otherwise known as Müdo. Often ridiculed for his ugliness, Müdo is Wanadi's brother and one of the three most powerful bird spirits.

29. Although the *wiriki* people are said to lack any collective name, the *Tingkui yechamatojo* does invoke a group called the Wadatakomo, the "Stone" or "Crystal People." As part of this invocation, the figures Sewi, Wawi, and Fatokoingma are called upon, in a variation of the *kananasi* refrain, to make the basket, food, and chant "just as clear and pure" as their crystals. Or in the words of the chant itself: Wadatakomo *wadataduche wakadawanaduke,* "Crystal People with their crystals. Make it just as clear as that."

30. The singer apparently mixes two different formulas here, as Fatokoingma *wadataduche* would normally be followed by *wakadawanaduke* or "Fatokoingma with that crystal. Make it just as clear as that." Instead, it concludes with *kananasi akane,* "with *kananasi* inside," the phrasing that usually follows the name of a *wiriki* person. Whether this truncated form, which appears nowhere else in the chant, was intentional or simply a lapse of concentration could not be ascertained.

31. This reference is to the large gourds or *famuka* that are used to serve fermented yuca drinks such as *iarake* and *cashiri*. As the only other containers in which yuca products are presented, they must also be cleansed of any *mawadi* by the chant. A natural extension of this invocation is the request that the alcohol, or the *mawadi* in it, not give the drinker a headache.

32. Another threat to the baskets in addition to the *mawadi* is the Snake People or Madedekomo who often "plug up their mouths." This threat of course is mainly to the *sebucan* and *wuwa*, the two baskets with pronounced mouth-like openings. As such, the invocations against these beings are made in both the *sebucan* and *wuwa* sections of the chant. In addition to these invocations, it is asked that the Madedekomo not "plug up the mouths of the children," that is, that they not cause them to lose their appetites or their ability to eat and digest. Closely associated with Odosha, the Madedekomo are actually the masters or *arache* of all the earth spirits. Known as *nono akudi,* the "earth snake" in vulgar, nonshamanic language, they are said to be the size of coral snakes, with small painted heads. And while they do not bite, they are considered harbingers of death. Hence, the appearance of a *nono akudi* is always interpreted as the announcement of one's death.

 Although it was impossible to ascertain the exact identity of the *nono akudi* it is quite probable that it is actually a blind and limbless subterranean amphisbaena lizard, noted for its supernatural powers among the neighboring Yanomami as well. As Lizot writes:

 > The Indians [Yanomami] believe that an amphisbaena comes out of the spinal column of every man killed in war. They hold that this lizard is in contact with the underworld where dwell the *amahiri;* indeed, it is not unusual to see one emerge in the central plaza, but the dwelling where it appears is never that of the human being from whom it came. When one sees it, one asks: Who are you? Where do you come from?
 > If it has friendly intentions, the amphisbaena makes high-pitched noises: ei, ei, ei!
 > If it remains quiet, it is advisable to distrust it. (1985:54)

33. "Kuwaha" is the name of a *maada* or magic herb used specifically against the Madedekomo. While it is difficult to determine its exact identity, *kuwaha* might be a *Marantaceae,* otherwise known among the Yekuana as *katano kato.* In this latter form it is used to treat children's fevers and to keep enemies away. Among the criollo population of Venezuela, this same plant is commonly used to treat diarrhea and in the easternmost region of Guiria as a powdered food for children.

34. Kawütawa is the nighthawk (*Podager nacunda*) who lives with Müdo and Höhöttu in the sixth house of Heaven, where he serves as a powerful shamanic helper. Normally referred to as Tawadi, his shamanic name (Kawütawa) may be translated as "Tawa" or "Tawadi above."

35. Kakuyawa, Edakiyuwa, and Iyaduwo are all unidentified *wiriki* people.

36. Another of the *wiriki* people, Dohütowa is the name of a very tall tree, the hardwood of which is used for certain cures.

37. Wajaniyuwa, whose name means "who uses *waja*," was the first woman to ever use a *waja* and to purify it with the *Tingkui yechamatojo*. Identified as Wanadi's daughter, Wanasicha, she is said to have received the first *waja* along with the chant directly from Edodicha. Or, as the *aichudi* itself says, "Edodicha made it. He made Wajaniyuwa's *waja*." This particular section of the chant is referred to as the *Wajaniyuwa'jai*, the part that specifically detoxifies "painted" *waja*. Immediately following this section is the one addressing *manade*, hence the reference to Yanadewa, the first woman to ever possess and purify a *manade*.

38. The final part of the *Tingkui yechamatojo* focuses on the only basket woven by women, the *wuwa*, along with the materials used in its construction. In the shamanic language of the chant, the women's carrying basket is referred to as *amunkayedono* or "the woven thing hanging down their back," from the root *unkawa*, meaning "back" or "behind." The *muñatta* with which it is woven is referred to by both its master, Wasamo Wasadi, and the sacred name, *wasamé*. *Amaamada*, on the other hand, the material used to form the stiff inner rings of the *wuwa*, is called, in the language of the chant, *yowada*.

7. TO WEAVE THE WORLD

1. The small rafters around which the vines for the outer thatch are wrapped, the *yaradi* or "fingers" are laid directly on top of the *biononoi*. When looking up at them from the floor of the *atta*, as one often does when lying in one's hammock, they form a pattern similar to the "rain" (*konohokudu*) design of the "painted" *waja*. This parallel is underlined by the close relation of two synonyms for these forms: for *konohokudu*, *konoho inyadi*, "it's raining," and for the entire inner canopy of the roof, *inyaduhtu*, a word used to describe anything "completely closed in."

2. Several of these associations concerning the structural relation between the "painted" *waja* and the Yekuana conceptualization of the universe are also discussed by Henry Corradini in the introduction to a brochure published on the occasion of an exhibition of Yekuana basketry held in Caracas in 1982.

3. The relationship between the designs of artifacts and the personal or psychic integration of an individual has been pointed out in several other South American traditions as well (cf. T. Turner 1969, Reichel-Dolmatoff 1978*a*, and Perrin 1986). Among the Shipibo-Conibo of Peru, for example, a form of design therapy is practiced in which shamans actually sing invisible designs onto their patients' bodies in order to restore them to order and balance. As described by one shaman:

 At first, the sick body appears like a very messy design. After a few treatments, the design appears gradually. When the patient is cured, the design is clear, neat, and complete. In my visions, I watch Hummingbird hover above the patient. With each swish of his wings, a part of the design emerges. He also draws with his

> beak and tongue. If the design refuses to become clear, I know
> that I cannot heal the patient. I am not told the meaning of the
> individual design elements, but I know by my overall impression
> of the designs what I have to sing. (Gebhart-Sayer 1985:164)

It is these healing designs which in turn form the basis of the Shipibo-
Conibo's intricate cloth, ceramic, bead, and face-paint patterns. Also de-
rived from healing visions are the many designs used to cover both the
artifacts and bodies of the different Tukanoan groups. As E. Jean Langdon
makes clear, these designs are an integral part of the songs received by
shamans while traveling in the spirit world:

> When under the affects of *yagé,* he [the shaman] sings of what he
> is seeing; he sings of the spirits who are coming and describes
> their clothing, faces, houses, and furniture. All the spirits have de-
> signs on their bodies and belongings, and the shaman sings of the
> motifs of the designs by naming the motifs and their colors. These
> different motifs are already known to the Siona, for they occur on
> the painted faces of the elders, on the decorated pots and other
> artifacts, and in times past on their clothing. (1979:67)

Bibliography

Adovasio, J. M.

1977 *Basketry Technology: A Guide to Identification and Analysis.* Chicago: Aldine Publishing Company.

Alizo, David, and Ramón Palomares

1969 *La rana, el tigre, los muchachos y el fuego: mito de los indios Maquiritares.* Caracas: Ediciones Caballito del Sol.

Anthon, Michael

1957 "The Kanaima." *Timehri* 36: 61–65.

Aretz, Isabel

1972 *Manual de folklore Venezolano.* Caracas: Monte Avila Editores.

Armellada, Cesáreo de

1972 *Pemonton Taremuru: Invocaciones mágicas de los indios Pemon.* Caracas: Universidad Católica Andrés Bello.

Armellada, Cesáreo de, and Carmela Bentivenga de Napolitano

1975 *Literaturas indígenas Venezolanas.* Caracas: Monte Avila Editores.

Arvelo-Jimenez, Nelly

1971 *Political Relations in a Tribal Society: A Study of the Ye'cuana Indians of Venezuela.* Latin American Studies Program Dissertation Series, no. 31. Ithaca, N.Y.: Cornell University.

1972 "An Analysis of Official Venezuelan Policy in Regard to the Indians." In *The Situation of the Indian in South America,* edited by World Council of Churches. Geneva: University of Berne.

1973 *The Dynamics of the Ye'cuana (Maquiritare) Political System: Stability and Crises.* IWGIA Document, no. 12. Copenhagen: International Work Group for Indigenous Affairs.

1977 "A Study of the Process of Village Formation in Ye'cuana Society." In *Carib-Speaking Indians.* See Basso 1977.

Basso, Ellen B., ed.

1977 *Carib-Speaking Indians: Culture, Society, and Language.* Tucson: University of Arizona Press.

Basso, Ellen B.

1985 *A Musical View of the Universe: Kalapalo Myth and Ritual Performances.* Philadelphia: University of Pennsylvania Press.

1987 *In Favor of Deceit: A Study of Tricksters in an Amazonian Society.* Tucson: University of Arizona Press.

Biocca, Etore

1971 *Yanoama.* New York: E. P. Dutton & Co., Inc.

Blixen, Olaf

1965 "La colección etnográfica Dikuana (Makiritare) del Museo Nacional de Historia Natural." *Comunicaciones antropológicas del Museo de Historia Natural de Montevideo* 4(1):1–31.

Blixen, Olaf, and Miguel A. Klappenbach

1966 "Notas sobre tatuajes y pinturas corporales de los Makiritare." *Comunicaciones antropológicas del Museo de Historia Natural de Montevideo* 5(1):1–7.

Bourdieu, Pierre

1977 *Outline of a Theory of Practice.* Cambridge: Cambridge University Press.

1979 "The Kabyle House or The World Reversed." In *Algeria 1960.* Cambridge: Cambridge University Press.

Butt, Audrey J.

1956 "Ritual Blowing: Taling as a Causation and Cure of Illness among the Akawaio." *Man* 56:37–52.

1957 "The Mazaruni Scorpion: A Study of the Symbolic Significance of Tatoo Patterns among the Akawaio." *Timehri* 36:40–49.

1961 "Symbolism and Ritual among the Akawaio of British Guiana." *Nieuwe West-Indische Gids* 2:141–61.

1970 "Land Use and Social Organization of Tropical Forest Peoples of the Guianas." In *Human Ecology in the Tropics*, edited by J. P. Garlick. Oxford and New York: Pergamon Press.

1973 [Audrey Butt Colson] "Intertribal Trade in the Guiana Highlands." *Antropológica* 34:2–70.

1976 [Audrey Butt Colson] "Binary Oppositions and the Treatment of Sickness among the Akawaio." In *Social Anthropology and Medicine*, edited by J. B. Loudon. ASA Monograph no. 13. London: Academic Press.

1978 [Audrey Butt Colson] *Oposiciones binarias y el tratamiento de la enfermedad entre los Akawaio*. Caracas: Universidad Católica Andrés Bello.

Chaffanjon, Jean

1889 *L'Orénoque et le Caura*. Paris: Hachette.

Cocco, P. Luis

1972 *Iyëwei-teri, quince años entre los Yanomamos*. Caracas: Escuela Técnica Popular Don Bosco.

Cohen, J. M., ed. and trans.

1969 *The Four Voyages of Columbus*. Baltimore: Penguin Books.

Coppens, Walter

1971 "Las relaciones comerciales de los Yekuana del Caura-Paragua." *Antropológica* 30:28–59.

1972 *The Anatomy of a Land Invasion Scheme in Yekuana Territory, Venezuela*. IWGIA Document, no. 9. Copenhagen: International Work Group for Indigenous Affairs.

1981 *Del canalete al motor fuera de borda*. Monograph no. 28. Caracas: Fundación La Salle de Ciencias Naturales.

Coppens, Walter, Barbara Brändli, and Jean Francois Nothcomb

1975 *Music of the Venezuelan Yekuana Indians*. FE 4104. New York: Folkways Ethnic Records.

Cora, María Manuela de

1972 *Kuai-Mare: Mitos aborígenes de Venezuela*. Caracas: Monte Avila Editores.

Corradini, Henry E.

1982 *Los Ye'kwana en Yakera*. Caracas: Editorial Arte.

Crocker, Jon Christopher

1985 *Vital Souls: Bororo Cosmology, Natural Symbolism, and Sha-manism.* Tucson: University of Arizona Press.

Cruxent, José M.

1953 "Guanari, dios bueno Makiritare." *Boletín indigenista Venezolano* 1(2):325–29.

de Barandiarán, Daniel

1961 *Santa María de Erebato o la Fundación de un nuevo pueblo en el Estado Bolívar.* Caracas: Editorial Sucre.

1962*a* "Actividades vitales de subsistencia de los indios Yekuana o Makiritare." *Antropológica* 11:1–29.

1962*b* "Shamanismo Yekuana o Makiritare." *Antropológica* 11:61–90.

1966 "El habito entre los indios Yekuana." *Antropológica* 16:1–95.

1979 "Introducción a la cosmovisión de los indios Ye'kuana-Makiritare." *Montalbán* 9:737–1004.

de Civrieux, Marc

1957 "Un mapa indígena de la cuenca del alto Orinoco." *Memoria de la Sociedad de Ciencias Naturales La Salle* 17(47):73–84.

1959 "Datos antropológicos de los indios Kunuhana." *Antropológica* 8:85–146.

1960*a* "Leyendas Maquiritare." *Memoria de la Sociedad de Ciencias Naturales La Salle* 20(56):105–25.

1960*b* "Leyendas Maquiritare (continuación)." *Memoria de la Sociedad de Ciencias Naturales La Salle* 20(57):175–88.

1968*a* "El viaje extraordinario de Meda'tia: Tradición Makiritare." *Elan* 1(1):14–27.

1968*b* "Mitología Maquiritare: La primera historia." *Oriente: Revista de Cultura* 1(3):30–33.

1970*a* "Los Ultimos Coaca." *Antropológica* 26:3–108.

1970*b* *Watunna: Mitología Makiritare.* Caracas: Monte Avila Editores.

1973 "Clasificación zoológica y botánica entre los Makiritare y los Kari'ña." *Antropológica* 36:3–82.

1974*a* *El hombre silvestre ante la naturaleza.* Caracas: Monte Avila Editores.

1974*b* *Religión y mágia Kari'ña.* Caracas: Universidad Católica Andrés Bello.

1976 *Los Caribes y la Conquista de la Guayana Española (Etnohistoria Kari'ña).* Caracas: Universidad Católica Andrés Bello.

1980 *Watunna: An Orinoco Creation Cycle.* Edited and translated by David M. Guss. San Francisco: North Point Press.

1985 "Medatia: A Makiritare Shaman's Tale." Translated and with an introduction by David M. Guss. In *The Language of the Birds: Tales, Texts, and Poems of Interspecies Communication*, edited by David M. Guss. San Francisco: North Point Press.

de Goeje, C. H.

1943 *Philosophy, Initiation, and Myths of the Indians of Guiana and Adjacent Countries.* Leiden: E. J. Brill.

de Schauensee, Rodolphe Meyer, and William H. Phelps, Jr.

1978 *A Guide to the Birds of Venezuela.* Princeton: Princeton University Press.

Duffek, Karen

1983 " 'Authenticity' and the Contemporary Northwest Coast Indian Art Market," *British Columbia Studies* 57:99–111.

Dumont, Jean-Paul

1972 *Under the Rainbow: Nature and Supernature among the Panare Indians.* Austin: University of Texas Press.

1978 *The Headman and I: Ambiguity and Ambivalence in the Field-working Experience.* Austin: University of Texas Press.

Dwyer, Jane Powell, ed.

1975 *The Cashinahua of Eastern Peru.* Providence: The Haffenreffer Museum of Anthropology.

Eliade, Mircea

1959 *The Sacred and the Profane.* New York: Harper & Row.

1960 *Myths, Dreams, and Mysteries.* New York: Harper & Row.

1964 *Shamanism: Archaic Techniques of Ecstasy.* Princeton: Princeton University Press.

1984 "Cosmogonic Myth and 'Sacred History.' " In *Sacred Narrative: Readings in the Theory of Myth*, edited by Alan Dundes. Berkeley, Los Angeles, London: University of California Press.

Escoriaza, Damián de

1959 "Datos lingüísticos de la lengua Makiritare." *Antropológica* 6:7–46.

1960 "Algunos datos lingüísticos más sobre la lengua Makiritare." *Antropológica* 10:61–70.

Farabee, William Curtis

1924 *The Central Caribs.* University Museum Anthropological Publications, vol. 10. Philadelphia: University of Pennsylvania Press.

Fernández, Rafael, Mireya Figueroa, and Hernán González

1979 *Ye'kuana: Nos cuentan Los "Makiritares."* Caracas: Biblioteca de Trabajo Venezolano.

Fock, Niels

1963 *Waiwai: Religion and Society of an Amazonian Tribe.* Copenhagen: The National Museum.

Frechione, John

1986 "Unión Makiritare del Alto Ventuari: Autodeterminación por los indios Yekuana en el sur de Venezuela." *Montalbán* 16:7–46.

Fuchs, Helmuth

1962 "La estructura residencial de los Maquiritare de 'El Corobal' y 'Las Ceibas,' Territorio Federal Amazonas, Venezuela." *América Indígena* 22(2):169–90.

1964a "El sistema de cultivo de los Deukwhuana (Maquiritare) del alto Río Ventuari, Territorio Federal Amazonas, Venezuela." *América Indígena* 24(2):171–95.

1964b "Un mito aborigen y su significado." *Revista Nacional de Cultura* 162/63:179–96.

Fundación para el Desarrollo de la Cultura

1983 *Arte Indígena de Venezuela.* Caracas: Ministerio de Estado para la Cultura.

Furst, Peter

1972 "Symbolism and Psychopharmacology: The Toad as Earth Mother in Indian America." In *Religión en Mesoamerica, XII Mesa Redonda.* Mexico, DF: Sociedad Mexicana de Antropología.

Furst, Peter, ed.

1972 *Flesh of the Gods: The Ritual Use of Hallucinogens.* New York: Praeger Publishers.

Gebhart-Sayer, Angelika

1985 "The Geometric Designs of the Shipibo-Conibo in Ritual Context." *Journal of Latin American Lore* 11(2):143–75.

Geertz, Clifford

1973 *The Interpretation of Cultures.* New York: Basic Books.
1976 "Art as a Cultural System." *Modern Language Notes* 91:1473–99.
1983 *Local Knowledge.* New York: Basic Books.

Gheerbrant, Alain

1952 *L'expédition Orénoque-Amazone.* Paris: Gallimard.

1954 *Journey to the Far Amazon.* Translated by Edward Fitzgerald. New York: Simon and Schuster.

Giménez, Simeón

1981 "Testimonio del dirigente indígena Ye'kuana Simeón Giménez: La Espada y la Cruz: Misión Nuevas Tribus." In *El caso Nuevas Tribus,* edited by Estaban E. Mosonyi et al. Caracas: Editorial Ateneo de Caracas.

González Niño, Edgardo

n.d. *Amazonas: El medio—el hombre.* Caracas: Ministerio de Obras Publicas.

Govinda, Lama Anagarika

1976 *Psycho-cosmic Symbolism of the Buddhist Stupa.* Emeryville, Calif.: Dharma Press.

Gross, Daniel R., ed.

1973 *Peoples and Cultures of Native South America.* Garden City, N.Y.: Doubleday.

Guss, David M.

1977*a* "Letter from Venezuela." *Maratto* 1:22–23.

1977*b* "Parishira." *Maratto* 3:49–51.

1977*c* "Watunna." *Parabola* 2(2):56–65.

1979 "Jesus-Wanadi." *Zero* 3:148–56.

1980*a* "The Atta." *New Wilderness Letter* 2(8):14–16.

1980*b* "The Possessor of Songs." *Folklore and Mythology Studies* 4:17–25.

1980*c* "Steering for Dream: Dream Concepts of the Makiritare." *Journal of Latin American Lore* 6(2):297–312.

1981*a* "Adekato." *New Wilderness Letter* 2(10):31–33.

1981*b* "The Encantados." *Parabola* 6(1):20–21.

1981*c* "Historical Incorporation among the Makiritare: From Legend to Myth." *Journal of Latin American Lore* 7(1):23–35.

1981*d* "The Tale." In *The Poetry Reading: A Contemporary Compendium on Language and Performance,* edited by Stephen Vincent. San Francisco: Momo's Press.

1982*a* "The Encantados: Venezuela's Invisible Kingdom." *Journal of Latin American Lore* 8(2):223–72.

1982*b* "The Enculturation of Makiritare Women." *Ethnology* 21(3):260–69.

1985*a* *The Language of the Birds: Tales, Texts, and Poems of Interspecies Communication.* San Francisco: North Point Press.

1985*b* "El segundo círculo: la carrera de una mujer entre los Makiritares." *Montalbán* 16:277–95.

1985*c* "The Travel Dance." In *Secret Destinations: Writers on Travel* (Pequod 19–21), edited by Mark Rudman. New York: New York University.

1986*a* "History as a Symbolic System." Presented at the Eighty-fifth Annual Meeting of the American Anthropological Association, Philadelphia.

1986*b* "Keeping It Oral: A Yekuana Ethnology." *American Ethnologist* 13(3):413–29.

1987 "All Things Made: Myths of the Origins of Artifacts." Presented at the Fifth International Symposium on Latin American Indian Literatures (LAILA), Ithaca, N.Y.

Hames, Raymond B., and Ilene L. Hames

1976 "Ye'kwana Basketry: Its Cultural Context." *Antropológica* 44:3–58.

Harris, David R.

1971 "The Ecology of Swidden Cultivation in the Upper Orinoco Rain Forest, Venezuela." *The Geographical Review* 61(4):475–95.

Heinen, H. Dieter

1983/84 "Traditional Social Structure and Culture Change among the Ye'kuana Indians of the Upper Erebato, Venezuela." *Antropológica* 59–62:263–297.

Heizer, Robert F.

1963 [1948] "Fish Poisons." In *Handbook of South American Indians,* edited by Julian H. Steward, vol. 5, *The Comparative Ethnology of South American Indians.* Smithsonian Institution, Bureau of American Ethnology Bulletin 143. New York: Cooper Square Publishers, Inc.

Henley, Paul, and Marie-Claude Mattéi-Muller

1978 "Panare Basketry: Means of Commercial Exchange and Artistic Expression." *Antropológica* 49:29–130.

Hornbostel, Erich M. de

1955/56 "La Música de los Makushi, Taulipang, y Yekuana." *Archivos Venezolanos de Folklore* 3(4):137–58.

Hugh-Jones, Christine

1979 *From the Milk River: Spatial and Temporal Processes in Northwest Amazonia.* Cambridge: Cambridge University Press.

Hugh-Jones, Stephen

1979 *The Palm and the Pleiades: Initiation and Cosmology in Northwest Amazonia.* Cambridge: Cambridge University Press.

Humboldt, Alexander von

1852 *Personal Narrative of Travels to the Equinoctial Regions of America during the Years 1799–1804.* Translated and edited by Thomesina Ross. 3 vols. London: Henry G. Bohn.

Karsten, Rafael

1968 [1926] *The Civilization of the South American Indians, With Special Reference to Magic and Religion.* London: Dawsons of Pall Mall.

Kennedy, Alison Bailey

1982 "Ecce Bufo: The Toad in Nature and in Olmec Iconography." *Current Anthropology* 23(3):273–90.

Kleinman, Arthur M.

1974 "Medicine's Symbolic Reality: On a Central Problem in the Philosophy of Medicine." *Inquiry* 16:206–13.

Kloos, Peter

1968 "Becoming a Piyei: Variability and Similarity in Carib Shamanism." *Antropológica* 24:3–25.

1969 "Female Initiation among the Maroni River Caribs." *American Anthropologist* 71:898–905.

1971 *The Maroni River Caribs of Surinam.* Assen, The Netherlands: Van Gorcum.

Koch-Grünberg, Theodor

1979 [1924] *Del Roraima al Orinoco,* vol. 1. Translated by Federica de Ritter. Caracas: Ediciones del Banco Central de Venezuela.

1981 [1924] *Del Roraima,* vol. 2.

1982 [1924] *Del Roraima,* vol. 3.

Langdon, E. Jean

1979 "Yagé among the Siona: Cultural Patterns in Visions." In *Spirits, Shamans, and Stars: Perspectives from South America,* edited by David Browman and Ron Schwarz. The Hague: Mouton.

Lathrap, Donald W.

1970 *The Upper Amazon.* London: Thames and Hudson.

Lemonnier, Pierre

1986 "The Study of Material Culture Today: Toward an Anthropology of Technical Systems." *Journal of Anthropological Archaeology* 5:147–86.

Lévi-Strauss, Claude

1963*a* *Structural Anthropology.* Translated by Claire Jacobson and Brooke Grundfest Schoepf. New York: Basic Books. Reprint. Garden City, N.Y.: Doubleday, 1967.

1963*b* "The Effectiveness of Symbols." Chap. 10 in *Structural Anthropology.*

1966 *The Savage Mind.* Chicago: University of Chicago Press.

1969 *The Raw and the Cooked: Introduction to a Science of Mythology,* vol. 1. Translated by John and Doreen Weightman. New York: Harper & Row.

1977 *Tristes Tropiques.* Translated by John and Doreen Weightman. New York: Washington Square Press.

1979 [1955] "The Structural Study of Myth." In *Reader in Comparative Religion,* edited by William A. Lessa and Evon Z. Vogt, 4th ed. New York: Harper & Row.

Lizot, Jacques

1975 *El hombre de la pantorrilla preñada y otros mitos Yanomami.* Caracas: Fundación La Salle de Ciencias Naturales.

1985 *Tales of the Yanomami: Daily Life in the Venezuelan Forest.* Translated by Ernest Simon. Cambridge: Cambridge University Press.

Magaña, Edmundo, and Peter Mason, eds.

1986 *Myth and the Imaginary in the New World.* Amsterdam: Center for Latin American Research and Documentation.

Maquet, Jacques

1979 *Introduction to Aesthetic Anthropology.* 2d ed. Malibu: Undena.

Marquina, Brigido

n.d. *Las Nuevas Tribus.* Caracas: Comité Evangélico Venezolano por la Justicia.

Mason, Otis Tufts

1976 [1904] *Aboriginal American Indian Basketry: Studies in a Textile Art without Machinery.* Santa Barbara and Salt Lake City: Peregrine Smith, Inc.

Mattéi-Muller, Marie-Claude, and Paul Henley

1978 *Wapa: La comercialización de la artesanía indígena y su innovación artística: El caso de la cestería Panare.* Caracas: Litografía Tecnocolor.

Meggers, Betty J.

1971 *Amazonia: Man and Culture in a Counterfeit Paradise.* Chicago: Aldine Publishing Company.

Métraux, Alfred

1946 "Twin Heroes in South American Mythology." *Journal of American Folklore* 49:114–23.

Migliazza, Ernest C.

1980 "Languages of the Orinoco-Amazon Basin: Current Status." *Antropológica* 53:95–162.

Miller, Leo E.

1917 "The Land of the Maquiritares." *The Geographical Review* 3:356–74.

Morphy, H., and R. Layton

1981 "Choosing among Alternatives: Cultural Transformations and Social Change in Aboriginal Australia and French Jura." *Mankind* 13(1):56–63.

Mosonyi, Esteban Emilio

1972a "Indian Groups in Venezuela." In *The Situation of the Indian.* See Arvelo-Jimenez 1972.

1972b "The Situation of the Indian in Venezuela: Perspectives and Solutions." In *The Situation of the Indian.* See Arvelo-Jimenez 1972.

Mosonyi, Esteban Emilio, et al.

1981 *El caso Nuevas Tribus.* Caracas: Editorial Ateneo de Caracas.

Newton, Dolores

1981 "The Individual in Ethnographic Collections." In *The Research Potential of Museum Collections,* edited by A. Cantwell, J. Griffin, and N. Rothschild. Annals of the New York Academy of Sciences 376:267–88.

Ocando Oria, Luis R.

1965 "Informe sobre el rito de purificación del recien nacido y de su madre entre los Makiritare." *Antropológica* 14:61–63.

Oficina Central de Estadística e Informática

1985 *Censo Indígena de Venezuela.* Caracas: Taller Gráfico de la Oficina Central de Estadística e Informática.

Ohnuki-Tierney, Emiko

1987 *The Monkey as Mirror: Symbolic Transformations in Japanese History and Ritual.* Princeton: Princeton University Press.

O'Neale, Lila M.

1963 [1948] "Basketry." In *Handbook of South American Indians.* See Heizer 1963.

Ong, Walter J.

1982 *Orality and Literacy: The Technologizing of the Word.* New York: Methuen & Co.

Ortega, Kalinina

1976 "La Unión Makiritare de Alto Ventuari discutida en el simposio sobre Amazonas." *El Nacional.* December 9, 1976, p. C-15.

Paternosto, César

n.d. "Stone Sculpture of the Incas." Ms.

1984 "Escultura Incaica y Arte Constructivo." *Arte Informe* (Buenos Aires) 8:46–47.

1985 "Escultura abstracta de los Incas." Boletín del Centro de Investigaciones Históricas y Estéticas, Facultad de Arquitectura y Urbanismo, Universidad Central de Venezuela.

Perrin, Michel

1986 " 'Savage' Points of View on Writing." In *Myth and the Imaginary.* See Magaña and Mason 1986.

1987 *The Way of the Dead Indians: Guajiro Myths and Symbols.* Austin: University of Texas Press.

Ramos, Alcida Rita

1977 "El Indio y los otros: La visión multietnica de un indio Maiongong." *América Indígena* 37(1):89–111.

1979 "Rumor: The Ideology of an Intertribal Situation." *Antropológica* 51:3–25.

Reichel-Dolmatoff, Gerardo

1971 *Amazonian Cosmos: The Sexual and Religious Symbolism of the Tukano Indians.* Chicago: University of Chicago Press.

1975 *The Shaman and the Jaguar: A Study of Narcotic Drugs among the Indians of Colombia.* Philadelphia: Temple University Press.

1976 "Cosmology as Ecological Analysis: A View from the Rain Forest." *Man* 11:307–18.

1978*a* *Beyond the Milky Way: Hallucinatory Imagery of the Tukano Indians.* Los Angeles: University of California, Los Angeles Latin American Center Publications.

1978*b* "The Loom of Life: A Kogi Principle of Integration." *Journal of Latin American Lore* 4(1):5–27.

1981 "Mind and Brain in Desana Shamanism." *Journal of Latin American Lore* 7(1):73–98.

1985 *Basketry as Metaphor: Arts and Crafts of the Desana Indians of the Northwest Amazon.* Occasional Papers of the Museum of Cultural History, no. 5. Los Angeles: University of California, Los Angeles.

Ribeiro, Darcy

1957 *Arte Plumária dos Indios Káapor.* Rio de Janeiro: Editôra Civilição Brasileira S. A.

1980 *Kadiwéu: Ensaios etnológicos sobre o saber, o azar e a beleza.* Petrópolis, Brazil: Vozes.

Riviere, P. G.

1969 "Myth and Material Culture: Some Symbolic Interrelations." In *Forms of Symbolic Action,* edited by Robert F. Spencer. Proceedings of the 1969 Annual Spring Meeting of the American Ethnological Society. Seattle and London: University of Washington Press.

Roe, Peter G.

1982 *The Cosmic Zygote: Cosmology in the Amazon Basin.* New Brunswick: Rutgers University Press.

1987 "Impossible Marriages: Cashi Yoshiman Ainbo Piqui (The Vampire Spirit Who Ate a Woman) and Other Animal Seduction Tales among the Shipibo Indians of the Peruvian Jungle." Presented at the Fifth International Symposium on Latin American Indian Literatures (LAILA), Ithaca, N.Y.

Roth, Walter E.

1915 *An Inquiry into the Animism and Folk-lore of the Guiana Indians.* Thirtieth Annual Report of the U. S. Bureau of American Ethnology (1908–09). Washington, D. C.: Smithsonian Institution.

1924 *An Introductory Study of the Arts, Crafts, and Customs of the Guiana Indians.* Thirty-eighth Annual Report of the U. S. Bureau of American Ethnology (1916–17). Washington, D. C.: Smithsonian Institution.

Sahlins, Marshall

1972 *Stone Age Economics.* Chicago: Aldine Publishing Company.

1981 *Historical Metaphors and Mythical Realities: Structure in the Early History of the Sandwich Islands Kingdom.* Ann Arbor: University of Michigan Press.

Salazar Quijada, Adolfo

1970 *Onomastica Indígena.* Caracas: Universidad Católica Andrés Bello.

Schneider, David M.

1968 *American Kinship: A Cultural Account.* Chicago: University of Chicago Press.

1976 "Notes toward a Theory of Culture." In *Meaning in Anthropology,* edited by Keith H. Basso and Henry A. Selby. Albuquerque: University of New Mexico Press.

1977 "Kinship, Nationality, and Religion in American Culture: Toward a Definition of Kinship." In *Symbolic Anthropology: A Reader in the Study of Symbols and Meanings,* edited by Janet L. Dolgin, David S. Kemnitzer, and David M. Schneider. New York: Columbia University Press.

Schomburgk, Robert

1847 *Reisen in Britisch Guiana.* Leipzig: J. J. Weber.

Schwartzenberg Rincón, Juan Carlos

n.d. "Diseño de un proyecto de educación intercultural bilingüe: Estudio preliminar en la comunidad indígena Makiritare de Parupa." Thesis, Universidad de Oriente, Cumaná, Venezuela.

Seeger, Anthony

1981 *Nature and Society in Central Brazil: The Suya Indians of Mato Grosso.* Cambridge, Mass.: Harvard University Press.

Sponsel, Leslie E.

1986 "La cacería de los Yekuana bajo una perspectiva ecológica." *Montalbán* 17:175–95.

Stevens, Albert W.

1926 "Exploring the Valley of the Amazon in a Hydroplane." *The National Geographic Magazine* 49(4):353–420.

Stewart, Hilary

1979 *Robert Davidson: Haida Printmaker.* North Vancouver: Douglas & McIntyre Ltd.

Tate, G. H. H., and C. B. Hitchcock

1930 "The Cerro Duida Region of Venezuela." *The Geographical Review* 20:31–52.

Tello, Jaime

1979 *Mamíferos de Venezuela.* Caracas: Fundación La Salle de Ciencias Naturales.

Turner, Terence S.

1969 "Tchikrin: A Central Brazilian Tribe and its Symbolic Language of Bodily Adornment." *Natural History* 78(8):50–70.

1985 "Animal Symbolism, Totemism and the Structure of Myth." In *Animal Myths and Metaphors.* See Urton 1985.

Turner, Victor

1967 *The Forest of Symbols: Aspects of Ndembu Ritual.* Ithaca, N. Y.: Cornell University Press.

1969 *The Ritual Process: Structure and Anti-Structure.* Ithaca, N.Y.: Cornell University Press.

1975 "Symbolic Studies." *Annual Review of Anthropology* 4:145–61.

Urton, Gary, ed.

1985 *Animal Myths and Metaphors in South America.* Salt Lake City: University of Utah Press.

Wagner, Roy

1981 *The Invention of Culture.* 2d ed. Chicago: University of Chicago Press.

1986 *Symbols That Stand for Themselves.* Chicago: University of Chicago Press.

Washburn, Dorothy K.

1983 *Structure and Cognition in Art.* Cambridge: Cambridge University Press.

Wavell, Stewart, Audrey Butt, and Nina Epton

1966 *Trances.* London: George Allen and Unwin, Ltd.

Wilbert, Johannes

1958 "Kinship and Social Organization of the Ye'cuana and Guajiro." *Southwestern Journal of Anthropology* 14:51–60.

1966 *Indios de la región Orinoco-Ventuari.* Caracas: Fundación La Salle de Ciencias Naturales.

1972 *Survivors of Eldorado: Four Indian Cultures of South America.* New York, Washington, London: Praeger Publishers.

1974 *Yupa Folktales.* Los Angeles: University of California, Los Angeles Latin American Center Publications.

1975 *Warao Basketry: Form and Function.* Occasional Papers of the Museum of Cultural History, no. 3. Los Angeles: University of California, Los Angeles.

1976 "To Become a Maker of Canoes: An Essay in Warao Enculturation." In *Enculturation.* See Wilbert, ed. 1976.

1981 "Warao Cosmology and Yekuana Roundhouse Symbolism." *Journal of Latin American Lore* 7(1):37–72.

Wilbert, Johannes, ed.

1976 *Enculturation in Latin America: An Anthology.* Los Angeles: University of California, Los Angeles Latin American Center Publications.

Wilbert, Johannes, and David M. Guss

1980 *Navigators of the Orinoco: River Indians of Venezuela.* Museum of Cultural History Pamphlet Series, no. 11. Los Angeles: University of California, Los Angeles.

Williams, Llewelyn

1941 "The Caura Valley and Its Forests." The Geographical Review 31:414–29.

Yde, Jens

1965 *Material Culture of the Waiwai.* Copenhagen: The National Museum.

Zerries, Otto

1968 "Primitive South America and the West Indies." In *Pre-Colombian American Religions,* by Walter Krickeberg, Hermann Trimborn, Werner Muller, and Otto Zerries. London: Weidenfeld and Nicolson.

Index

263

Designer: Linda M. Robertson
Compositor: Huron Valley Graphics
Text: 10/12 Garamond Light
Display: Garamond Light